# FRANK LLOYD WRIGHT
# MASTER BUILDER

D0489417

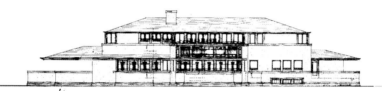

# FRANK LLOYD WRIGHT
# MASTER BUILDER

EDITED BY DAVID LARKIN AND BRUCE BROOKS PFEIFFER
TEXT BY BRUCE BROOKS PFEIFFER ■ THAMES AND HUDSON
IN ASSOCIATION WITH THE FRANK LLOYD WRIGHT FOUNDATION

First published in Great Britain in 1997
by Thames and Hudson Ltd, London

Updated and revised edition of *Frank Lloyd Wright: The Masterworks*,
first published in Great Britain in 1993 by
Thames and Hudson Ltd, London

British Library Cataloguing-in-Publication Data

A catalogue record for this book is available from the British Library

ISBN 0-500-28027-4

Original photography by Paul Rocheleau and Michael Freeman

Designed by David Larkin / A David Larkin Book

Additional photography by
Paul Warchol (the Solomon R. Guggenheim Museum, exterior at night)

Project dating: The buildings in this volume have been dated by the year in which the
commission was received whether or not construction actually began in that year. Projects that
spanned a number of years have been assigned dates that reflect the years of
Frank Lloyd Wright's personal supervision.

All measurements for drawings are given height before width.
FLLW Fdn numbers refer to the cell numbers of the
Frank Lloyd Wright Foundation Archives.

Printed in Italy

# CONTENTS

# INTRODUCTION

ARCHITECTURE, MORE THAN ANY OF THE ARTS, is the most susceptible to the hazards of nature, time, and man. Music, literature, drama, painting, sculpture—to cite a few examples—seem largely spared. Music and literature, poetry and drama can be read, relived, or re-created hundreds of times over and generations after the original text or score was written. A vast array of art museums and collections hold safe the works of painters, sculptors, printmakers, potters, and weavers, as well as the artifacts and artworks of cultures long since lost. But architecture, for all its apparent sturdiness and supposed permanence, has no such guarantee of immortality. It is, actually, relatively frail: out under the hot summer sun or in below-zero snows, architecture is a victim of the elements. Neglect is an even greater foe, which with time slowly eats away at a building. But the most destructive force is man, as he remodels, "improves," adds to—or eventually demolishes—the great buildings of history.

In the mid-nineteenth century Eugène-Emmanuel Viollet-le-Duc, under the patronage of Napoleon III, saved some of the great monuments and cathedrals of France. At about the same time in Japan, the American Ernest Fenollosa, first curator of the Japanese Department in Boston's Museum of Fine Arts, campaigned to prevent the Japanese from destroying historic temples. Less fortunate were some 75 of the 484 buildings by Frank Lloyd Wright. Until recently, it seemed that the wanton demolition of his buildings would find no end. But the resurgence of interest in him as an architect and thinker has likewise spurred renewed interest in the extant buildings. Conservation and restoration of such important works as the Oak Park Home and Studio, the Barnsdall "Hollyhock House," and the Susan Lawrence Dana house have brought the importance of his buildings to public attention and saved them. Much of this conservation has been funded by state and federal agencies, but several other residences have been conserved by private means, such as the John Storer house, the Auldbrass Plantation, and the Isadore Zimmerman house. In fact, across the nation there is a strong movement to save more and more of Wright's buildings, to research conscientiously their histories, and to make a concentrated effort to preserve them faithfully and accurately.

Frank Lloyd Wright was born at the close of the Civil War; he died at the advent of the Space Age. He lived to be nearly ninety-two. For seventy-two of those years he was involved in the practice of architecture, and his talent and vision continue to inspire architects and laymen alike. His architectural achievements were made possible by the methods and materials available at the start of the twentieth century: concrete, steel, reinforced concrete, sheet metal, plate glass, and, later, plastics. Out of these elements he wove spaces and forms that no longer imitated the styles of the past but breathed new life into architecture and propelled the art of building into a dynamic and innovative era.

Wright chose the word "organic" to describe his architecture and first used the term in a

public address in 1894: "Let your home appear to grow easily from its site and shape it to sympathize with the surroundings if Nature is manifest there, and if not, try and be as quiet, substantial, and organic as she would have been if she had the chance."[1] A devoted student of nature and of the philosophical principles underlying the fabric of nature, he used the precepts of organic growth to inspire his architecture. He likened the flow of form from root to stem to blossom to fruit as a valuable lesson in building construction. This sense of the whole, indivisible and integral, he described as "an architecture that *develops* from within outward in harmony with the conditions of its being as distinguished from one that is *applied* from without."[2]

He defined "organic architecture" as architecture that is appropriate to time, appropriate to place, and appropriate to man. These three concepts characterized his work throughout his career. By "appropriate" to time he meant a building should belong to the era in which it is created. A twentieth-century building, for example, should not imitate a seventeenth-century building. Buildings of the past, he argued, addressed the lifestyles, social patterns, and conditions that are no longer applicable in modern times. A twentieth-century building should also make use of the materials and methods available at the time that it is designed. About this subject of materials he wrote a great deal: his basic belief was in using natural materials honestly in accordance with their own best characteristics; in using new materials innovatively. The skyscrapers of the early twentieth century, for example, were piles of stone masonry applied to an iron or steel frame, taking minimal advantage of what the new methods and technology had to offer to the art and science of building construction. Wright's National Insurance Company skyscraper (1924), Johnson & Son Company Research Tower (Racine, WI, 1944), and the H.C. Price Company Tower (Bartlesville, OK, 1952), on the other hand, are clear expressions of twentieth-century building methods, epitomizing a new way of building tall buildings.

He defined a building as "being appropriate to place" if it is in harmony with its natural environment, with the landscape, wherever possible taking best advantage of natural features. At the turn of the century this placed him at the forefront of what we call environmental planning. With the prairie houses, Wright was building with the prairie environs in mind, letting the houses extend along predominantly horizontal lines, which he found conducive to the geography of the region, and raising the living quarters up off the prairie floor to afford a view of the surrounding vista. In an entirely different setting, his design for Kaufmann's "Fallingwater" is the ultimate example of building and site in harmony. By "appropriate to man" he meant that a building's first mission is to serve people. In that respect he planned his structures with the human as the unit of measure. He extolled human values, and his architecture did likewise. He subscribed to the concept that "the reality of the building is the space within to be lived in, not the walls and ceiling."[3]

His quest for freeing architectural space began with his early houses, in which he opened rooms into one another, eliminating unnecessary partitions and giving what has been called "the open plan" to the family home. In his nonresidential work, starting with the Larkin Building (Buffalo, NY, 1903) and Unity Temple and continuing with such outstanding works as the Imperial Hotel (Tokyo, 1913), S. C. Johnson & Son Company Administration Building (Racine, WI, 1936), Solomon R. Guggenheim Museum, and the Marin County Civic Center, this concept of space-flow took on an even greater significance as it affected not just the family unit but the general public as well.

The development of these three themes was constant in his life, no one progressing without the other two. That was how he judged the significance of his work: all parts related to the whole as the whole is related to the parts, an organic entity.

The masterworks in this volume were not selected by virtue of their size or magnitude, costs, or elegance; the selection of buildings was based upon the importance of the building in the annals of architectural history. "Fallingwater" and the Guggenheim Museum are widely acclaimed masterworks; but Wright's own home and studio in Oak Park, Illinois, and the modest Herbert Jacobs Usonian house in Madison, Wisconsin, can also claim this distinction.

Wright was primarily a residential architect. Homes for clients of moderate incomes constitute by far the majority of his executed buildings. This is in contrast to the standard practice of large architectural firms. His first employers, Adler and Sullivan, shunned residential work and courted only those clients desiring large commercial buildings. But Frank Lloyd Wright placed great faith in the family unit as the essential core of a free democracy. His mission was to create an architectural environment that would address the individual and the family unit first of all, and then society as a whole.

The photography in this volume is new and takes a fresh approach to the work. The book is designed so that the buildings appear chronologically, for the evolution and development of Wright's ideas to be shown in clear progression. As early as 1908 he prophesied, "As for the future—the work shall grow more truly simple; more expressive with fewer lines, fewer forms; more articulate with less labor; more plastic; more fluent, although more coherent; more organic."[4]

Both the variety and the contrasts among the different buildings are immediately apparent. Today, standing in the meadow by the lagoon and looking up at Wright's Marin County Civic Center of 1957, one is struck by the almost unbelievable realization that this building is actually from the same hand that designed the William H. Winslow house over one hundred years ago. The same virtuosity distinguishes the Beth Sholom Synagogue and the John Storer house. What these buildings clearly establish is the infinite variety of Wright's spaces. No other architect in history can claim such variety and such a body of work. The principles of organic architecture remain faithfully interpreted for each and every one of them: their placement in an environment respectful of nature and the landscape. They are an inspiration to the people living, working, or worshiping within them.

Bruce Brooks Pfeiffer
Taliesin West, 1997

# THE EARLY YEARS 1889–1898

FRANK LLOYD WRIGHT spent the first twenty years of his life in southwestern Wisconsin, with the exception of a brief spell of time in New England. The story of those first twenty years, many of them spent on his uncle's farm, is movingly told in his autobiography. Both his mother and father were highly educated persons: she taking an active role in the school her sisters founded, the Hillside Home School; he a student of medicine, then law, and finally the ministry. Wright's father was also a musician—pianist, organist, and composer— and he instilled in his son a deep reverence for music, much as Wright's mother instilled in him a similar reverence for poetry and literature. Frank Lloyd Wright's life on the farm embedded in him a love for the agrarian way of life, a love he would never lose.

His mother amplified his training by exposing him to the ideas of the German educator Friedrich Froebel. Froebel did not believe a child should learn to draw by copying nature, but rather should undergo a system of visual education that involves manipulating wooden blocks, cubes, and spheres laid out on a table marked with a grid. This, Froebel believed, gives the child an understanding of the geometry and form underlying all things in the natural world. It was a training that Wright would never forget, and even in the last decade of his life he would recognize his debt to his early training.

Wright also attributed much of what he learned to the deep study of nature he was afforded during his years on his uncle's farm. He noticed, for example, that trees with spreading roots, such as the elm, would, after a hurricane or tornado, be uprooted and upturned. Pine trees, on the other hand, had a tap-root foundation, one long root extending far down into the ground. Some of the upper limbs might have been snapped off, but the trunk and the roots were spared intact. From this simple observation in his boyhood, Wright translated the principle of the tap-root foundation into his designs for such tall buildings as the S.C. Johnson & Son Company Tower and the H. C. Price Company Tower.

At the age of twenty, after attending courses in engineering at the University of Wisconsin, he left home for Chicago to pursue a life in architecture. This pursuit was not something that came upon him suddenly; before he was born his mother, Anna Lloyd Wright, determined that the child she was carrying would be a boy, and that boy would grow up to build beautiful buildings.

It would seem a fearful challenge to come out of rural Wisconsin, where he had been steeped in Unitarian transcendentalism, and suddenly be thrown into the midst of the industrial revolution taking place at breakneck speed in turn-of-the-century Chicago, where he arrived on a drizzling rainy night and saw, for the first time in his life, electric lights. But there was something in his composition that easily blended sources of influence. He

would make use of the advantages of the machine age in order to bring architecture and nature into the lives of human beings just as his mother planned he should.

The Chicago Wright first saw was still rebuilding after the fire of 1871, and the young Wright wanted to be part of the new architectural energy fueling the building of the first skyscrapers. After working for various architects, among them Joseph Lyman Silsbee, who was building a chapel for the Lloyd-Jones family in a valley of the Wisconsin River near Spring Green, Wright came upon the work of Adler and Sullivan. The Chicago Auditorium was in the planning stages, and Sullivan needed help in drafting all the decorative elements of the great structure. Wright approached Sullivan for a job and was asked to submit some sketches. The samples impressed Sullivan, who immediately employed him. Shortly after entering Sullivan's employ, Wright was married and needed a home for his wife and growing family. Sullivan arranged a contract and a loan by means of which Wright could acquire property in Oak Park, a quiet suburb of Chicago, and build his own house.

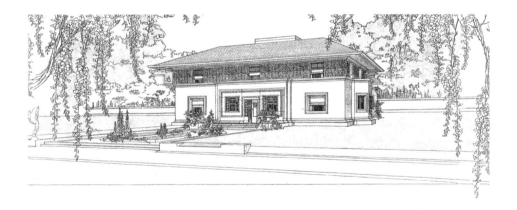

WILLIAM H. WINSLOW HOUSE. PLATE FROM A PORTFOLIO OF WRIGHT'S DRAWINGS PUBLISHED BY ERNST WASMUTH.

# FRANK LLOYD WRIGHT HOME AND STUDIO, 1889–1909
## Oak Park, Illinois

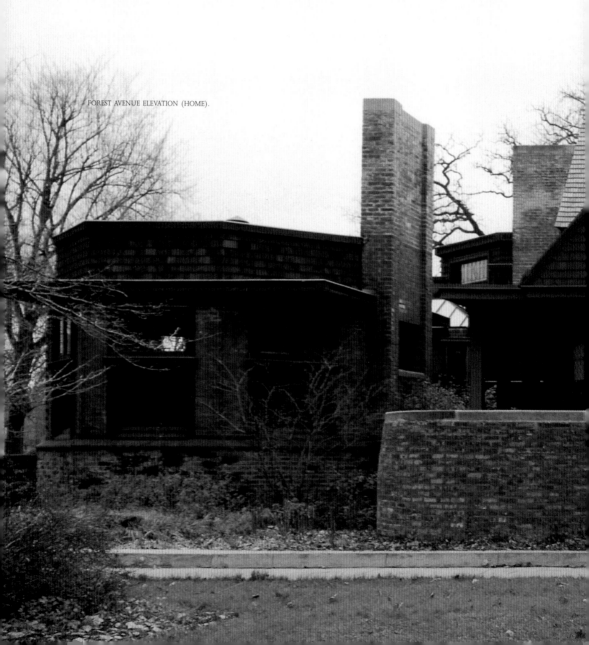

FOREST AVENUE ELEVATION (HOME).

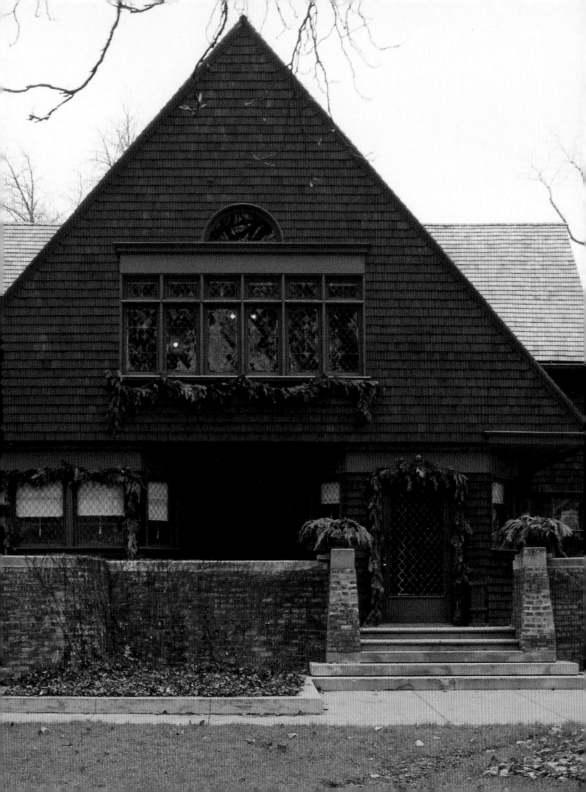

In 1958, near the end of his life, Frank Lloyd Wright wrote below a photograph of the Oak Park house he resided in from 1889 to 1909, "Seaside Colonial." He was referring to the wood shingles and the high gable roof that are the house's two predominant features. Despite these characteristics, however, Wright's first home was not the average house of the time: it was not a conglomeration of varied building materials and narrow precipitous chimneys, nor was it decorated with the curlicues and other affectations that abounded in the late Victorian era and found their way into much of America's domestic architecture. Instead, the Oak Park house had a quiet simplicity, achieved by the combination of dark stained shingles and brick terrace walls with white stone coping.

Photographs from Wright's first years in the house show that the interior, in contrast to this subdued exterior, was richly, in fact profusely, furnished with oriental rugs, Japanese prints and kakemono, bowls of wildflowers and weeds, even busts of Beethoven—all assembled in a staggering clutter that paradoxically does not reflect the sense of simplicity and repose for which the young architect would soon be noted. Eventually this early clutter would give way to his growing demand for simplicity. In the plan there is strong evidence, at this early stage, of his desire for a sense of space flowing from room to room and for an "honest" use of materials. Entryway, living room, and dining room are grouped together and only partially separated by large openings rather than by partitions or walls with small doors. The grain and luster of the wood have been left in their natural state, with the wood lightly stained and waxed to reveal its inherent character. Plaster walls are unadorned, and there is no use of wallpaper or bright, shiny paint. The hardwood floors are also left in their natural tone, with rugs and runners strategically placed to let the beauty of the wood show through.

The focal point of the interior is undoubtedly the fireplace. Fireplaces would figure strongly in Wright's residential work. Here the family, that sacred, individual unit of democracy, in Wright's terminology, gathered before the hearth. Thus, the fireplace occupies its own private nook, accessible to the living room but affording a pleasant, intimate space secluded from the rest of the downstairs area. Over the mantel are two inscriptions carved into a smooth, wooden panel: "Truth Is Life," and "Good Friend, Around These Hearth-Stones Speak No Evil of Any Creature."

The upper floor was given over to two bedrooms and bath and a studio, across the front of the house, in which Wright could work. During the next twenty years Wright altered the house considerably. The only plans that survive the changes is a set of blueprints heavily edited by him.

As his family grew, Wright realized the need for a space dedicated solely to his children, and he added a playroom to the house in 1895. Since this addition was planned for the second floor, the first-floor plan was altered extensively. The original dining room became

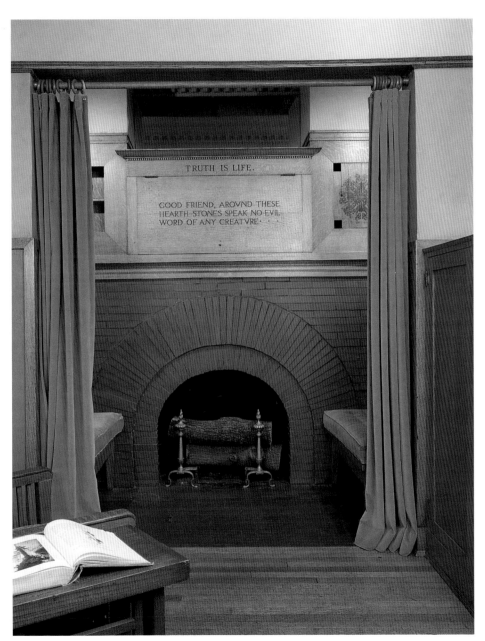

TRUTH IS LIFE.

GOOD FRIEND, AROVND THESE
HEARTH-STONES SPEAK NO EVIL
WORD OF ANY CREATVRE·

LIVING-ROOM FIREPLACE INGLENOOK.

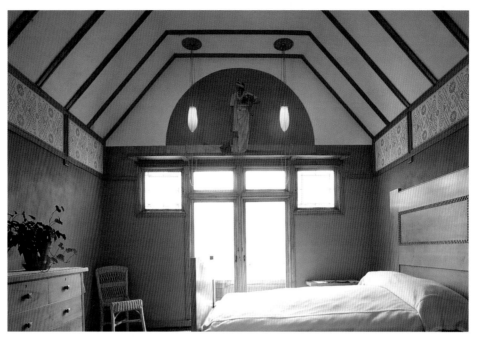

NORTH BEDROOM.

a study, but opened directly into the living room. The former kitchen was expanded to become a larger dining room with bay windows. A new pantry, maid's room, and adjacent kitchen expanded the first floor, and above these he built the playroom.

The high slat-back dining chair became a Wright "signature" piece after its first appearance in his own Oak Park house. He thought that the tall slat chairs could form a sort of screen around the family conclave. Just as the fireplace nook, contained and cozy, held the family at the home's hearth, so the dining table is also contained and protected, intensifying the family unit. That deeply rooted sense of the family or clan appears often in his work. His own family's religious background, Welsh Unitarianism combined with transcendentalism, was the predominating influence in his philosophy. And when he made his first voyage to Japan in 1905, what he saw of Shinto and Buddhism, of how the Japanese combined both and developed an intensely earth-bound but heaven-inspired culture, would not only inspire him, but be a confirmation for him. Shinto, with its reverence for nature, and the "Druid-Welsh" blood in his veins mixed wonderfully well.

Lighting was of special interest to him, and he experimented with both natural and artificial light sources. In his own home, ceiling globe designs, which he called "sunlight," and recessed indirect grille lighting of the dining room, which he called "moonlight," first appeared.

DINING ROOM, WITH ORIGINAL FURNITURE AND CEILING GRILLE.

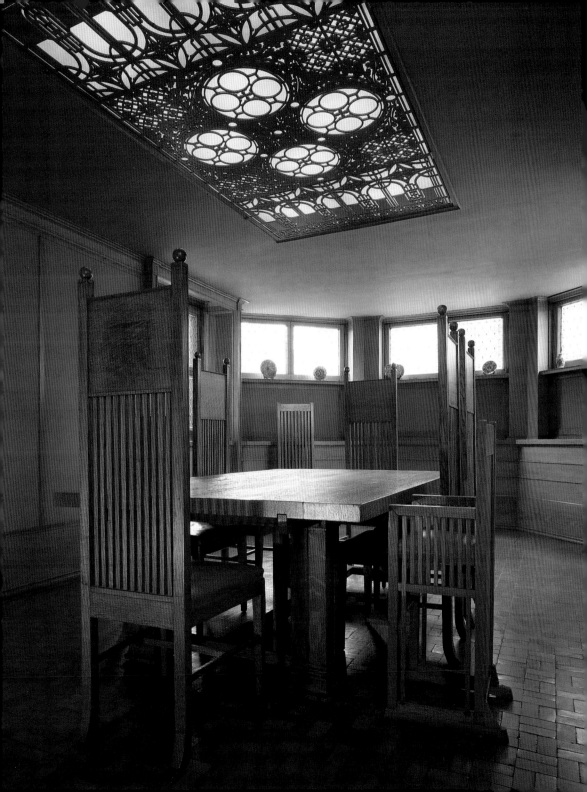

It is the playroom that best reveals new directions in Wright's work and is a clear demonstration of the learning process through which the young architect was developing the elemental needs of space, light, and simplicity. The sense of spaciousness in this room is more expansively suggested than in the rooms of his original home. Reinforcing this, windows are treated as long bands of continuous light.

The scale of the playroom is carefully tailored to a child's point of view. Window seats are low, and the vaulted ceiling falls to the windows, which are at a height a child can easily reach (but an adult must stoop to look out). A large, arched fireplace dominates one wall of the room. At the other end, a piano is built into a small balcony and a stairway leads past the piano to an even smaller balcony beyond.

This playroom became the focal point for the entire neighborhood. As the father of six children—four boys and two girls—Wright understood what delighted the child's mind and emotions: dolls, playhouses, stories read around the fireside, games and toys, the acting out of plays and charades, and, above all, parties—all these elements were considered in the design of the playroom. The placing of the room itself, on the second story, looking out to the branches of the trees, gives it the sense of being an elevated, enclosed treehouse. Over the fireplace Wright designed a large mural, based on a tale from the *Arabian Nights*, "The Fisherman and the Genie." Although the mural is representational, depicting a fisherman gazing up at the genie just released from the lamp, the decorations around the genie's wings are stylized abstract straight-line patterns. On a photograph of this mural Wright later wrote, "First straight line ornament. FLLW designer."[1]

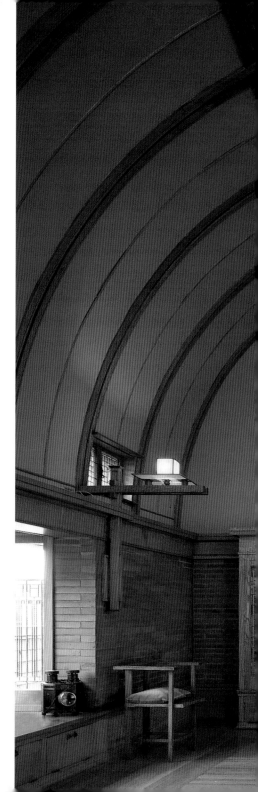

18

PLAYROOM, WEST END.

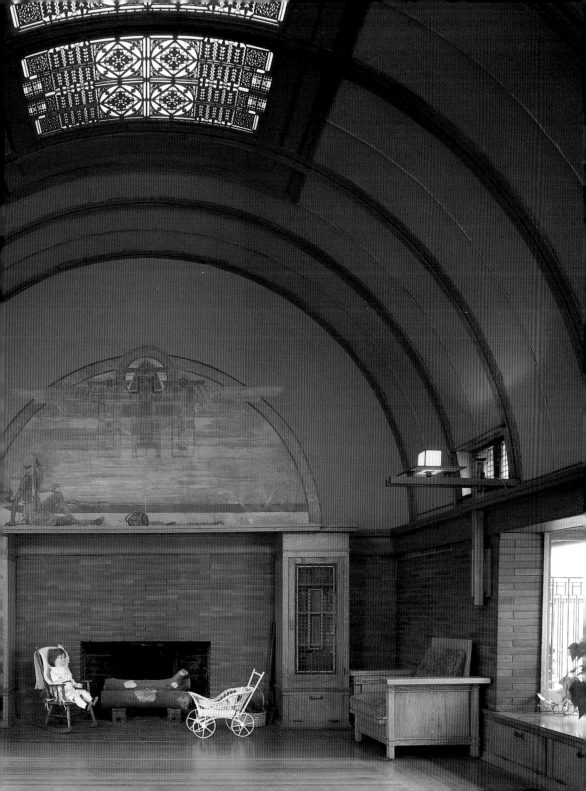

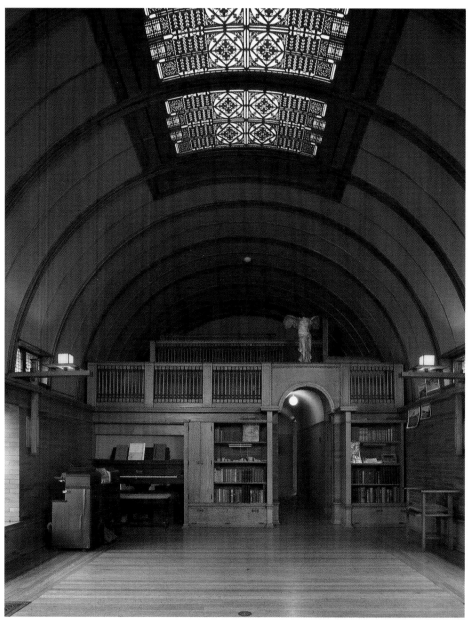

PLAYROOM, EAST END.

STUDIO DRAFTING ROOM.

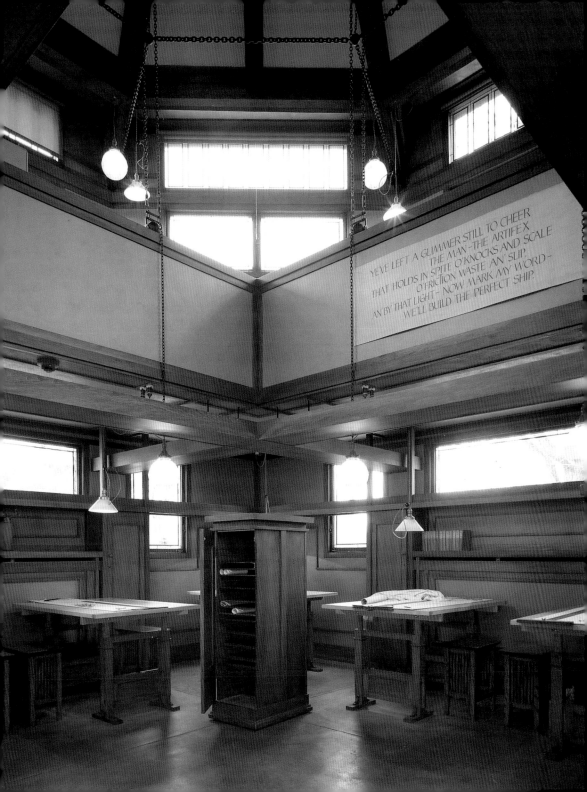

YE'VE LEFT A GLIMMER STILL TO CHEER
            THE MAN -THE ARTIFEX
THAT HOLDS IN SPITE O'KNOCKS AND SCALE
            O'FRICTION WASTE AN' SLIP
AN BY THAT LIGHT – NOW MARK MY WORD–
            WE'LL BUILD THE PERFECT SHIP.

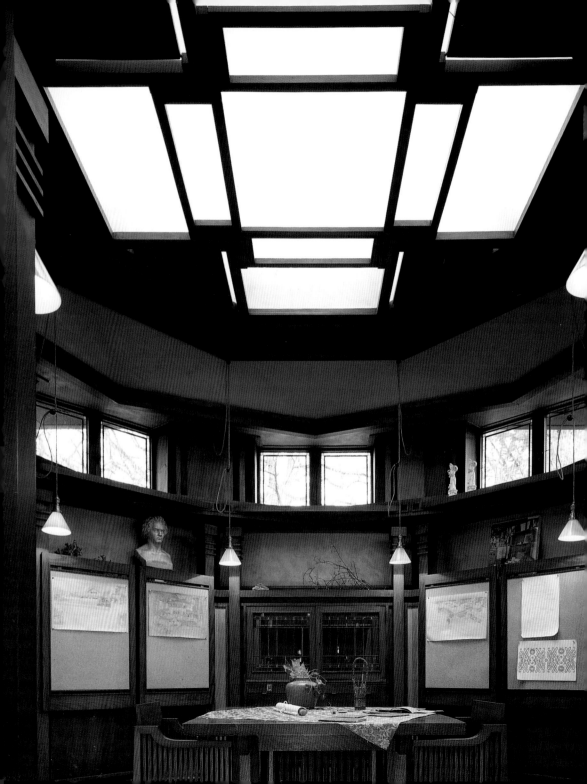

In 1897 Wright moved his office from downtown Chicago to Oak Park. He maintained that by having his place of work next to where he lived, he could extend his output by at least one-third. The new studio he designed for himself and his office staff was completed and in operation by June the following year. With the upstairs studio in his house no longer necessary, he divided the area into two "dormitories," one for the boys and the other for the girls. The new studio, attached to the house and gained through a corridor from the study, is a complex of two main elements, drafting room and library. In between is a reception room, where clients entered, and directly behind that is the architect's private office. The drafting room is a large square space with an octagonal balcony dramatically suspended from the ceiling rafters by great iron chains. Rows of windows on both levels provide ample light for work. The library is more secluded, with high windows stacked above book cabinets and a central skylight. This is where Wright showed his plans and drawings to clients, in a quiet space removed from the office and drafting room beyond. The same care and attention to materials that he exhibited in the adjacent house are evident here. His personal office is still more secluded, lit only by a skylight and a stained-glass window behind his worktable. The skylight over the reception area, however, is one of the richest in color and pattern of his work in this medium. Most of his stained-glass windows, such as the one in his office, employ color and pattern as a border or a central section of the window, and clear glass occupies the rest of the window. But the reception-room skylight is all stained glass, in muted shades of amber, green, and tawny brown. It is a perfect complement to the woodwork throughout the studio and a brilliant expression of the deep autumnal colors of the plaster—colors that Wright loved.

By 1898, when the studio was built, Wright was already mastering stained-glass designs, which he employed to bring patterned color into his interiors. But he was also intrigued by the manufacturing process of the windows. It was the machine-technique that particularly interested him in these abstract patterns: the machine allowed glass to be cut with a straight-edged tool, in contradistinction to the handcrafted techniques of the Arts and Crafts designers (as in the luxurious lamps and windows of Louis Comfort Tiffany). Wright also felt that his straight-line patterns were more in keeping with architectural forms and cleaner and more modern in every sense.

During the twenty years that Wright lived in the Oak Park house and conducted his work in the Oak Park studio—which he called the Oak Park Workshop—it is estimated that he made changes to the complex on the average of once every six months. Restored now by the Frank Lloyd Wright Home and Studio Foundation, the building is a National Historic Landmark open to the public on guided tours. It affords a detailed and revealing look into his life and work from 1889 to 1909.

# WILLIAM H. WINSLOW HOUSE, 1893  River Forest, Illinois

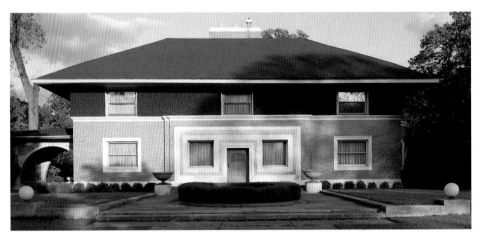

STREET ELEVATION.

The William H. Winslow house was the first commission Frank Lloyd Wright received after he opened his architectural practice. Built in River Forest in 1893, the elegance and grace of the building express a masterful handling of materials and proportion that is at once staggering—the architect was just twenty-six years old—and prophetic: the house marks the beginning of a new language in domestic architecture for the United States. Although its stately, formal appearance and well-balanced, centered front elevation suggest classical origins, Wright took the simple, natural materials of Roman brick, cast concrete, and terra-cotta and molded them together in a manner that was contrary to contemporary residential architecture. The brick rises off a cast-stone water table, or low platform. The upper floor, in contrast to the rich golden brick, is in subdued dark brown terra-cotta. The roof projects beyond the eaves, and the pitch of the roofline is gentle and hovering, in opposition to the high-peaked turrets of the late Victorian era. These elements alone distinguished the house from its neighbors, and its unusual frankness of design and honest treatment of materials mark it as irrevocably "modern." One of Wright's next clients, Nathan Moore, expressed a characteristically conservative reaction to the Winslow house when he told Wright, "Now we want you to build our house, but I don't want you to give us anything like that house you did for Winslow. I don't want to go down the backstreets to my morning train to avoid being laughed at."[1] (Surprisingly, Wright gave Moore an English Tudor–style house, but with a large front porch and terrace. "Probably the only English Tudor with a large front porch on record!" Wright later acknowledged.)

24

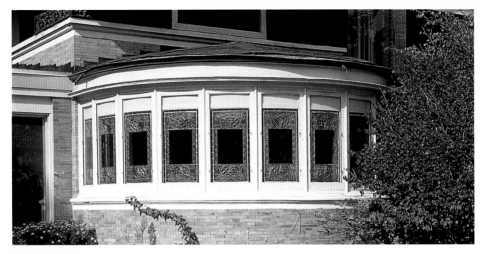

CONSERVATORY EXTERIOR.

Louis Sullivan's influence (Wright had left his office just weeks before the house was designed) can be seen in the pattern of the terra-cotta frieze on the upper-story outside surface, in the colonnade at the entry hall just in front of the fireplace, and in the designs for the stained-glass window bay of the conservatory. Sullivan's language of ornament was founded in nature: trees, plants, foliage, blossoms, seedpods—all can be seen in great poetic profusion in his building ornamentation. Wright inevitably absorbed much of his mentor's sense of design along these elemental, ornamental lines, and in Wright's own early work Sullivan's influence is strongly apparent. But soon it gave way to a language of his own:

By that time, 1894–5, architecture so-called "modern" had made sporadic appearances here and there around Chicago; reminiscent of Lieber Meister's [Sullivan's] ornament or something I had myself done or was doing as a dwelling. . . . But, now independent, I didn't use the fascinating ornament, had struck out a new line in a field of my own—the American dwelling: the nature of materials and steel in tension.[2]

FRONT DOOR, DETAIL.

25

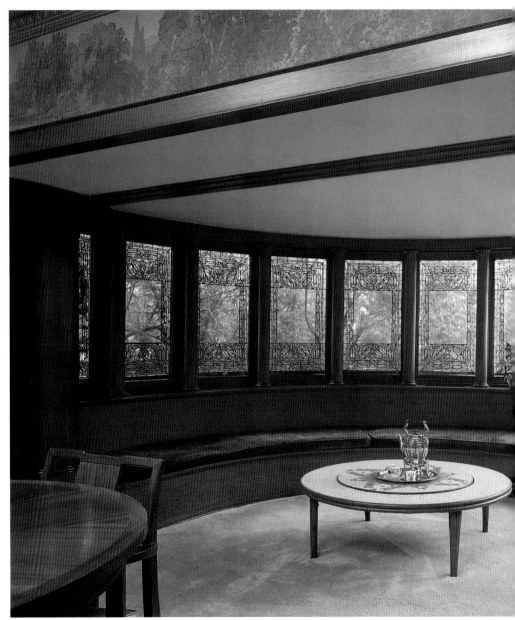

CONSERVATORY.

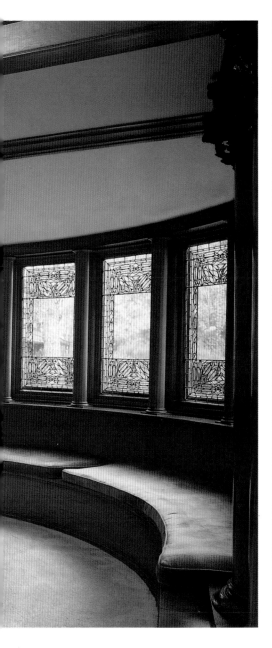

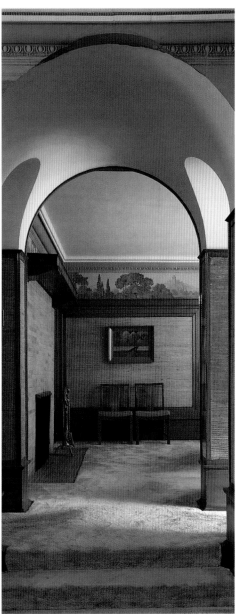

VIEW INTO DINING ROOM FROM LIVING ROOM.

Certainly the use of wood is radical in the Winslow house. While the columns and round arches of the prominent fireplace inglenook are Sullivanesque, the wood grille that flanks the steps up to this area is purely Wright, as is the wood grille by the window bay in the living room. These screen-like grilles are a preview of the style of ornament that would most appeal to Wright: the straight-line patterns so easily produced by the machine. His belief in the machine as the tool of the twentieth-century artist was first forcefully presented in his now-famous address in 1901 to a group at reformer Jane Addams's Hull House. The speech was published as "The Art and Craft of the Machine" and contains the young Wright's theses on simplifying the plan and ornamentation of a house so that it is in keeping with a modern, machine aesthetic: "The Machine is a marvelous simplifier; the emancipator of the creative mind, and in time the regenerator of the creative conscience."[3]

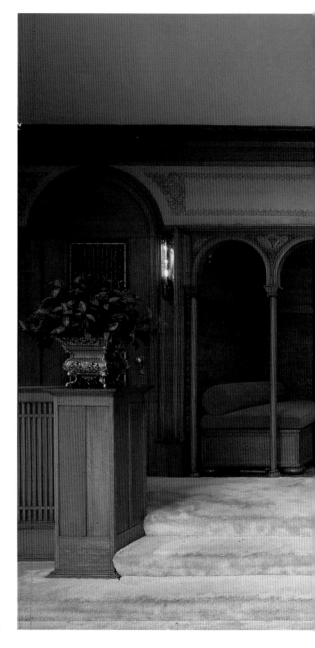

HALL ARCADE, WITH FIREPLACE INGLENOOK.

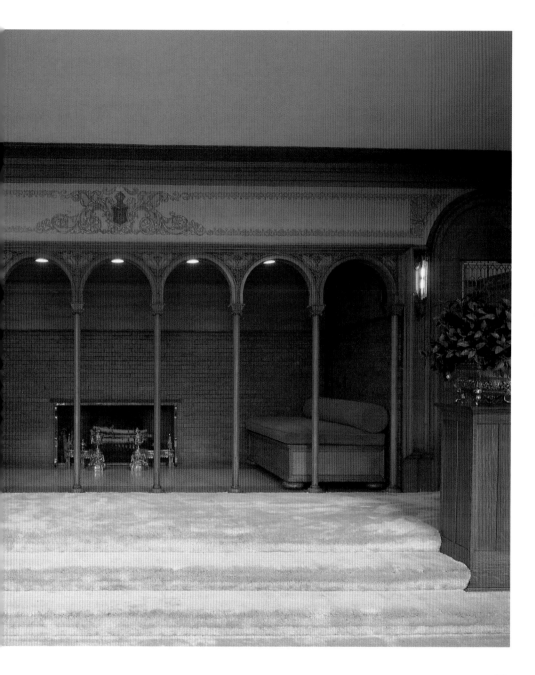

Daniel Burnham, Chicago's most fashionable architect at the end of the nineteenth century, praised the William H. Winslow house—"A gentleman's house from grade to coping"—and offered Wright an opportunity to leave Chicago to study at the École National des Beaux-Arts in Paris for four years and then in Rome for two additional years. He would pay Wright's way and support his family for the duration of his studies in Europe. Burnham was convinced that the Chicago World's Fair, of that same year, 1893, had established the nation's taste for classicism in architecture:

The Fair, Frank, is going to have a great influence in our country. The American people have seen the "Classic" on a grand scale for the first time. You've seen the success of the Fair and it should mean something to you, too. We should take advantage of the Fair.[4]

But Wright was not convinced. With this house for William H. Winslow he had demonstrated his ability as an architect and innovative designer. Classicism did not interest him, and accordingly he declined Burnham's generous offer: "I know how obstinate and egotistic you think me, but I'm going on as I've started. I'm spoiled, first by birth, then by training, and [this had now come clear under pressure] by conviction, for anything like that."[5]

The formal facade of the front elevation is the most famous view illustrating this work, but the rear elevation is far more interesting, as it reveals much of Wright's special sense of proportion, his distinct balance of forms and masses. Through the simple square plan of the house rises an octagonal stair tower, set off-center, and lit by slender vertical windows that run the length of the structure. All sense of rigid classical symmetry has been abandoned and a greater sense of freedom put in its place. This freedom is something that Wright would often refer to as "plasticity," or "continuity in the building itself":

If form really followed function (it might be seen that it did by means of this concrete ideal of plasticity as continuity), why not throw away entirely the implication of post and beam? Have no beams, no columns, no cornices, nor any fixtures, nor pilasters or entablatures as such. Instead of two things, one thing. Let walls, ceilings, floors become part of each, growing into one another, getting continuity out of it all or into it all, eliminating any constructed feature.[6]

Years later Wright acknowledged that it was in this all-important commission he first matured as an architect:

The Winslow house had burst on the view of that provincial suburb like the Prima Vera in full bloom. It was a new world to Oak Park and River Forest. That house became an attraction, far and near. Incessantly it was courted and admired. Ridiculed, too, of course. Ridicule is always modeled on the opposite side of that shield.[7]

STAIR TOWER EXTERIOR.

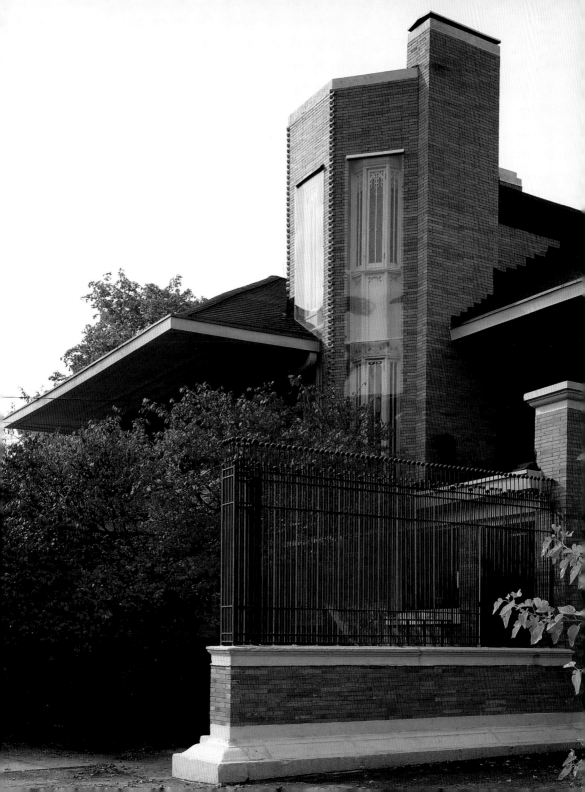

# THE PRAIRIE YEARS 1899–1910

WITH THE WORK OF ADLER AND SULLIVAN, a prominent Chicago firm at the end of the nineteenth century, a new architecture was being built in the Middle West, no longer based on classical examples, but founded on new design and engineering principles. Sullivan gave the skyscraper an aesthetic expression it never had before.

Until Sullivan the tall building was little more than a piling up of masonry boxes on a cast-iron or steel frame. Sullivan accentuated the sense of verticality, the long lean lines extending from ground to cornice, emphasizing this now remarkable and new characteristic: height. Adler's engineering, especially his intuitive knowledge of architectural acoustics, resulted in some of the best opera houses and concert halls yet built. But their work—and thus their innovations—was confined to commercial projects. While Frank Lloyd Wright was in their employ, from 1887 to 1893, they only accepted residential designs to accommodate a commercial client or a friend who wanted a house, and those commissions they turned over to the young Wright.

When he started his own practice, Wright sought to create a new architecture for residential designs springing from the work he had been doing with Adler and Sullivan. Although the Winslow house was his first independent commission, on a photograph of this house he wrote in 1950, "First house design under own name: 1893. Previously, Charnley House, Astor St. Chicago. Harlan House first building designed while with Adler and Sullivan that was as I would have it. Harlan house may be said to be beginning of my own practice."[1]

Within six years of opening his own office, Wright had developed a new architecture that changed the face of residential design and created new patterns for living. These revolutionary designs—soon widely imitated in what would become known as the "prairie style"[2]—have today made the dozens of Wright homes in Oak Park and neighboring areas the destination of thousands of architectural enthusiasts. When Wright's "prairie" designs were first published by the German Ernst Wasmuth in 1910 in the portfolio *Ausgeführte Bauten und Entwürfe von Frank Lloyd Wright*, the influence of these early buildings moved beyond the boundaries of the suburbs of Chicago to the capitals of Europe.

Wright was born on the Midwest prairie—in a small town in southwestern Wisconsin on June 8, 1867. He later moved with his family to Madison, the more urbane capital of Wisconsin, but still spent his summers on the farm of his uncle James, near Spring Green, Wisconsin. In 1887 Wright moved to Chicago for two years. But settling in the suburb of Oak Park in 1889, he once again took up life on the Midwest prairie. As he recalled in July 1936:

*I loved the prairie by instinct as, itself, a great simplicity; the trees, flowers, and sky were thrilling by contrast. And I saw that a little of height on the prairie was enough to look like much more. Notice how every detail as to height becomes intensely significant and how breadths all fall short.*[3]

The houses around him, however, appeared to Wright to be unsympathetic to their region: jumbles of tall, pointed roofs and narrow, threatening chimneys. Natural materials were treated unsympathetically: wood and shingles were painted, stone and brick plastered over. Inside, small rooms were cut up like so many boxes and displayed even more idiosyncratic uses of paint and wallpaper. Windows were small holes cut into the walls. Everything about these houses seemed confined and constricted.

In seeking to create a new language in domestic architecture, Wright took the prairie as his thesis. He wanted an architecture of long, low lines, which he argued was more desirable on the prairie. He eliminated the attic and basement and made his rooflines quiet and graceful, designing wide and generous masonry masses to contain fireplaces and flues for heating. The walls of the first floor of the building rose directly from a stylobate, or water table. This effected a very clear, clean outline of the house on its site, elevated the living quarters above the ground level, and negated the need for the usual bank of plants and shrubs to conceal the normal basement walls. Wright later elucidated his thoughts on prairie architecture:

*An idea (probably rooted deep in instinct) that shelter should be the essential look of any dwelling, put the low spreading roof, flat or hipped or low-gabled with generously projecting eaves, over the whole. I began to see a building primarily not as a cave but as broad shelter in the open, related to vista; vista without and vista within. You may see in these various feelings all taking the same direction that I was born an American, child of the ground and of space, welcoming spaciousness as a modern human need, as well as learning to see it as the natural human opportunity. The farm had no negligible share in developing this sense of things in me, I am sure.*[4]

*I had an idea (it still seems to be my own) that planes parallel to the earth in buildings identify themselves with the ground, do most to make the buildings belong to the ground. At any rate, independently I perceived this fact and put it to work. I had an idea that every house in that low region should begin on the ground, not in it as they then began, with damp cellars. This feeling became an idea also; eliminated the basement. I devised one at ground level. And the feeling that the house should look as though it began there at the ground put a projecting base course as a visible edge to this foundation where, as a platform, it was evident preparation for the building itself and welded the structure to the ground.*[5]

The types of floor plans of the prairie houses vary with the sites and the clients' needs. There was no set formula at work, but rather an individual response to each situation. Wright did, however, make a concerted effort to abolish the sense of the house being a "box," what he later in life referred to as "the destruction of the box in architecture." This meant that rooms would flow into each other by the elimination of unnecessary walls and doors, that light and air would come in by way of generous glass areas, and that the dwelling would open onto the landscape.

Windows were no longer treated as individual holes cut into the walls, but grouped together as bands of light. On ground level, or opening to a terrace, were French doors. On the upper stories windows were treated as continuous bands. He abhorred the traditional double-hung—or what he called "guillotine"—window, and he revised the European casement from windows that swing in to ones that swing out. He achieved a complete opening of the window space, usually opening under the soffit overhang, and extended the roof three to four feet beyond the window wall to protect the open swinging sash. He later recollected that many an early client would not accept his casement

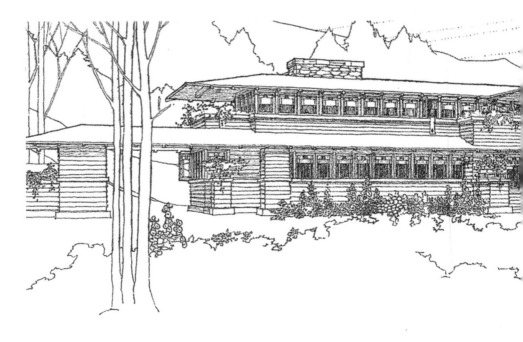

windows—and the commission usually ended at that point.

Wright's prairie houses, for the most part, did not enjoy dramatic sites. They were built in sedate, suburban regions. But by the use of extending terraces, some open, some roofed over, Wright was able to let the walls of the interior rooms reach out to engulf gardens and plantings, to make the connection between interior and exterior more obvious, and therefore more pleasurable, than it had ever been. He recalled his native-inspired philosophy in 1955:

In considering the various forms and types of these structures, the fact that nearly all were buildings for our vast Western prairie should be borne in mind; the great rolling prairies where every detail of elevation becomes exaggerated; every tree towers above the great calm plains of flowered surfaces as the plain lies serene beneath a wonderful unlimited sweep of sky. The natural tendency of every ill-considered thing on the prairie is to detach itself and stick out like a sore thumb in surroundings by nature perfectly quiet. All unnecessary heights have for that reason and for other reasons economic been eliminated, and more intimate relation with outdoor environment sought to compensate for loss of height.[6]

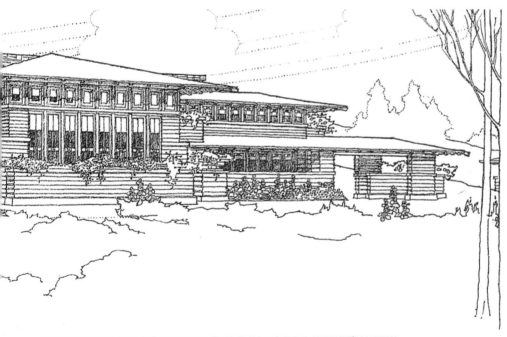

CLUBHOUSE FOR THE COMO ORCHARD COMMUNITY. PLATE FROM PORTFOLIO OF WRIGHT'S DRAWINGS PUBLISHED BY ERNST WASMUTH, BERLIN, 1910.

SUSAN LAWRENCE DANA HOUSE, 1902  Springfield, Illinois

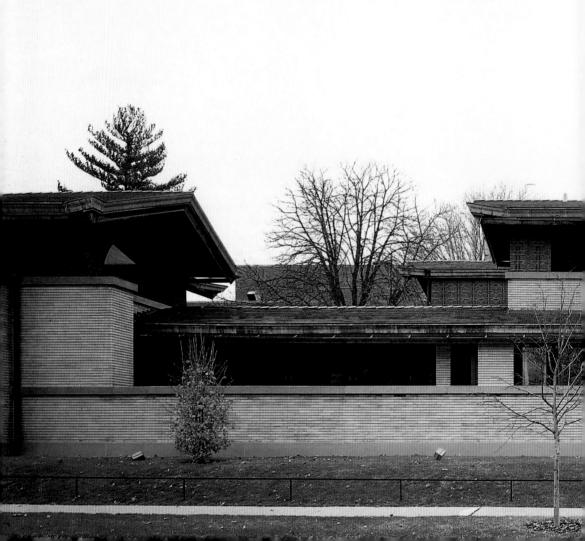

The luxuriously large Susan Lawrence Dana house is rather precariously crammed into a tight, conventional city corner lot. There is no expansive view, no broad extension onto the prairie. But Wright managed to design a building that creates a spacious, yet intimate, world. The tawny colors are composed by beautiful golden gray Roman brick (imported from England), warm oak woodwork, and stained glass—in a display of the finest craftsmanship ever to appear in his work.

The client, Susan Lawrence Dana, came from a prestigious political and social family in Springfield. Her foremost requirement of her architect was that he build a home in which she could entertain on a lavish scale. This gave Wright the opportunity to design a residence that was not just a single-family dwelling, but which in fact was destined to become an important Illinois social center.

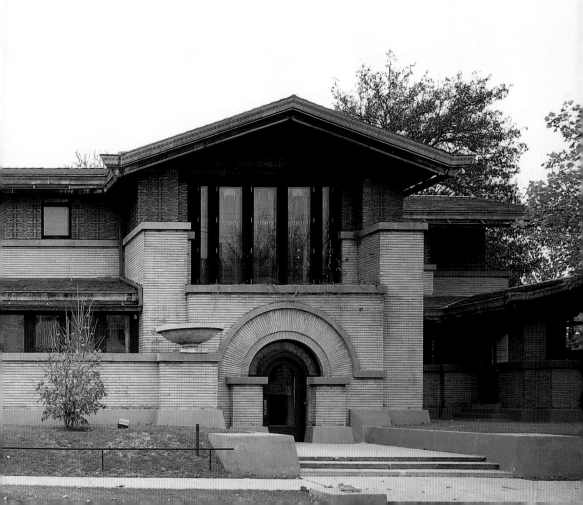

Of the designs for the Dana glass, as well as his other glass designs, Wright wrote:

I used to love to sit down at the drawing board with a T square and triangle and concoct these patterns that you will see in the windows. I evolved a whole language of my own in connection with those things. That was long before the Mondrians and these other things ever happened. You will see nearly everything that they ever thought of in these glass patterns—especially in the Midway Gardens. And also in the home of Mrs. Lawrence Dana. That was when I was most interested in it. And when I had found the means in Chicago—electro-glazing—where you could take a little copper strip and set it in between two pieces of cut glass—any pattern you wanted—and by just sticking it there with solder, in any pattern you wanted, all in shape, and then drop it into an electric bath, and the copper would attract from the bath enough more copper to seal the glass. That was an invention that just occurred during my youth as an architect. Every house I did had it in evidence—especially the Dana house, and especially the Midway Gardens.[1]

LEADED GLASS AND BRONZE DOUBLE-PEDESTAL TABLE LAMP.

ENTRYWAY ART GLASS CEILING LIGHT.

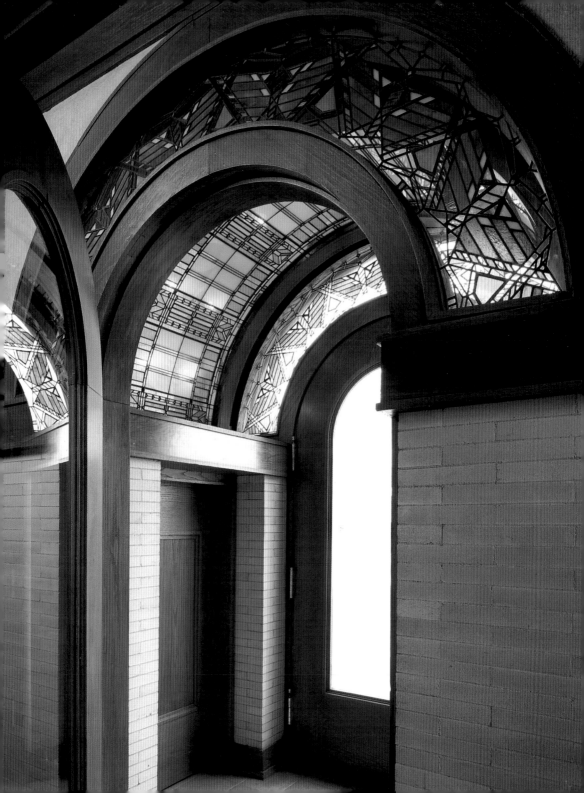

The working drawings, or construction documents, for the Dana house are typical of Wright's working drawings from 1893 to 1909. Drawn with black india ink, or china ink, with red to denote the brickwork, on tracing linen, they are in remarkably fine condition to this day. Several of the working drawings for other houses are now over a century old, and they constitute some of the prized items in The Frank Lloyd Wright Archives. There is a certain beauty in the precision of the lines that is also typical of Wright's working drawings. Another aspect of these drawings that might, at first glance, escape attention is the manner in which Wright instructed his draftsmen to use the full sheet of paper: Wright reveals himself as a conservationist, one not wanting to waste paper, or in this case, expensive tracing linen.

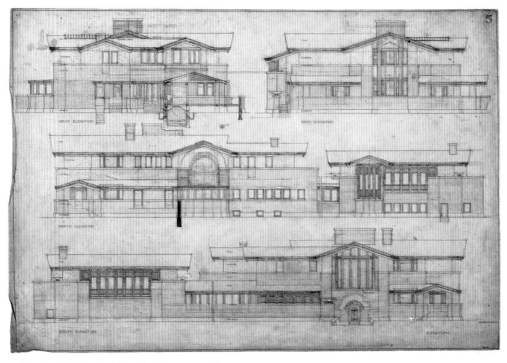

ELEVATIONS. INK ON LINEN, 32 x 47". FLLW FDN#9905.028.

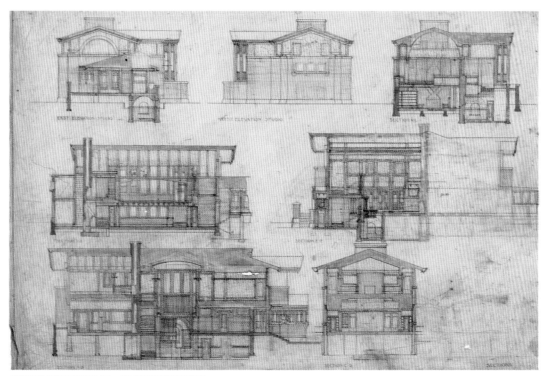

SECTIONS. INK ON LINEN, 32 x 47". FLLW FDN#9905.029.

41

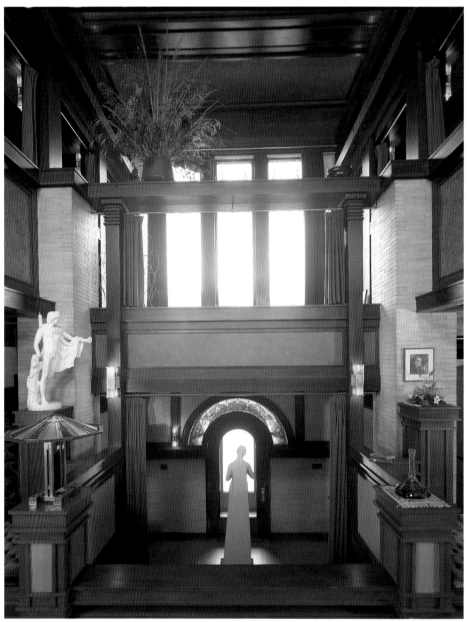

ENTRANCE HALL.

DINING ROOM WITH ORIGINAL FURNITURE.

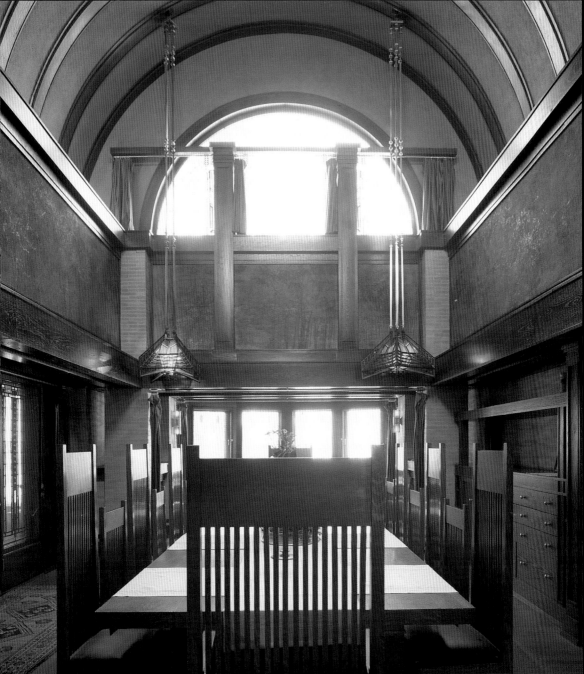

The entrance leads directly into the reception hall, on the ground level, but the hall is not an alcove separated from the main spaces. Rather it is a three-story sweep of space connected, vertically, to the larger, more "public" spaces above. Wright's treatment of space in the interior of his buildings is most frequently thought of in terms of flowing horizontal channels. In the entry of the Dana house, however, the sweep of space is primarily vertical, and the vast amount of light that pours in from the windows on the level above the arched doorway amplifies this sensation. On the first floor, above the entry level, the upper halves of these two-story windows continue to flood the general reception area with light. This is not the standard, small reception room that Wright relegates to many of his prairie houses; with its own arched fireplace, it is more in the character of a "lobby," an obvious meeting area where guests can socialize before going into the adjacent dining room. The flow from one area to the other is generous and unobstructed by doors or partitions. In fact, it is only the placing of the main dining table at the end of this area that marks the actual dining "room," under a vaulted ceiling. Connected to this area is the breakfast alcove, in a curved bay of stained-glass widows. The windows of this bay have been called the "sumac windows" and clearly demonstrate what Wright meant when he cautioned the artist not to draw literally from nature, but to be inspired by her inherent principles and discover his own forms. Indeed, the patterns of the glass and the exterior frieze running around the second floor are abstracted from the patterns of nature: sumac, butterflies, ferns, stalks of wildflowers, and leaves. Here the sumac leaf is totally abstracted, as are the wings of the butterfly in the glass transom at the entrance of the house. Prompted by the autumnal colors of the glass, one can well imagine a stroll through the house being like a walk through a northern forest in late October.

GALLERY WITH PRINT TABLES.

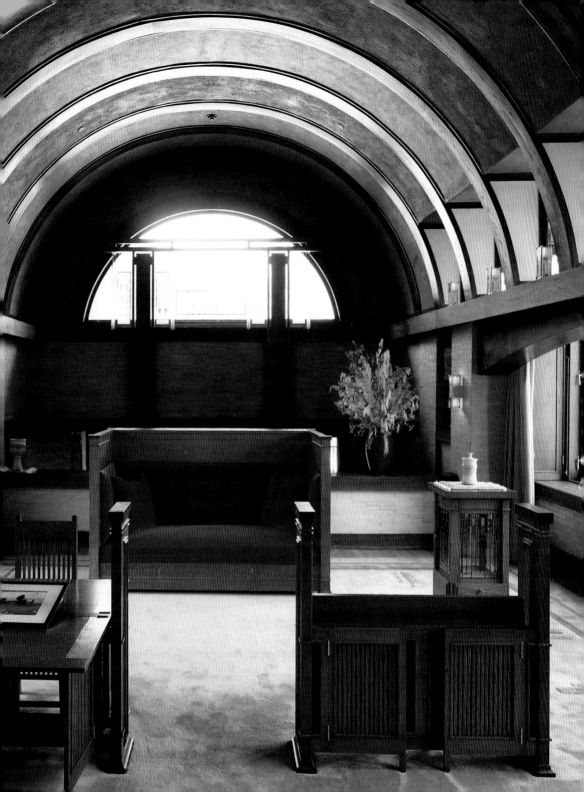

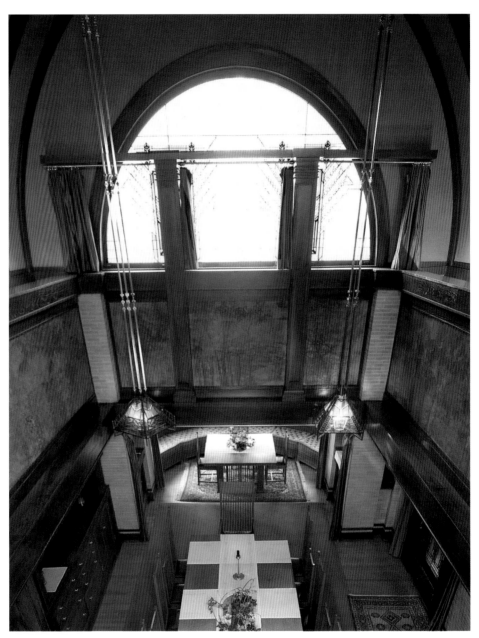

DINING ROOM FROM BALCONY.

46

From the reception room a long, narrow passageway with stained-glass windows on both sides leads to another entertainment space, called the "gallery." A two-story structure with vaulted ceiling, it served for the parties, balls, and galas for which Mrs. Dana was famous. The living room, on the other side of the reception hall, is more secluded, manifestly reserved for the immediate family. The second floor is for bedrooms, with halls that look over balconies to the two-story dining area and the three-story entry.

There is an interesting side note to this work: Mrs. Dana's mother, Mrs. Lawrence, built the original home on this site. To accommodate the Frank Lloyd Wright structure, much of the Lawrence home was demolished, but to honor the aging mother the library was left intact. It is tucked behind the reception room, a small Victorian-type study with hearth. It was assumed that Mrs. Lawrence, surrounded by all the "modern" architecture, would prefer her study and its traditional ambience. But in actuality, she found the new house so charming and livable that she closed the doors to her "study" and practically never bothered to go there. An ample bedroom and bath were provided for her on the main level, adjacent to the passageway and the reception room, so as to give her access to main functions of the house and still allow her to retire to her room without having to negotiate the stairs.

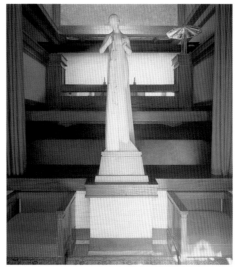

SCULPTURE, DESIGNED BY FRANK LLOYD WRIGHT. EXECUTED BY RICHARD BOCK (CA. 1903).

The tall, slender statue Wright designed for the entrance to the Dana house (executed by Richard Bock) depicts a female figure examining a hollyhock-like shaft of flowers. On the back is inscribed a Tennyson poem:

*Flower in the crannied wall,*
*I pluck you out of the crannies,*
*I hold you here, root and all, in my hand*
*Little flower—but if I could understand*
*What you are, root and all, and all in all,*
*I should know what God and man is.*

This poem aptly reflects Wright's attitude toward nature. His reverence for the natural world and the inspiration that it gave him remained constant throughout his life. As a great book of wonder and knowledge, he wrote, nature was a study of inner principles, "not looking at, but looking in."

47

GALLERY WINDOW.

VIEW OF GALLERY FROM SECOND-STORY LOGGIA OF MAIN HOUSE.

49

# ARTHUR M. HEURTLEY HOUSE, 1902   Oak Park, Illinois

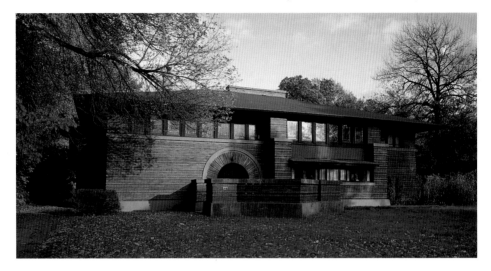

STREET ELEVATION.

The plans for most of Wright's prairie houses suggest buildings with a distinctly horizontal emphasis, as, for instance, the Willits house. Even the grand and eloquent Dana house stretches along the limited lot in a predominantly horizonal sweep. But the Heurtley house is another matter entirely. It is almost fortress-like, isolated on a great lawn like a castle rising from a green park. The plan hints at formidable, stately proportions, but Wright, in fact, created a dynamic front elevation with a dramatic arched entrance purposefully placed off-center.

Retaining the appearance of imposing mass, the building nevertheless possesses grace and contrast due to Wright's innovative intermingling of brickwork with extensive areas of glass. Although the plan is contained in a brick rectangular mass, the elements generally associated with his homes on the prairie are in place here: the gently sloping roof projecting out over the second-story windows, the centrally located brick chimney mass, and the concrete stylobate, which marries the building to the ground but still elevates it above the prairie floor.

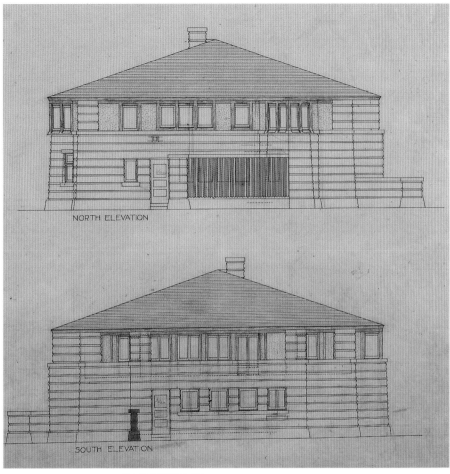

NORTH ELEVATION

SOUTH ELEVATION

ELEVATIONS. INK ON LINEN, 20 x 29". FLLW FDN#0204.009.

The brickwork itself alternates courses of smooth and projecting bricks and also alternates between red and delicate rose as the courses rise. Nothing in Wright's work anticipated this treatment of brickwork, and he never repeated it. The walls of the second level have long bands of windows set well beneath the overhanging soffit. These soffits, usually painted off-white, shade the glass in bright sun but reflect light in on cloudy days.

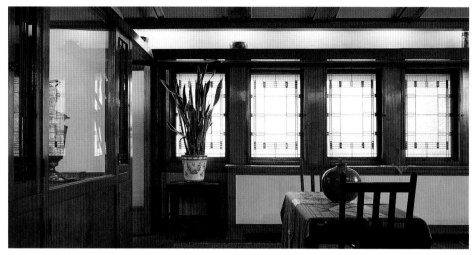

DINING-ROOM BAY.

The second level holds the main living area, with dining room, living room, and veranda (now unfortunately closed in) laid out in one flowing space and divided only by screens of glass.

Certain design elements in both plan and elevation are skillfully reiterated in the interiors. The forty-five-degree angled bays, which jut out of the rectangular plan for the dining room and for the bedroom beyond the kitchen, form a pleasing contrast to the otherwise contained formality of the overall design. In the stained-glass windows, especially beautiful—and still intact—the predominant pattern is a rather simple design of elongated squares connected by came, with wide spaces of clear glass throughout. But the ceiling light in the living room uses the motif of the extended bays as its theme, imaginatively embellished in a delightful array of triangles and wing-like forms.

The great entrance arch is reiterated in the "sunburst" fireplace in the living room, where radiating bands of brick make a surprising display of texture and design. Again, the hearth, gathering place for the family, is a special feature of the house.

LIVING ROOM.

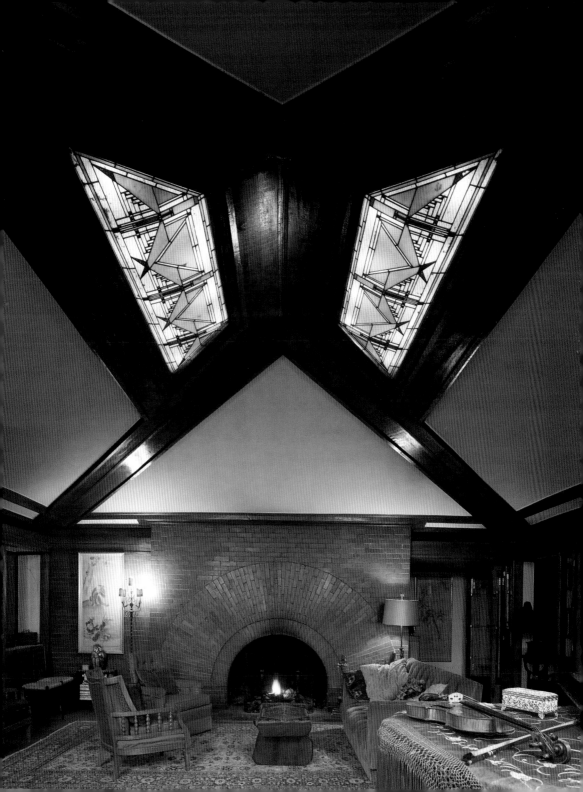

# WARD W. WILLITS HOUSE, 1902 Highland Park, Illinois

An early priority of Frank Lloyd Wright's was the use of materials in accordance with their natural characteristics. When Wright was a draftsman and a young architect, materials were rarely used in architecture with any consideration for their proper attributes. He, on the other hand, saw the inherent beauty in natural materials and was astonished to learn that there was no literature on the subject. "So I began to study the nature of materials," he wrote, "learning to 'see' them. I now began to learn to see brick as brick, learned to see wood as wood, and to see concrete or glass or metal each for itself and all as themselves."[1]

Cement plaster, or cement stucco, had been little used in architecture before Wright began to exploit it. There had, of course, long been the half-timbered English Tudor imitations in the United States, and plaster was widely used in interiors, but it was generally papered over. The treatment of cement stucco as the overall construction material was relatively new. In Wright's stucco houses exteriors are smooth stucco, with a sand texture created by mixing a coarser sand than that used for the interiors. Undoubtedly, stucco houses were less expensive to build than those of stone masonry or brick, and the majority of his early prairie houses are constructed in stucco. The natural evolution for this technique is toward a structure of poured concrete. To Wright's way of thinking, both stucco and concrete were moldable, or what he described as "plastic." But the term "plastic" went far beyond the mere use of a material: for him it signified a freedom of plan and form that the architecture of the Old World rarely produced.

The use of wood trim in the Willits house is both structural and aesthetic, as it was in Wright's earlier cement stucco houses for Warren Hickox and B. Harley Bradley, both built in 1900. Where plaster parapets or balconies extend outdoors, the trim running along the upper edge protects the wall from rain or snow seeping down and causing rot or frost damage.

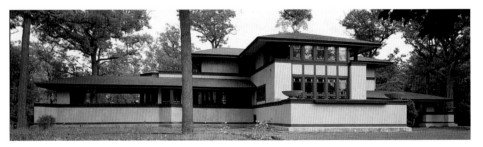

VIEW FROM STREET.

LIVING ROOM, EXTERIOR CORNER.

The same holds true where the wall rests on the concrete base. An aesthetic effect was carefully considered: on the front facade, the lines of the living-room door jambs are extended over the stucco above to meet the second-story window jambs, creating a satisfying linear rhythm. The use of wood trim on the inside is predominantly aesthetic: the wood accents conceal plaster joints and protect the inside corners of the walls. An uneven plaster ceiling might also be disguised by a repeated pattern of these strips. As with the exterior, the trim creates a directed rhythm—Wright called it "eye-music"—on an otherwise very plain ceiling surface.

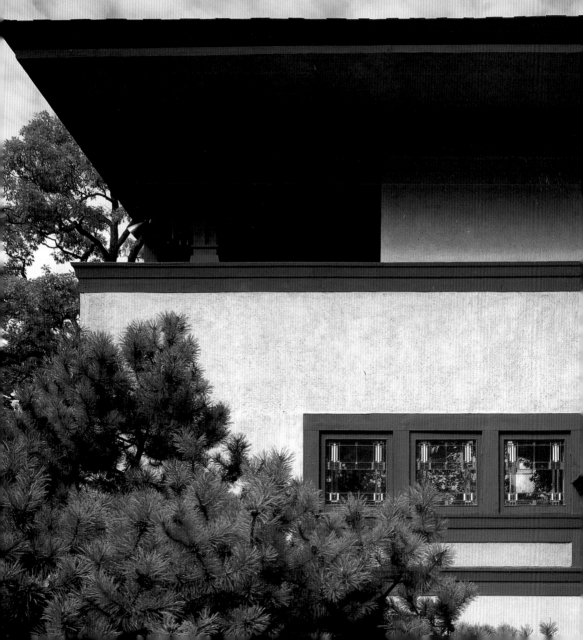

The Willits house is cruciform in plan, a plan type that Wright frequently used because each wing could extend into the prairie and be fenestrated on both sides. In the Willits house, the living room projects onto its own terrace and has remarkable floor-to-ceiling windows that afford a luxurious view of the property. The dining room also opens onto a covered dining terrace, sheltered from summer sun and rains. The other extension of the cruciform holds the reception room, still at this time an important domestic area in which guests were received, hats and coats left, and "preparation" made prior to entering the more personal living quarters.

Screens and grilles differentiate the rooms of the home without confining space. They are of wood, cut square rather than lathed into curlicues and circular shapes. At heart, Wright was a conservation- ist. He said that on visits to millwork or cabinet- work shops at the turn of the century, when the fashionable treatment in wood furniture and detailing was to use the lathe to produce curving or curling forms, spindles, and knobs, he envisioned half the forests of the nation lying on the floors of the shops in piles of sawdust and wood shavings. This was instinctively repugnant to him. He argued as early as 1893 that craftsmen had the machines that could well be "a tool in the hand of the artist" and no longer needed to imitate the old hand- carving and chiseling of the past. With these criteria in mind, Wright designed his millwork details and furniture to be cut in long, rectilinear pieces that used lumber with a minimum of waste. His furniture, designed to be an integral part of the interior, and his screens and grilles are in simple lines that declare a simplicity he believed appropriate to modern buildings.

LIVING-ROOM WINDOWS AND ORIGINAL CHAIRS.

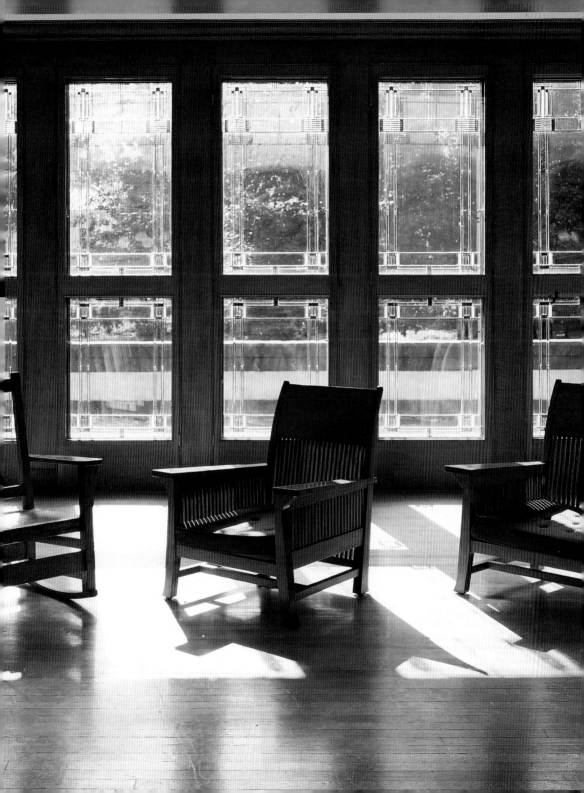

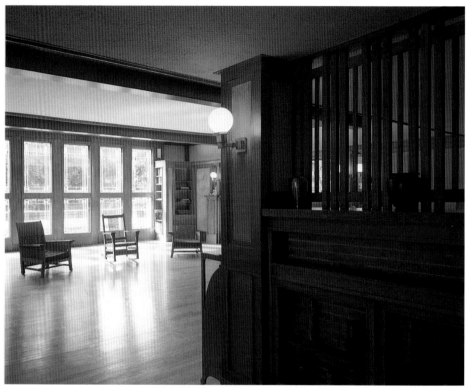

LIVING ROOM.

Despite the revolutionary aspects of his designs, composing an entirely new interpretation of architecture, Wright was not a starving young artist in a garret waiting for commissions. To the contrary: during the sixteen-year span in the Oak Park studio, from 1893 to 1909, it has been estimated that a complete set of working drawings was prepared on average every six weeks. That the greater number of these designs were built further attests to the success of Wright's practice. His clients, for the most part, were upper-class businessmen and professionals, many of them of considerable means. They also were conservative and highly respected in their communities. Yet, like their architect, they were visionaries. They recognized the honesty, simplicity, and frankness—Americanness— of his work, and they wholeheartedly subscribed to his solutions, even at the expense of criticism from some of their peers who still looked to Europe for aesthetic ideals.

DINING ROOM, WITH ORIGINAL FURNITURE.

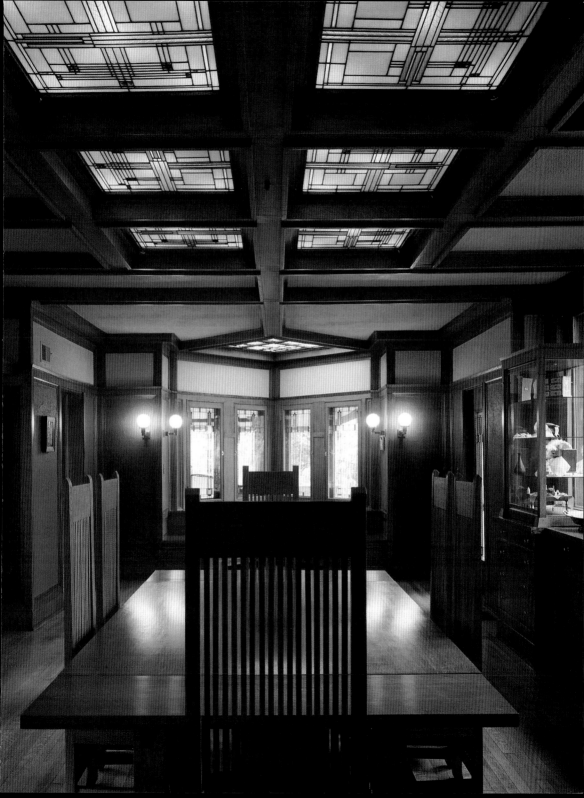

# UNITY TEMPLE, 1905  Oak Park, Illinois

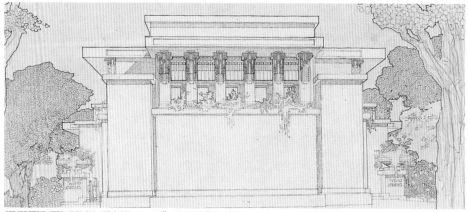

PERSPECTIVE. SEPIA INK ON ART PAPER, 18 x 27". FLLW FDN#0611.005.

The Unity Temple of 1906 was reinforced concrete. It was the first building to come complete as architecture cast from forms. The idea of the reality of the building as the space within had found tangible expression.[1]

   The first idea was to keep a noble room for worship in mind, and let that sense of the great room shape the whole edifice. Let the room inside be the architecture outside. What shape? Well, the answer lay in the material. There was only one material to choose—as the church funds were $45,000—to "church" four hundred people in 1906. Concrete was cheap. Why not make the wooden boxes or forms so the concrete could be cast in them as separate blocks and masses, these grouped about an interior space in some such way as to preserve this sense of the interior space, the great room, in the appearance of the whole building? And the block-masses might be left as themselves with no facing at all? . . . The wooden forms or molds in which concrete buildings must at that time be cast were always the chief item of expense, so to repeat the use of a single form as often as possible was necessary. Therefore a building, all four sides alike, looked like the thing. This, reduced to simplest terms, meant a building square in plan. That would make their temple a cube—a noble form of masonry. . . . The room itself—size determined by comfortable seats with leg-room for four hundred people—was built with four interior posts to carry the overhead structure. The concrete posts were hollow and became ducts to insure economic and uniform distribution of heat. The large supporting posts were so set as to form alcoves on four sides of the room. I flooded these side alcoves with light from above to get a sense of a happy cloudless day into the room. And with this feeling for light, the center ceiling between the four great posts became skylight; daylight sifting through between the intersecting concrete beams, filtering through amber glass ceiling lights. Thus managed, the light would, rain or shine, have the warmth of sunlight. Artificial lighting shone from the same place there at night as well.[2]

<div align="right">—Frank Lloyd Wright</div>

AUDITORIUM, VIEW TOWARD ORGAN SCREEN AND PULPIT.

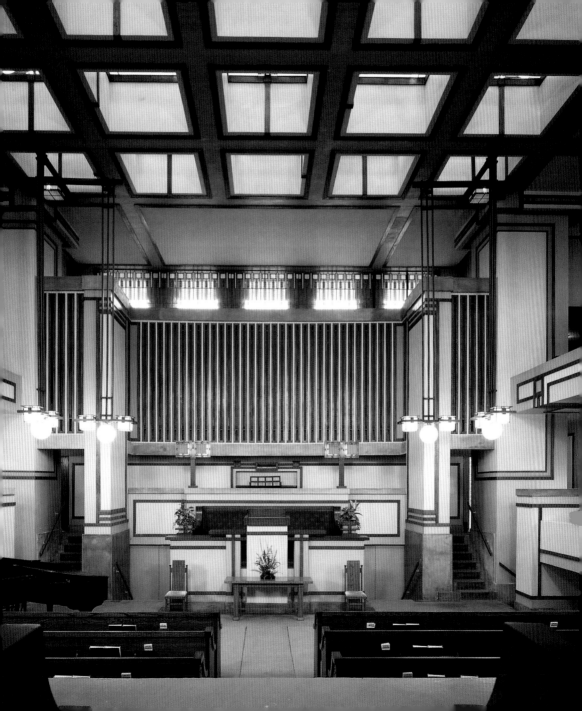

In consideration of the economics of building a church that would cost, at that time, $45,000, Wright chose poured concrete as the least expensive material. But rather than covering it, inside and out, with plaster, or brick, or stone, or paint, he elected to let the material of the structure be the material of the design.

Wright abhorred the "grand entrance," or what he called "grandomania" in any form in architecture. The entrances to his buildings are always simple and quiet, leading visitors into the space via a series of gradations, from one space, or one scale, to another. At Unity Temple the congregation mounts a few steps onto a spacious terrace and enters through a series of French doors into a low, wide foyer or loggia.

Two main masses form the church: the temple itself, the larger mass, and behind it, the secular section, a meeting hall with classrooms, kitchen, and facilities for the social life of the congregation. In between these two masses is a low entry area, or vestibule. The auditorium is reached by going in one direction, the social hall by moving to the other. Unlike most churches, in which the pulpit and altar are at the end of a nave, here parish- ioners enter the auditorium and absorb an enormous space with great surfaces of glass and stained glass. Only when they find their seats and turn around do they face the pulpit, with organist and organ behind it. Wright planned it this way so that the square plan unifies the congregation and, once the service is over, people do not turn their backs to the pastor, but rather file out on either side of him.

The concrete ornament, cast into the forms of the main structure, took its grammar from the wooden blocks around which the concrete was poured. The light fixtures are pleasing combinations of solid squares, cubes, and spheres. The light cords hanging inside the wooden strips that held the lamps are wrapped in gold silk to make a special feature of the wiring—a glimmer of gold running down from the ceiling to the fixture.

Looking back over his work and how his ideas developed and grew, Wright recounted an important event in his life as it related to the Larkin Building and Unity Temple in a talk to the Taliesin Fellowship in 1952:

Now when the Larkin Building model first came, that stair tower at the corner was part of the mass, part of the building. And I didn't know what was the matter. I was trying for something with some freedom that I hadn't got. Suddenly, the model was standing on the Studio table in the center, and I came in and I saw what was the matter. I took those two fore corners and I pulled them out away from the building, made them individual features, planted them, and there began the thing that I was trying to do. You see, I got features instead of walls. I followed that up with Unity Temple where there were no walls of any kind, only features; and the features were screens grouped about interior space. The thing that came to me by instinct in the Larkin Building began to come consciously in Unity Temple. When I finished Unity Temple, I had it. I was conscious of the idea. I knew I had the beginning of a great thing, a great truth in architecture. Now architecture could be free.[3]

This concept of walls as "features" or screens is what Wright's "destruction of the box" is all about. He explained that by pulling the supports of a building in from the outside edge, the roof becomes a cantilever. A see-saw is the ultimate cantilever. Every branch of a tree is a cantilever. With structural support no longer needed at the outside edge, windows—or screens of glass—could be set in under the roof. Instantly the sense of a box or a container is abolished. The corner window becomes possible. With Unity Temple, the roof overhead is supported by four square masses in the room, set in from the edge. The walls, being non-supporting, become screens. To insure privacy and quiet in a religious structure built on a noisy city lot, the screens are made of poured concrete. But high above the concrete walls are further screens of glass windows to emit light, while the entire ceiling itself is a skylight made up of stained-glass squares. The sense from within is of being in a space bathed by translucent elements of colored glass above.

Earlier architects could never have achieved this; neither the materials nor the technology existed for them. But once it was discovered that concrete and steel have the same coefficient of expansion, that is to say that when heat or cold is applied they expand or contract to the same degree, then a new "miracle," as Wright called it, happened. Twentieth-century architects could build with steel, concrete, and polished plate glass. The old orders of form—of post and beam construction—were immediately obsolete, and a new expression of form was available such as had never existed before in architecture. In speaking of this, Wright noted, "I often thought what a blessing it would have been for us if the Greeks would have had this. If the Greeks had steel and glass, we wouldn't have to be thinking about this now; they would have done it for us."[4]

Wright berated the architects in the United States for imitating historic styles, though he was not berating the buildings of those eras. He was once asked by one of his apprentices, "Among the famous buildings of the world, which of those do you consider true works of art?" To which he replied:

Those which were true to Time, Place, and Man. Those things which, in their day, presented the life of the period most completely. You can find them. The Etruscan was one where everything was becoming and natural; the Chinese was another, the Japanese was another. The Egyptian was one, certainly. Who couldn't fail to admire the Gothic cathedral? Who couldn't fail to admire the Romanesque in its time? Who couldn't stand thrilled by the Byzantine, and go to Persia—almost to lose your senses with the beauty of the thing at that time? But it would only be an idiot who would try to bring it home and plant it under different conditions to which it did not belong. Now when we begin to build buildings that have that same expression of beauty, of our own time, then we will have an architecture that we can call organic.[5]

# EDWARD E. BOYNTON HOUSE, 1907   Rochester, New York

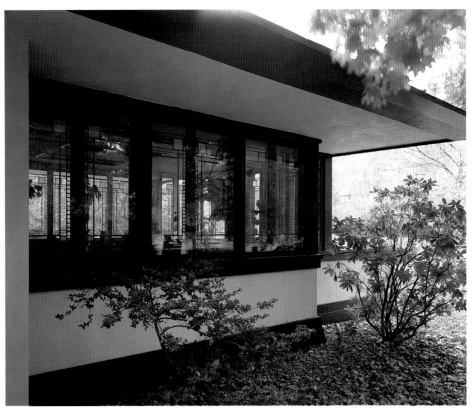

LIVING ROOM, EXTERIOR.

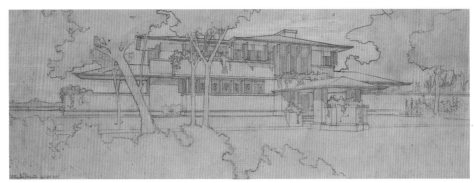

PERSPECTIVE. COLOR PENCIL ON TRACING PAPER, 12 x 34". FLLW FDN#0801.001.

ENTRANCE.

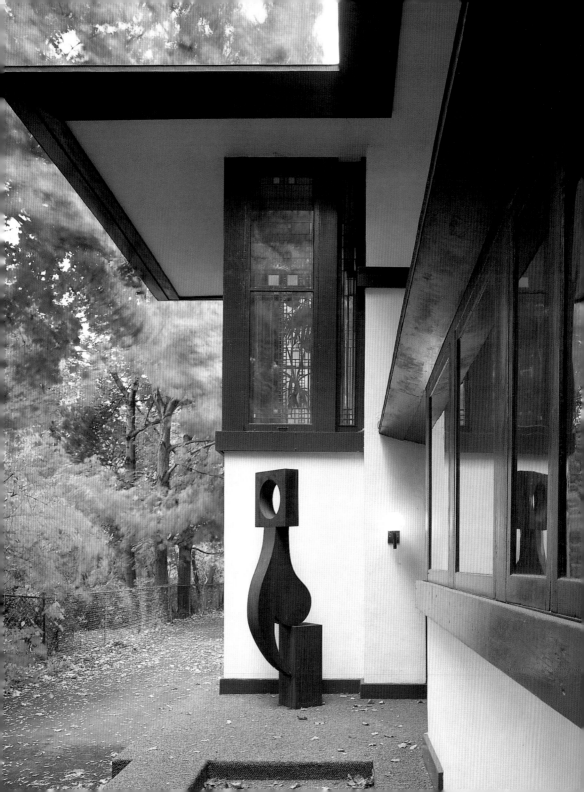

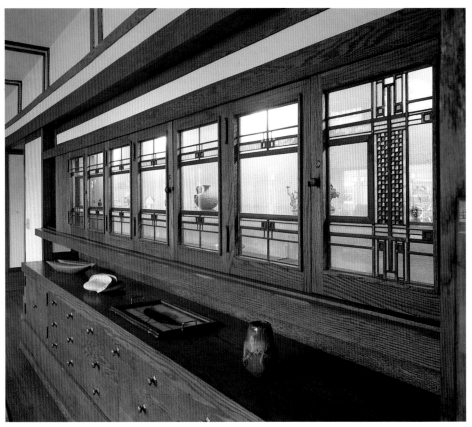

DINING-ROOM SIDEBOARD.

When he engaged Frank Lloyd Wright as his architect, Edward E. Boynton was a widower living with his only daughter, Beulah. An intelligent and perceptive young person, Beulah was a guiding force in the Boyntons' relationship with their architect. She put forward ideas of how various functions of her house should work, and Wright's design reflects many of her suggestions, especially in her rooms and in the storage areas.

The entrance to the house is set in the middle of the plan, with a hall that leads into the dining room, living room, and den. The dining room is more segregated from the living room than in most of Wright's prairie houses, but the great expanse of stained-glass windows and French doors in the living room, as well as the beautiful glass bay in the dining area, unify the house with light and pattern.

DINING ROOM AND BREAKFAST ALCOVE, WITH ORIGINAL FURNITURE.

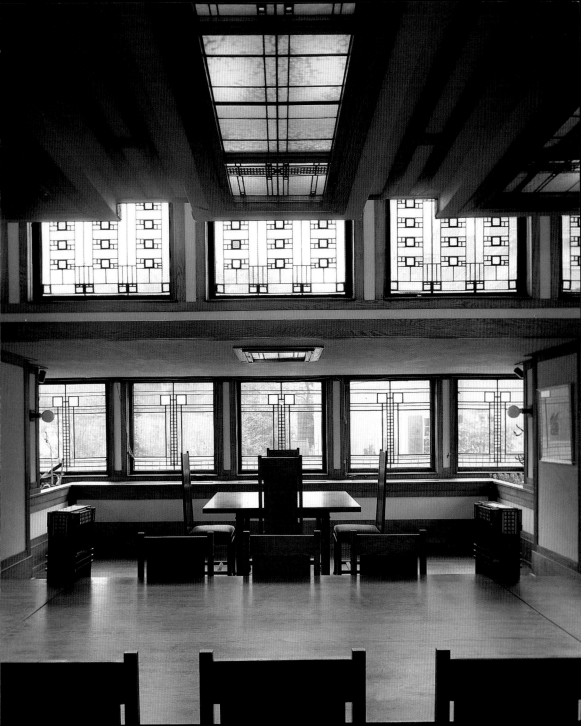

In the plan, the dining-room area is larger than one would expect, with provisions for two large tables: the larger, for more formal occasions, is near the sideboard; the smaller is set in a lovely breakfast nook illuminated by stained-glass windows.

As important as this creation of a sense of spaciousness within the building was the creation of light to fill the space. What Wright particularly sought to avoid was a room with only one source of light. He found darkened spaces with light coming from a solitary angle sufficiently disturbing to nullify any effort he could make to create a beautiful space. Therefore, he often carefully balanced his sources of light by using clerestory windows. In the Boynton house, in addition to the windows of the breakfast area, the top light, or indirect ceiling light, lets in light over the main dining table, while the clerestory windows bring in more light, this time from daylight sources through the stained glass. The combination of the two dining areas with their resplendent glass windows is one of the finest features of any Wright house.

Wright visited the site many times, making the long trip to Rochester from Oak Park. George Swan, son of the contractor who built the house, gave an account of these visits of Wright to the site.

*He might come into town on a train that arrived at midnight. He wouldn't put up at a hotel. He would hire a hack and go directly to the Boynton house and stay there the remainder of the night. He would never leave the house during his stay in Rochester, which might continue for two or three days. He was on the job night and day, and of course, no workmen were there at night. He once made one of his unexpected visits during a spell of miserable weather. It was cold and rainy. As yet there was no roof on the house. Wright had workmen throw up a sort of lean-to, a few two-by-fours with a tarpaulin thrown over it, and remained in this during the night. He seemed to feel that when he was here he had to live uninterruptedly with his work.*

DINING ROOM AND BREAKFAST AREA,
WITH CEILING LIGHTS AND ORIGINAL FURNITURE.

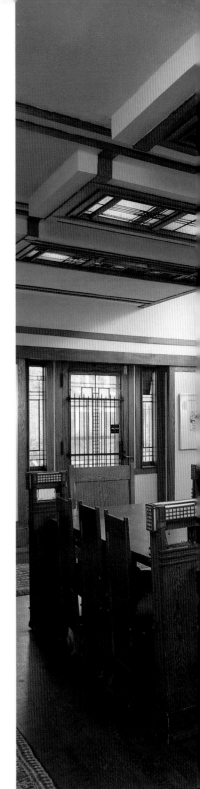

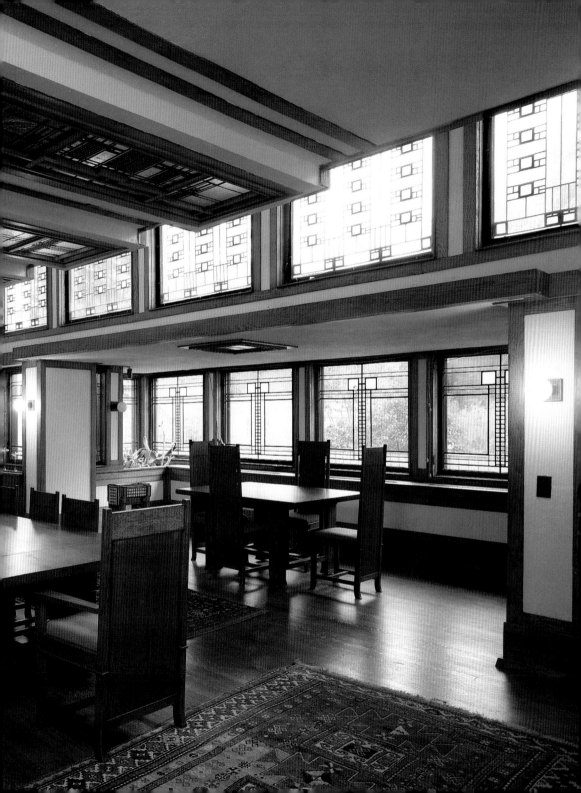

# FREDERICK C. ROBIE HOUSE, 1906   Chicago, Illinois

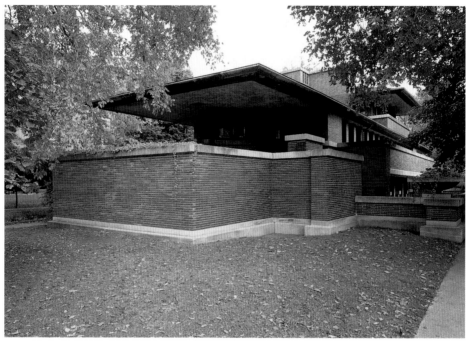

STREET VIEW.

Chicago-born Frederick C. Robie was trained as an engineer. By the time he was thirty-three, he was president of a company that manufactured bicycles. With the mind of an engineer, as well as that of a young and successful businessman, he had very precise and particular ideas about what he favored in a house. He did not want a wooden house (he wanted a fireproof house); nor a house with cramped, cut-up spaces. He wanted a building of concrete and steel, with open vistas protected by sheltering roofs. "I wanted sunlight in my living room in the morning before I went to work, and I wanted to be able to look out and down the street to my neighbors without having them invade my privacy," he told his son in an interview some fifty years after this house was built. He visited several prominent architects in the Chicago area and invariably got the reply, "I know what you want, one of those damn Wright houses." Wright and Robie finally met in 1906. Robie remembered, "When I talked in mechanical terms, he talked in architectural terms. I thought, well, he was in my world."[1]

LIVING-ROOM TERRACE AND BEDROOM BELVEDERE.

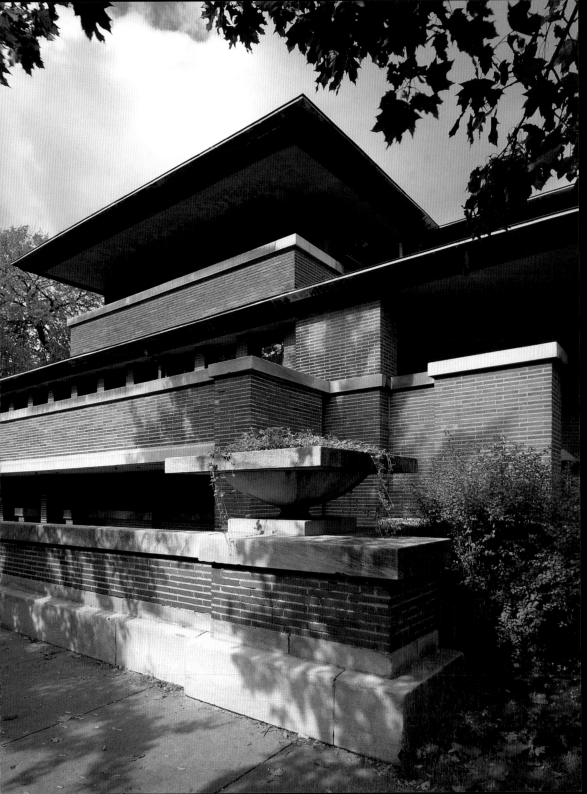

The interiors were sympathetically furnished according to Wright's designs. He conceived special tables, chairs, sofas, lamps, and lighting fixtures of wood and bronze, as well as textiles and carpets. Some of the individual pieces, like the slat-back chairs, the coffee tables, end tables, and living-room sofa have since become so famous as to constitute a language of their own in modern furniture design.

The Robie House was immediately published, and it exerted tremendous influence worldwide. It was especially influential among the new generation of European modern architects. Many of Wright's other prairie houses, built mainly of cement stucco and wood, are comfortable dwellings most appropriate for the Midwestern prairie landscape. But the Robie house, constructed of concrete, brick, and steel, and with its sleek, streamlined appearance, is truly a house of the machine age; indeed, a work of art. Wright was pleased, he wrote, that "the house became known in Germany as *Dampfer* [ocean-liner] architecture; it was a good example of the prairie house of that period. This further emphasized that the machine could be a tool in the hands of the artist."

House and Home magazine, in a May 1957 article entitled "One Hundred Years of the American House," perhaps most eloquently posited its lasting importance:

During the decades of eclecticism's triumph there were also many innovators—less heralded than the fashionable practitioners, but exerting more lasting influence. Of these innovators, none could rival Frank Lloyd Wright. By any standard his Robie house was the House of the 1900s—indeed the House of the Century.

Above all else, the Robie house is a magnificent work of art. But, in addition, the house introduced so many concepts in planning and construction that its full influence cannot be measured accurately for many years to come. Without this house, much of modern architecture as we know it today, might not exist.[2]

Unquestionably the most widely published of all the prairie houses was this house for Frederick Robie. From the moment it was completed, it seemed to epitomize the era of Frank Lloyd Wright's work from 1893 to 1909. In some respects it may be considered to be the quintessence of that first sixteen years of work in residential architecture. It was, to domestic architecture, what the Larkin Building and Unity Temple were to public buildings: strong, sculptural, and dynamic, with its sweep of lines and abstract composition of masses; but at the same time sheltering and protective. It made great use of steel, concrete, brick, and glass—those elements already in place at the beginning of the twentieth century—but with profound understanding of their practical potential wedded to artistic sensitivity. This building alone could well stand as the herald of a new era in residential architecture.

LIVING ROOM.
OVERLEAF: LIVING ROOM.

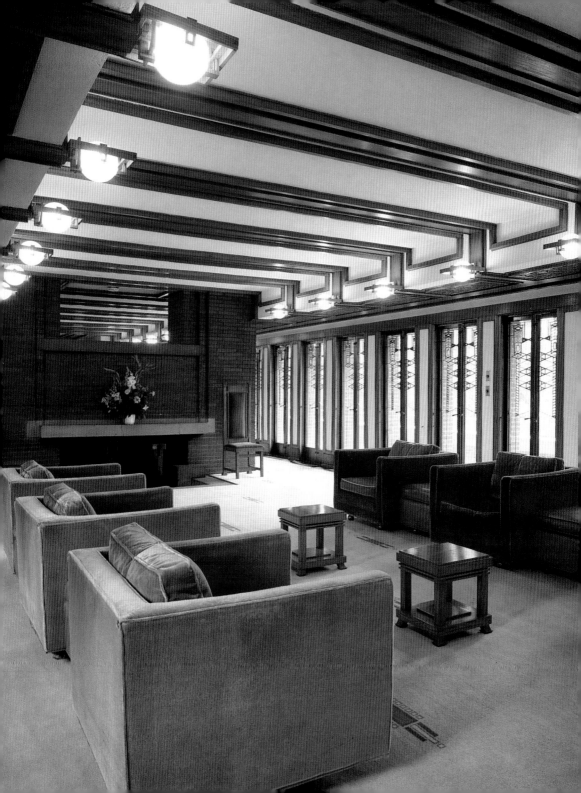

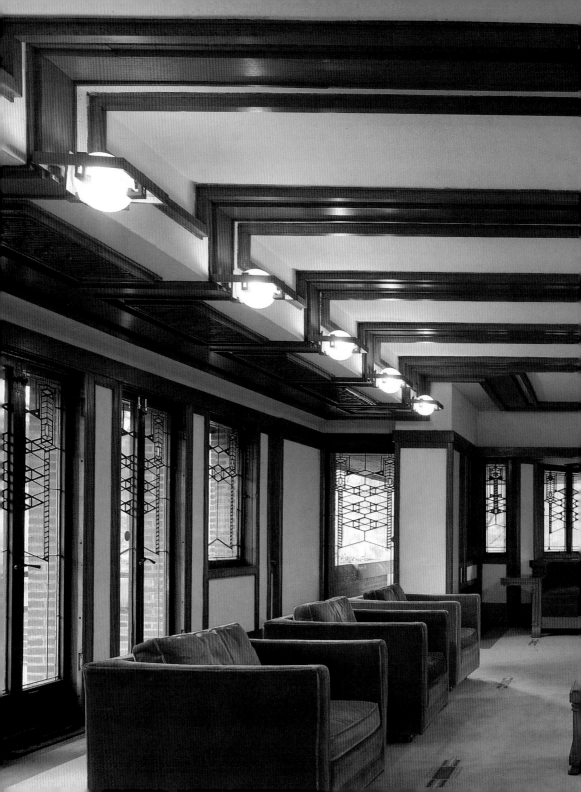

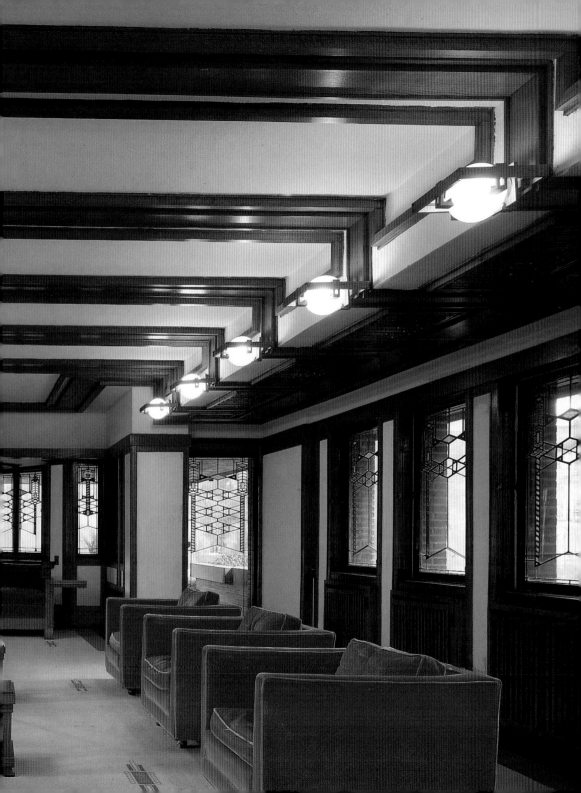

# EXODUS AND NEW ERA 1911–1931

KUNO FRANCKE, professor of the history of German culture at Harvard, visited Oak Park in 1908 and toured the Wright buildings in the area. When he met Wright, he urged him to leave the United States to practice architecture in Germany. But Wright declined the offer. Fifteen years earlier, in 1893, Daniel Burnham had also urged Wright to go to France to study the classical traditions. In 1909 Wright finally went to Europe, but not to practice architecture, rather to assist in Ernst Wasmuth's publication of his work in portfolio form in Berlin. This trip was truly an exodus: he left his wife and family behind in Oak Park, closed his studio, and turned the ongoing work over to one of his draftsmen:

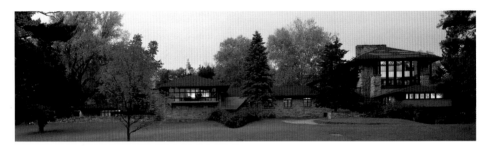

This absorbing, consuming phase of my experience as an architect ended about 1909. I had almost reached my fortieth year: weary, I was losing grip on my work and even interest in it. . . . I could see no way out. Because I did not know what I wanted, I wanted to go away. Why not go to Germany and prepare the material for the Wasmuth Monograph? . . . I looked longingly in that direction. . . . Everything, personal or otherwise, bore down heavily on me. Domesticity most of all. What I wanted I did not know. I loved my children. I loved my home. A true home is the finest ideal of man, and . . . to gain "freedom" asked for a "divorce." It was, advisedly, refused. But these conditions were made: Were I to wait a year, divorce would be granted. The year went by and contrary to promises legal freedom was still refused.[1]

Upon his return to the United States in 1910, he initially settled again in Chicago. In 1911 he began sketches for a cottage for his mother, Anna Lloyd Wright, to be built in the valley where he grew up, near Spring Green, Wisconsin. As the drawings progressed, Mrs. Wright realized that her son needed a new place to live and work; accordingly, she encouraged him to take this country cottage over for himself. In doing so, he expanded the simple cottage into a complex of home, studio, and farm. Wright knew the region intimately, every hill, every field, every forest, every outlook, and every stream. The site for his new home was a hill where he had spent much of his boyhood, and he called the house "Taliesin," a Welsh word meaning "shining brow." It is also the name of a Druid

bard who lived in the sixth century and who sang of the fine arts. Wright's maternal roots were Welsh—his mother's family had immigrated to Wisconsin from Wales in 1845—and in keeping with Welsh tradition, all the brothers and sisters of the original clan had selected Welsh names for their homesteads and the surrounding terrain. Three hills, bordering the valley, were named after the famous Welsh mountains Bryn Mawr, Bryn Kindel, and Bryn Beck. He built into the home all the love and attachment he had for this ancestral valley of his youth.

Wright intuitively understood that to put a house on top of a hill destroys the hill. Rather, a house should wrap around the brow of the hill. With this in mind, he created a complex of courts and wings that stretched along the brow and reached back into garden courts, with steps leading up the hill to a tea circle under a pair of great oak trees and eventually onto the hill crown itself. At Taliesin, he created a self-contained, self-sufficient world devoted to architecture, art, and agriculture.

From the brow of its hill, the house overlooks water gardens that were formed by throwing a dam across a stream. A great park of cultivated fields extended over the rolling hills, bordered by forests and the Wisconsin River.

All Wright's work prior to the building of Taliesin was for urban or suburban sites. Now, in his native valley and in his own home, he was in a vast pastoral landscape, and he could design the building to take full advantage of its natural surroundings in each of the seasons. His response to the varied terrain was to wed the interiors to the exterior as closely as he could. From inside, long bands of glass windows looked out through the branches of great oak trees, pines, and birches, down onto the water gardens, and farther to the distant fields and hills. On the hillside garden court, doors and windows gave onto quiet, secluded areas of grass and flowers. Rooms were flush with terraces, which were flush with gravel courts and garden walks. In this treatment of floor levels merging with out-door terraces and courts and nestling into the hillside, Wright broke with his convention of raising the living quarters up off the prairie level. Taliesin, therefore, was not a prairie house. Instead, it responded to his concept of a building being appropriate to its terrain; here, a rich landscape of hills and valleys.

The materials were golden yellow limestone, found in the quarries in the neighbor-ing areas of the region; cement plaster was made with sand from the Wisconsin River, the gray beige sand itself becoming the color of the finished plaster. Low spreading roofs of cedar shingles hovered over the entire structure, the roofs themselves chang-ing heights and directions according to the rooms and spaces below—like an abstract reiteration of the hill ranges all around. The interior was finished in cypress, a soft golden color with a blush of rose. Floors were paved in limestone flagstone or wide boards of waxed cypress. Fireplaces were of exposed limestone with generous hearths of flagstone.

In 1905 and in 1913 Wright made voyages to Japan. Each time he brought back with him a trove of art objects: Japanese prints, hanging scrolls, folding screens, ceramics, bronzes, and wood carvings. Many of these objects he set into the walls and rooms, or placed on the decks and shelves of Taliesin, not so much as "decoration" as integrated features blending quietly with the soft, serene interiors. Of these objects, Wright wrote: "Hovering over these messengers to Taliesin from other civilizations and thousands of years ago, must have been the spirits of peace and good-will? Their figures seemed to shed fraternal sense of kinship from their places in the stone or from the broad ledges, where they rested. For the story of Taliesin, after all, is old: old as the human spirit. These ancient figures were traces of that spirit, left behind in the human procession as Time went on, and they now came forward to find rest and feel at home. So it seemed as you looked at them."[2]

Adjacent to the living quarters were his studio, drafting room and office for his architectural practice, and a vault for his drawings and art collections. Taliesin extended still farther, into courts and levels that provided living quarters for draftsmen, workmen, and farmers. There were stables for horses with carriages and tack rooms, an ice house, a milk room for making butter and buttermilk, a kitchen on the hill wing for making cheese and putting up preserves. In a deep root cellar under the hill was stored the produce from the farm. Cows, hogs, goats, and chickens were kept in additional out-buildings, still connected by roofs and courts.

"The whole," he wrote, "was low, wide and snug, a broad shelter seeking fellowship with its surroundings. A house that could open to the breezes of summer and become like an open camp if need be. With spring came music on the roofs, for there were few dead roof-spaces overhead, and the broad eaves so sheltered the windows that they were safely left open to the sweeping, soft air of the rain. Taliesin was grateful for care. Took what grooming it got with gratitude and repaid it all with interest. Taliesin's order was such that when all was clean and in place its countenance beamed, wore a happy smile of well-being and welcome for all. It was intensely human, I believe."[3] Taliesin was burned to the ground by a servant in the summer of 1914: the studio and farm quarters were spared, but his own quarters were lost. Far worse was the loss of life: seven people close to Wright were slain by the servant. Wright was in Chicago at the time, working on the final touches of Midway Gardens, when the news reached him. He returned to Taliesin to find the bodies laid out in the court and his home a gaping, smoldering black ruin.

But he rebuilt Taliesin, and in the aftermath of the tragedy came succor in the form of new work: he was commissioned to design the Imperial Hotel in Tokyo. Once again in Japan, he found solace in the land whose culture and art he deeply admired. Work on the Imperial Hotel would consume him from 1916 to 1922, with a few commissions in the

Midwest and California at the same time. Back in the United States in 1922, he took up residence in Los Angeles and established a practice in California. After completing the block houses in Los Angeles, however, he believed he had no future in the Southwest and returned to Taliesin. His personal life had gone through several turbulent changes, and Taliesin's second destruction by fire—this time in an accident—in 1925, again threw him into debt. His controversial behavior, along with his prolonged absence from the country and the faltering economy cost him dearly: few clients now came to him. But that did not stop the flow of his creative energies. From 1924 to 1934, although his designs were rarely built, he engaged in several projects of a highly innovative nature, focusing on engineering achievements and large planning concepts: a vast skyscraper for the National Life Insurance Company; a plan for urban redevelopment, called "Skyscraper Regulation"; a tourist facility in Maryland using a spiral ramp structure, the Gordon Strong Automobile Objective and Planetarium; a country club for Madison, Wisconsin; a vast interfaith cathedral for a million people in New York, known as the "Steel Cathedral"; an ambitious resort hotel for Arizona employing his concrete block system, San Marcos-in-the-Desert; and an apartment tower for a church complex in New York, St. Mark's-in-the-Bouwerie. Three solutions for the design of the Chicago World's Fair, including a series of vast glass and steel pavilions with escalators and moving sidewalks, floating barges out on Lake Michigan, and a skyscraper a half mile high, were also drawn up. These projects were conceived as great programs employing steel, reinforced concrete, glass, and sheet metal. Some of them would come to fruition in other forms: St. Mark's Tower, for example, would lead to the H. C. Price Company Tower (Bartlesville, OK, 1952), and the Steel Cathedral would lead to the Beth Sholom Synagogue (Elkins Park, PA, 1953). But most are known to us only by Wright's detailed drawings and discursive texts. The stock market crash brought those few, though significant, commissions to a complete halt.

# F. C. BOGK HOUSE, 1916  Milwaukee, Wisconsin

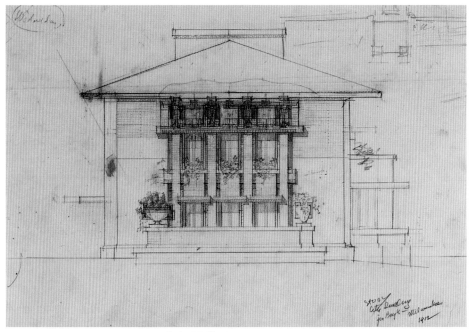

ELEVATION. PENCIL ON TRACING PAPER, 16 x 25". FLLW FDN#1602.011.

While Frank Lloyd Wright was living in Japan working on the Imperial Hotel, he made several voyages to the United States to fulfill a few important commissions, including a house for F. C. Bogk of Milwaukee in 1916. The Bogk property was a narrow city lot in a residential area, but the size of the lot was much smaller than Wright had contended with in Oak Park. He was forced to center the building on the lot, creating the traditional front and back yards, and to leave one side yard barely broad enough for access to the garage in the rear.

Originally the house was to have a flat roof emphasizing the abstract geometry of the facade, but a more conservative, pitched roof won out. Nevertheless, the massing of the elevations, in particular the front, is elegant and masterful, its superb sense of proportions revealing Wright at his best. His work in Japan at the same time he was designing the Bogk house obviously consumed him, and features of the Bogk front elevation closely relate to elevations of certain parts of the Imperial Hotel.

80

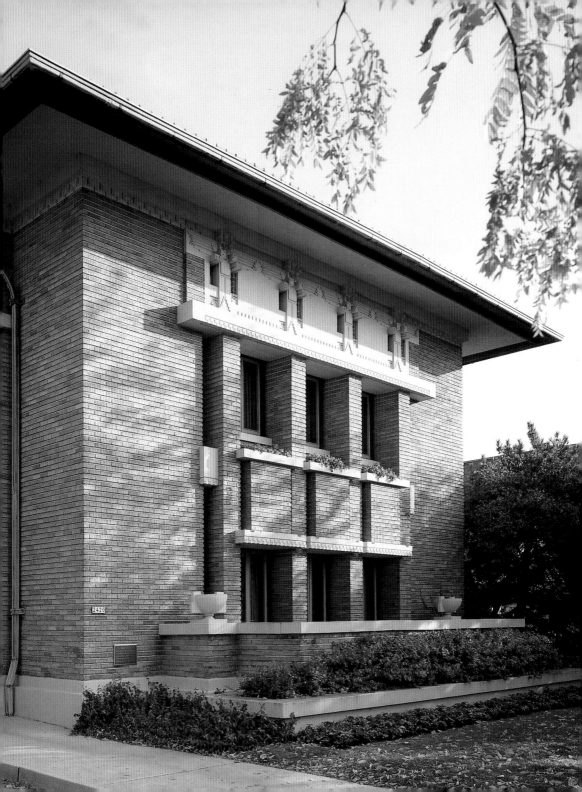

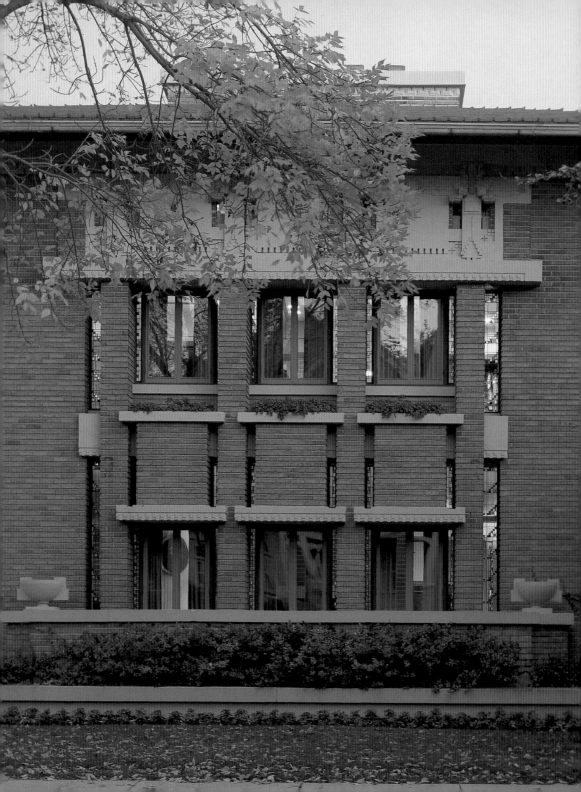

LINTEL DETAIL.

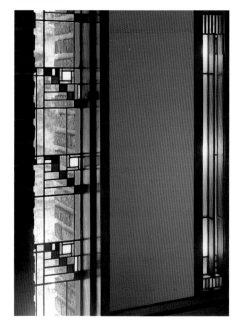

A series of window openings was designed to guarantee the occupants privacy, but also provided the interior with some delightful elements of fenestration. The stained-glass patterns here are relatively simple, however, in contrast to the fairly extravagant art glass of the Dana house.

As if to counterbalance the restraint evidenced in the glass patterns, the cast-concrete lintel at the top of the second-story windows is rich and florid, yet still employs as its motif the architect's tools: T square and triangle.

LIVING-ROOM WINDOWS.

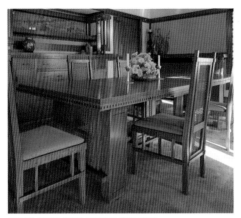

DINING ROOM, WITH ORIGINAL FURNITURE.

The dining room, although open to the living room, is raised a few steps above. Situated at the rear of the house, it offers some privacy, and Wright could afford to extend its windows around the corner. The view from the living room into this raised area bathed in light enhances the sweep from one space to the other. Jutting off the dining room is a charming "conservatory," with pool and planting box, likewise bathed in light. The same bay provides for an outdoor balcony on the second floor.

The original dining-room tables and chairs were recently returned to the house. Other furniture was acquired by the new owners from a line of Frank Lloyd Wright–designed commercial furniture produced by Heritage-Henredon in 1955. The original carpets for the house, also of Wright's design, woven in Czechoslovakia, have long since been removed, but replicas have been woven and are currently installed in the house.

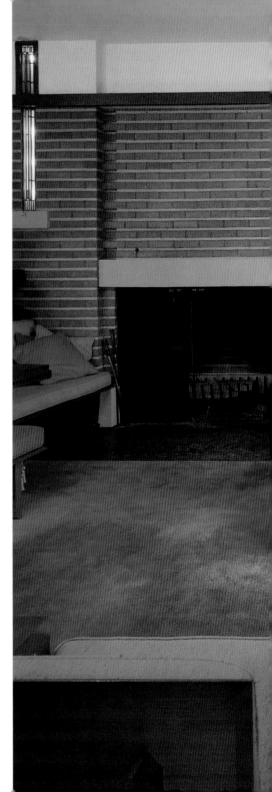

VIEW INTO DINING ROOM FROM LIVING ROOM.

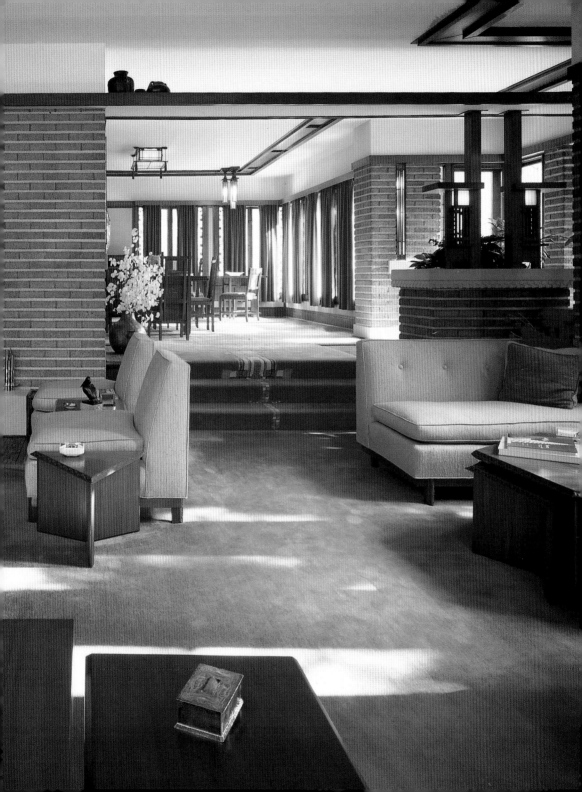

# ALINE BARNSDALL "HOLLYHOCK HOUSE," 1917
## Los Angeles, California

AERIAL PERSPECTIVE. INK AND INK WASH ON PAPER (DIMENSIONS UNKNOWN). FLLW FDN#1705.061.

MAIN ENTRANCE.

One of the most prominent commissions that came to Frank Lloyd Wright during the Japan years was a house and theater complex in Los Angeles for the oil heiress Aline Barnsdall. Wright first met Miss Barnsdall in 1914 in Chicago, where she was involved in an experimental community theater project. Consumed by a love for drama, she soon planned to move to Hollywood and to build a house and two theaters, one for drama, the other for motion pictures. Nothing could have pleased Wright more than these commissions: he was an ardent theater enthusiast and exhibited the same love for cinema that he did for the live stage.

Once established in Hollywood, Barnsdall asked Wright to produce a theater design on a tract of property she had purchased on "Olive Hill." The property is bordered by Sunset Boulevard, Vermont Avenue, Hollywood Boulevard, and Edgemont Street and rises to a steep hill with a large crown, which was planted with olive trees. On the flat ground below were to be the theaters, a long wing of shops and houses connecting them, and separate residences for directors; the hilltop site was to be reserved for Barnsdall's own residence and two other separate dwellings called, respectively, Residence A and Residence B, which she asked Wright also to design.

Los Angeles in 1917 was still a desert region, although planting and landscaping were beginning to turn it into a veritable garden. Photographs taken of the area during the time of the construction of some of the Wright buildings reveal sparse environs, especially in Hollywood, but irrigation was rapidly making the desert almost tropical. Wright believed that architecture for southern California should reflect the character of the region rather than being the product of imported European styles. Writing of Miss Barnsdall and the house he designed for her, he noted, "Herself a pioneer, this daughter of the pioneer lived up to integral romance when all about her was ill with pseudo-romantic in terms of neo-Spanish, lingering along as quasi-Italian, stale with Renaissance, dying or dead of English half-timber and Colonial."[1]

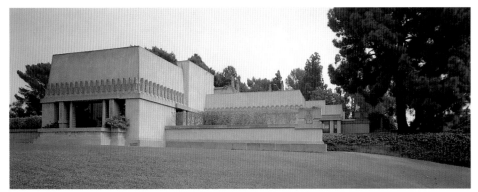

WEST ELEVATION.

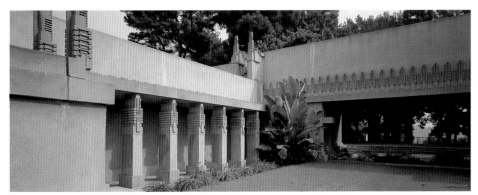

VIEW EAST ALONG DINING-ROOM WING.

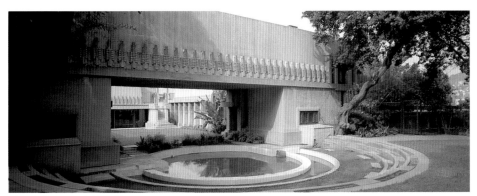

VIEW WEST TOWARD COURTYARD.

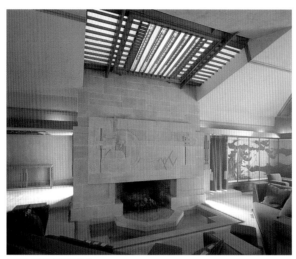

LIVING-ROOM FIREPLACE.

In response to the hot glare of the sun in this region, the main house turns in, rather than out, to an enclosed courtyard with grass, flowers, and trees; creating a shady glen. Window areas to the outside are kept to a minimum, a starkly different direction in his treatment of fenestration from his prairie houses. However, surrounding the pleasant courtyard patio are great areas of glass doors that slide open; he eliminated even the customary mullions to let the rooms become one with the outside environment. Water plays an important role in the overall scheme of the house, as a rivulet makes its course from a springhouse outside to a large reflecting pool in the patio to a stream alongside the dining-room windows, then momentarily disappears until surfacing, surprisingly, inside the house in front of the fireplace hearth. It appears again outside the living-room windows in a broad square reflecting pool. The area around the fireplace is an ensemble of the four ancient elements: fire, water (in front), stone—or earth (in the abstract mural he designed over the fireplace), and air (in the stained-glass skylight directly above).

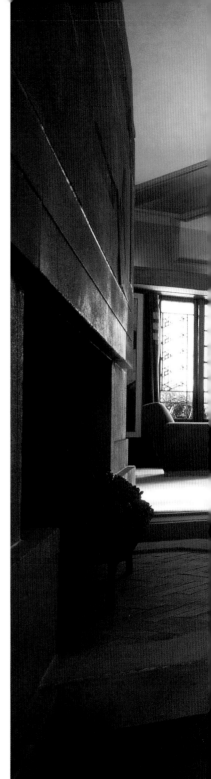

90        LIVING ROOM, WITH SOFA, PLANTER, AND LIGHT STAND.

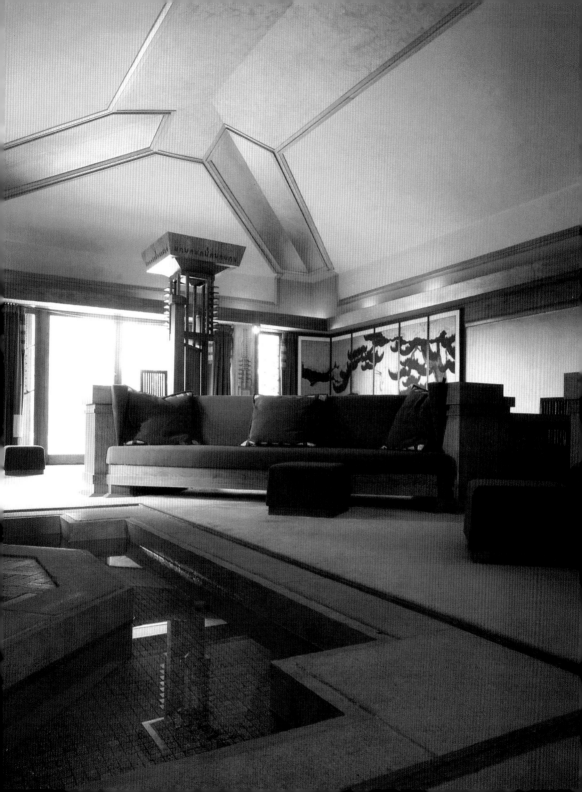

Wright frequently referred to the house as a "California Romanza design," and this sense of romance is apparent in all aspects of his design, from overall plan to the ornamental details:

*This old-fashioned term "romantic," too, so long and still so often meaning mere affectation or sentimentality, is become liberated and liberating. Architecture is truly romantic. There should lie in the very science and poetry of structure the inspired love of Nature. This is what we should and we do now call Romantic. The ceaseless overtones and intones of space, when developed as the new reality in architecture, go on, tone upon tone, as they do in the music of Beethoven or Bach, Vivaldi or Palestrina. Like music-totality every good building has this poise, floats, at home on its site as a swan on its lake.[2]*

The design for Hollyhock House represents a totally new direction in Wright's work. Four elevations, made during the preliminary stages, clearly document the process of this evolution. The first shows an elevation not dissimilar to that of the prairie houses: a low, hipped roof over masonry walls. The second shows the roofline more pitched, the wall masses more sculptural. But suddenly, with the third elevation, comes the scheme as seen today: sculptural concrete masses, slightly canted or sloped, with flat roof terraces over the entire house. Here at last is an architecture in sympathy with the region, not pretending to be anything other than a building that belongs where it is built. Since Barnsdall's favorite flower was the hollyhock, Wright built the abstractions of the plant into the decorative elements of her home, which she had already named "Hollyhock House." Running bands of these "flowers" adorn the concrete parapets, colonnades, and planters, as well as appearing on the backs of the house's specially designed chairs. Of all the projects he worked on for Barnsdall, only the main house and Residences A and B were constructed.

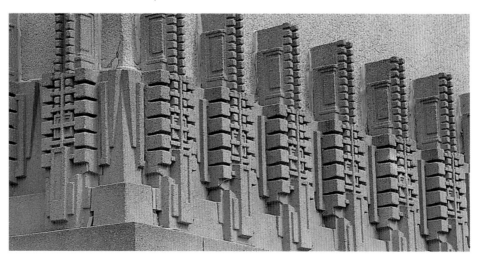

DETAIL OF HOLLYHOCK MOTIF.

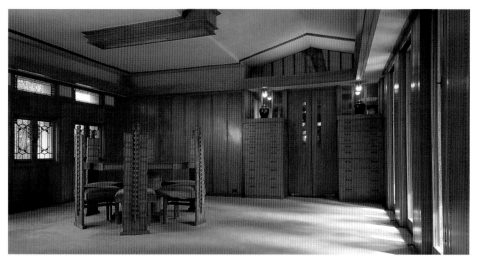

DINING ROOM, WITH ORIGINAL FURNITURE.

This was to prove to be the most difficult residential commission he encountered. Wright and his client, both perfectionists, conducted an awkward long-distance exchange. Nevertheless, he remembered this tumultuous relationship and his client with affection:

*A restless spirit—disinclined to stay long at any time in any one place as she traveled over the face of the globe, she would drop suggestions as a war-plane drops bombs and sail away into the blue. One never knew where or from whence the bombs would drop—but eventually they dropped. To add to this discomfort, the fates picked me up and were dragging me to and fro over the Pacific for four or five years, to build the Imperial Hotel at Tokyo. I would hear from her when I was wandering about in the maze of the Imperial Hotel in Japan while she was in Hollywood. She would get my telegrams or letters in Spain when I eventually got to Hollywood. And I would hear from her in New York while I was in Chicago or San Francisco. Or, hear from her from some remote "piney" mountain retreat in the Rockies when I was sea-sick out on the Pacific Ocean.*[5]

Since its construction, Hollyhock House has also undergone some turbulence. Barnsdall, an ethereal and peripatetic figure, soon moved out and gave the house to the city of Los Angeles, where it was used as a clubhouse for an artists' society. Later owners began to hack away at the house and then to neglect it. Only recently has the city become the responsible steward for this outstanding building and an effort been made to restore it. Wright's son Lloyd, a practicing architect in the Los Angeles area, was consulted in the restoration of the building he had assisted his father with years before. Most of the original furniture has been lost or demolished, but conservation efforts have recently provided new furniture, based on original designs, for the sculptural living-room sofas, writing tables, and light standards.

# JOHN STORER HOUSE, 1923   Hollywood, California

While Frank Lloyd Wright was working for Aline Barnsdall, he began building four other houses in the Los Angeles area. As with the Barnsdall house, he proposed an architectural language that he believed was more appropriate to southern California than the period-style houses that were proliferating there. The material that he chose for these works was the concrete block, a material considered so aesthetically unappealing that Wright explicitly qualified his new way of thinking about it:

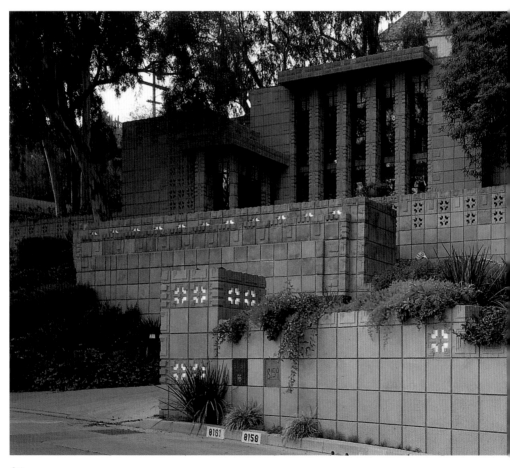

BLOCK DETAIL.

STREET ELEVATION.

*The concrete block? The cheapest (and ugliest) thing in the building world. It lived mostly in the architectural gutter as an imitation of "rock face" stone.*

*Why not see what could be done with that gutter-rat? Steel wedded to it cast inside the joints and the block itself brought into some broad, practical scheme of general treatment then why would it not be fit for a phase of modern architecture? It might be permanent, noble, beautiful. It would be cheap.*

*All that imagination needed to make such a scheme feasible was a plastic medium where steel would enter into inert mass as a tensile strength. Concrete was the inert mass and would take compression. Concrete is a plastic material—susceptible to the impress of imagination.* [1]

*We would take that despised outcast of the building industry—the concrete block—out from underfoot or from the gutter—find a hitherto unsuspected soul in it—make it live as a thing of beauty—textured like the trees. Yes, the building would be made of the "blocks" as a kind of tree itself standing at home among the other trees in its own native land.* [2]

Rather than using standard cinderblocks, which he agreed were rough and unsightly, Wright designed a block that could be molded on site into different patterns—some solid, some abstractly decorated, some perforated for glass inserts, some perforated for clear openings. The blocks themselves were made of a size and weight that could be easily handled by one person. They were joined by pouring concrete grout inside the grooved edges. By this method, a wall could be bound together without the customary concrete mason's mortar course. Wright discovered that skilled masons were unnecessary; relatively unskilled labor would suffice.

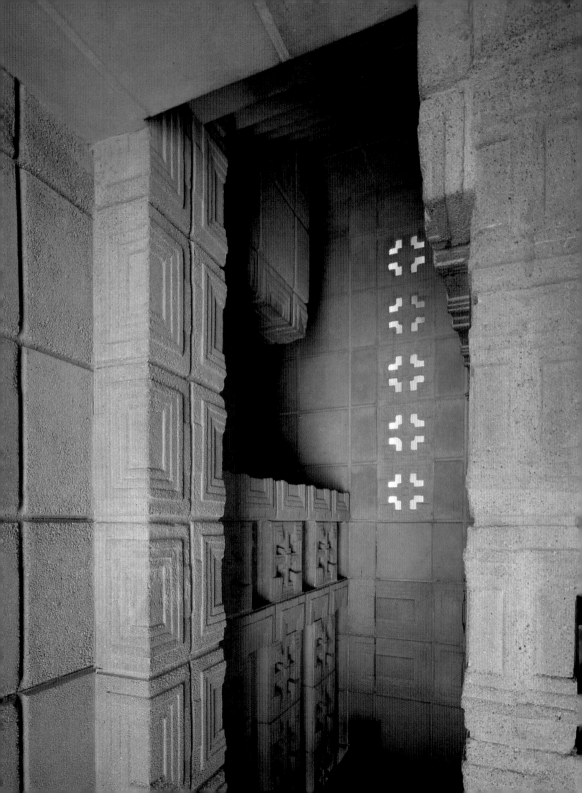

Lloyd Wright, Frank Lloyd Wright's oldest son and an architect practicing in the Los Angeles area, was using concrete block reinforced with steel for parts of a house he was building at the same time. Expanding on Lloyd's example, Wright developed a continuous reinforcing system in the three houses he subsequently built for John Storer, Samuel Freeman, and Charles Ennis. Slender steel rods were inserted course by course, both horizontally and vertically, as the wall rose. Concrete grout was then poured into the grooves, resulting in a strong bond of blocks and steel and a totally reinforced structure. This process Wright termed "textile block construction," a direct reference to his idea of weaving the concrete blocks on a warp and woof of reinforcing steel. In an earthquake-prone region, this seemed the most stable method of building. Wright in fact tested the concept successfully in the Imperial Hotel in Japan, which survived the great 1923 Kanto earthquake, primarily as a result of its steel structural reinforcing—what Wright often called "the ability to push and pull on a building," letting a building sustain great pressure by having the flexibility to sway and then return to its original position once the adversity subsided.

The four block houses in California presented the construction principle of reinforced concrete block as the language of form and structure, both on the inside and the outside of the building. The Storer residence, a two-story house, has a dining room on the first floor, with the living area above. Early historic photographs taken when the foliage was far more sparse than it is today, show that the raised living area commanded an uninterrupted view of Hollywood and distant Los Angeles.

The stairwell that connects the two levels lets the visitor wind his way through an interesting series of prospects; a physical sense of the building's vertical flow of space is thus gracefully imparted.

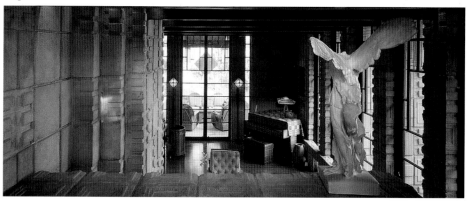

LIVING ROOM FROM LANDING.

OVERLEAF: LIVING ROOM.

STAIRWELL.

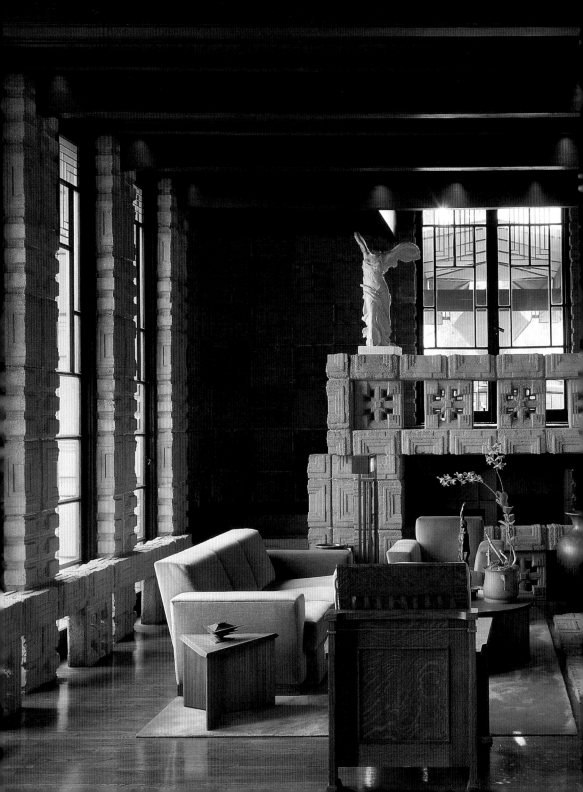

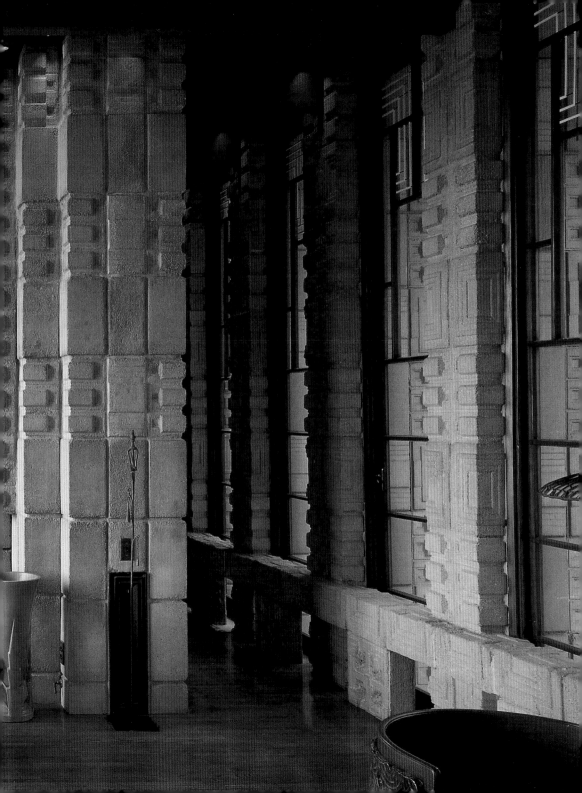

LIVING-ROOM (CHAIRS BY LLOYD WRIGHT).         VIEW OF LIVING-ROOM BALCONY WITH AWNING.

The central mass that contains both dining room and living room is lit from opposite sides by slender windows spaced between concrete block piers. Bedrooms are placed at one end, but on two levels, with the kitchen at the other end on ground level. A terraced balcony abuts the living room above.

As with so many of Wright's houses, change of ownership, neglect and disastrous remodeling attempts all but destroyed the Storer house. But recently film producer Joel Silver acquired the house and brought it back to its former state. Now it glows with a freshness that belies the fact that the building is nearly seventy years old. This careful conservation, aided by Wright's grandson Eric Lloyd Wright, also an architect, has set an example of the kind of restoration possible and has encouraged other Wright homeowners to follow suit.

The Storer house, along with the other three block houses—Millard, Freeman, and Ennis—represents Wright in two important facets: creating a new building system and creating a form that he believed was appropriate to southern California. The block construction was intended as a cost-reducing system by its elimination of much skilled labor along with the use of a decidedly cheaper material than masonry, wood, or reinforced cast concrete. In this region of abundant sunshine, the beautifully textured walls make shadow patterns a feature of the exterior, with perforated blocks permitting further shadow patterns and arabesque segments of sunlight to filter into the interiors.

But by the time these four residences were constructed, Wright—who believed that he might find a new career for himself in the Los Angeles area—soon found out that the newness and innovative appearance of these designs did not appeal to most potential clients. They preferred the very styles he was trying to supplant. He soon quit Los Angeles and returned to the Midwest. But the idea of an inexpensive concrete block building system would not be forgotten, and twenty-five years later he would revive the concept, in simplified form, and once more introduce it to Americans, this time calling it the "Usonian Automatic."

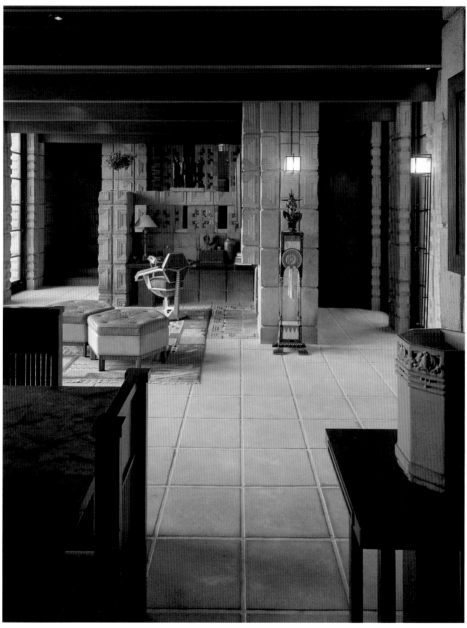

DINING-ROOM.

# USONIA 1932–1942

*"Every great architect is—necessarily—a great poet.*
*He must be a great original interpreter of his time, his day, his age."* [1]
—Frank Lloyd Wright

WRIGHT'S WORK FROM 1932 UNTIL THE SECOND WORLD WAR is characterized by a sharp shift in emphasis. The stock market crash of 1929 and the economic depression that followed forced a reevaluation of national priorities and possibilities. Wright's primary concerns during this period were decentralized planning to relieve cities and providing affordable housing for the average American family. Broadacre City and the Usonian house were his solutions. The word "Usonia" first appears in Wright's writings in 1925. It was an acronym for the United States of America that he credits Samuel Butler with inventing; Wright used it to define more precisely the architecture he proposed for this part of the vast American hemisphere.

The early years of the Depression brought a dramatic reduction in the number of Wright's architectural commissions. But inactivity was simply not in his nature, and he now also had time to found an architectural training program, the Taliesin Fellowship, in 1932, and to design Broadacre City, in 1934.

In fact, with no commissions coming into his office at the time the fellowship was established, Wright initiated the training of his apprentices by assigning them to assist in the design of a model for the Broadacre City project. Implementing his ideas about decentralization, Wright proposed moving the vital components of the overcrowded city into the healthy environment of the country and redesigning the architecture required by such a Usonian community so that the buildings would enhance the life of its citizens and also become integral features of the natural landscape. The members of the Taliesin Fellowship were responsible for the construction of this ambitious model, which eventually was exhibited across the country.

Closely related to the principle thesis of Broadacre City was the evolution of the Usonian house. After the financial crisis that paralyzed the nation in 1929, Wright recognized the need for a new, pragmatic approach to the homes of middle-income families. Not only was the residential plan concept in need of change, but more important, the method of housing construction.

In 1933 elements that would characterize Wright's Usonian houses appeared in the first scheme for the Malcolm Willey house: lapped board parapets in place of clapboard and masonry rising directly out of the ground without the stylobate of the prairie house. The

next year, in the house constructed for Willey, he brought the kitchen closer to the dining and living rooms, areas that shared the same space, with the dining table adjacent to the fireplace mass and the kitchen separated by shelves rather than partitions. The 1936 Robert Lusk house in South Dakota showed further development of this theme: in the drawings the kitchen is called "the Laboratory," and it occupies an alcove giving directly onto the dining space, which is adjacent to the living room and with its own window bay.

The main objective in these designs was to make available an affordable house during difficult financial times. Simplification in all aspects of construction, not only in design, was the only way to achieve this. The elimination of anything unnecessary—from features to materials—was the operative agenda for these buildings.

The plan for Broadacre City and the organization of the Taliesin Fellowship also occupied Wright during the lull in studio work, but by late 1934 outside work again resumed. Two of Wright's most successful commissions—"Fallingwater," the world-famous house for Edgar J. Kaufmann, and the Administration Building for the S. C. Johnson & Son Company (Racine, WI, 1936)—as well as dozens of residential commissions consumed him for the rest of the decade. Most of the residential designs were completed for middle-income clients. As the world had changed over the past two decades, so had the customers for his architecture. Such affluent clients as Kaufmann and Johnson were now the exception, rather than the rule. While most of Wright's early houses were built for wealthy, often self-made businessmen like Frederick C. Robie, the clients of the 1930s were more often from the ranks of professionals, such as teachers and journalists.

From 1932 until the architect's death in 1959, the presence of the fellowship made possible the prolific production of Wright's work. There was always a key group of six or seven permanent fellowship members to serve as Wright's production team, training new apprentices, completing studio drafting work, and acting as the architect's representative and on-site supervisor around the country.

The Usonian years are often eclipsed by the fame of the "prairie school" work, and the significance of Wright's achievements during this period is usually underestimated. Wright's basic principles never changed, however; he never detoured from his goal of creating organic architecture. But by the 1930s the world he lived in had changed, and as a result new architectural forms and ideas were required to serve, express, and enhance what he perceived to be the demands of that change.

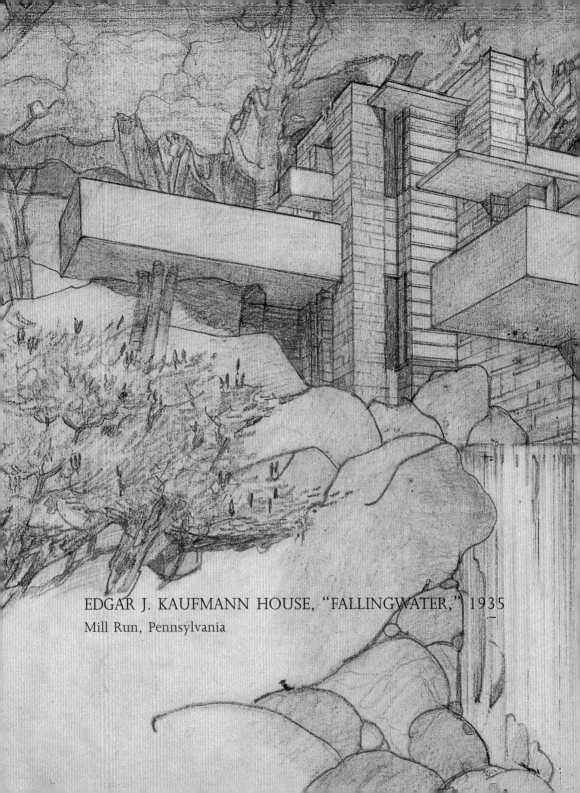

EDGAR J. KAUFMANN HOUSE, "FALLINGWATER," 1935

Mill Run, Pennsylvania

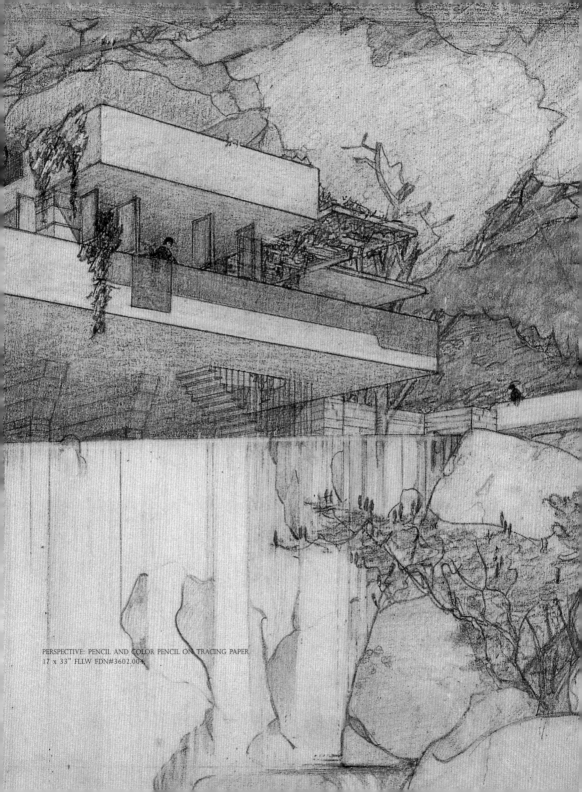

PERSPECTIVE: PENCIL AND COLOR PENCIL ON TRACING PAPER
17 x 33" FLLW FDN#3602.004

In the midst of Wright's designing new solutions for urban planning and developing better cost-saving building systems for the average American home came a rare and unexpected commission. The design that transpired, it would seem, was the outpouring of his pent-up creative energy. "Fallingwater," as this house is known, is perhaps Wright's most imaginative solution for a residential commission. It is now, more than fifty years after it was built, an icon of architecture that we associate immediately with the Frank Lloyd Wright canon.

Edgar J. Kaufmann, Jr., son of a successful Pittsburgh department-store owner, was one of the Taliesin Fellowship apprentices taking part in the construction of the Broadacre City model. Edgar persuaded his father to fund the construction of the model for a nationwide exhibition tour.

When the elder Kaufmanns met the Wrights, an immediate friendship blossomed. As Edgar Jr. wrote:

Soon my parents came to visit; they were moved by the extraordinary beauty of Wright's home and its landscape, and impressed by the devoted enthusiasm of the apprentices. Wright and my father were both outgoing, winning, venturesome men, and father quickly felt the power of Wright's genius. Mrs. Wright and my mother were cosmopolitan, and romantic in their taste for poetry; mother responded to Mrs. Wright's courageous character. Before the year's end [1934] Wright stopped off in Pittsburgh to discuss several projects with my father; one was a country house to replace a rudimentary cottage that had served for over a decade.[1]

Shortly after that first visit, in a letter written on December 26, 1934, Wright noted to Kaufmann: "The visit to the waterfall in the woods stays with me, and a domicile has taken vague shape in my mind to the music of the stream. When contours come you will see it."

Two elements are predominant in the setting of Fallingwater: the presence of the stream and cascades running immediately below the site of the house, which also affords a view of the hill slopes and wild rhododendron bushes, and the cliff ledges to which the house is anchored. The plan, positioning the house along the cliffside, moves in staggered bays and alcoves, with stone walls reiterating the stone cliffs and creating a sheltered, almost cave-like, atmosphere. But immediately over the waterfalls and facing the glen and its foliage, the plan dramatically opens the house up to expansive sweeps of glass windows and French doors giving onto projecting, cantilevered terraces.

NORTH ELEVATION FROM DOWNSTREAM.

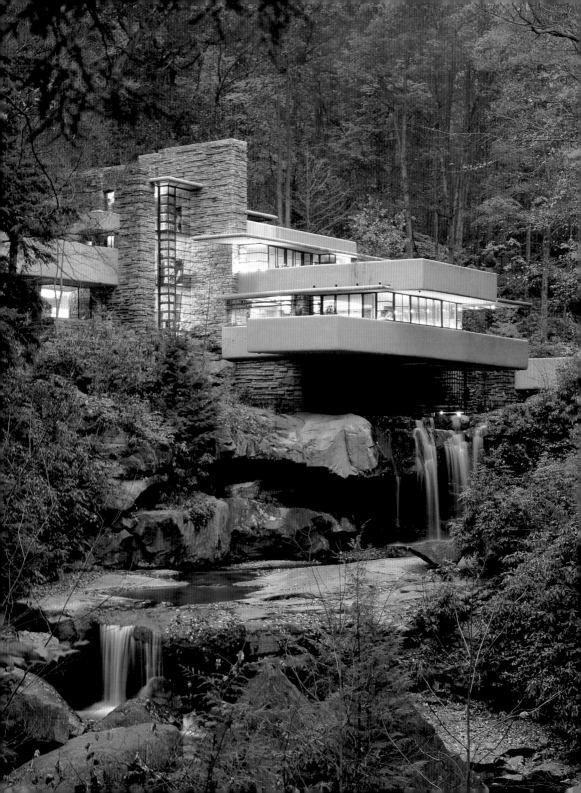

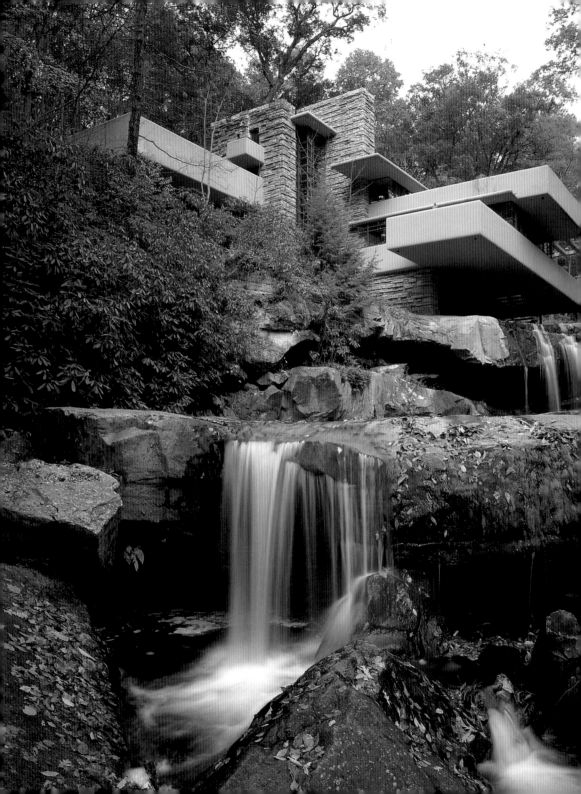

Thus, the main floor area is jagged on the side of the house that is anchored to the cliff ledges, while on the side opposite and on both ends, it is open to clean, clear lines of glass with little obstruction. The house has three levels, each with its own terrace, and outside stairways leading to other terraces. One stairway, tucked between two stone walls, permits private access to the natural pool beneath the house. Only the sound of the cascading waterfalls breaks the silence of the sequestered location. Indeed, Wright placed the house's occupants in nature in a way that requires a special effort to partake of her beauty: in order to see the waterfalls, people must move onto the terraces and lean over the balconies. It is as if they must make some obeisance in order to enjoy what an infinite force has created for their benefit. Perhaps in no other dwelling created by Frank Lloyd Wright has this accommodation between man and nature been more perfectly expressed.

The site had long been one of the favorite places for the Kaufmann family in their woodland retreat. They played in the cascades, slid down the smooth rocks, stood under the falls, and sunbathed at the cascade's edge. When they saw the architect's first sketches, they expressed surprise that Wright had placed the house not on the slope looking down to the falls, but directly over them. "No, not simply to look at the waterfalls but to live with them," was Wright's reply to their query.[2] In fact, a large boulder on which they once sunbathed was built into the house as the hearthstone for the fireplace. Edgar Jr. remarked that the falls were formed by stone ledges having broken loose, creating the diversion that the waters followed. He speculated that Wright had seen these broken ledges lying in the stream below and in the design of his parapets had really put those ledges back into the cliff from whence they had fallen—the width of the ledges being very similar to the width of the parapets themselves. Although this is pure conjecture, it was not unlike Wright to read quickly the conditions of a building site and to let its most salient features, even accidental ones, inspire his design.

VIEW FROM DOWNSTREAM.

109

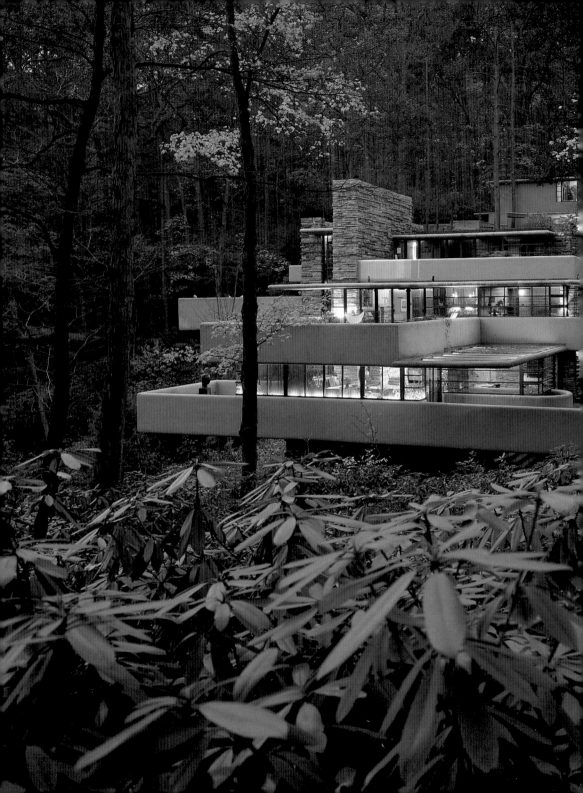

The stonework throughout Fallingwater—inside and out—is similar in technique to the stonework of the architect's own home, Taliesin. The walls are laid up in a series of stratified layers, with many stones projecting out from the general surface and re-creating the pattern of stone as it was originally found in a quarry.

An important and most significant feature of Fallingwater is in the detail of the balcony edges and the parapet edges throughout the house. On the preliminary studies, as well as on the famous color perspective and also on the first sketches for the working drawings, these edges are crisp and square. But as the scheme developed they are curved, the concrete gently wrapped around both edges and corners. This soft, curvilinear treatment is not only in marked contrast to the rugged stonework of the masonry walls, but also to the clean surfaces of the parapets themselves. This detail, which henceforth would continually recur in Wright's subsequent designs, is a break from the usual right-angle details of his earlier work. As the drawings progressed for the project, it is impossible to pinpoint when he made this important change, but later he returned to one of the four early perspective studies and in certain places rounded the edge of these once-square parapets. It is a trend that evolved into the curved forms of the Johnson Wax Administration building, which soon followed, and the Guggenheim Museum, which he designed nine years later.

SOUTH ELEVATION.

111

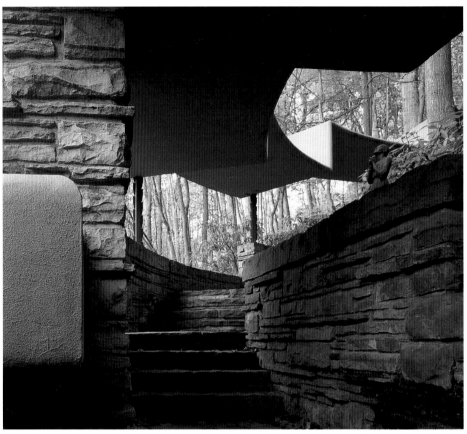

STAIRS AND CANOPY TO GUEST HOUSE.

When Fallingwater was completed, the Kaufmanns quickly realized that they needed more facilities for guests, and they commissioned Wright to design a guest house farther up the cliff side of the property. This addition is connected to Fallingwater via a half-circle walkway stepping along the slopes. The reinforced concrete roof over this outdoor passageway is a remarkable example of engineering. The supports are pipe columns set at one edge only; the step-down of the concrete acts like a steel "flag" to reinforce the cantilever, while the curve of structure prevents it from falling over. Details such as these demonstrate Wright's ingenious blending of structure and form.

COVERED WALKWAY FROM GUEST-HOUSE TERRACE.

112

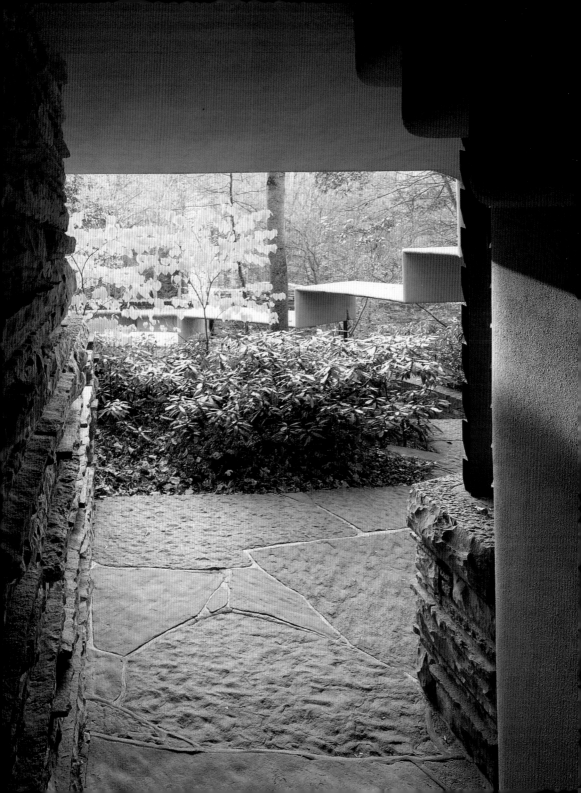

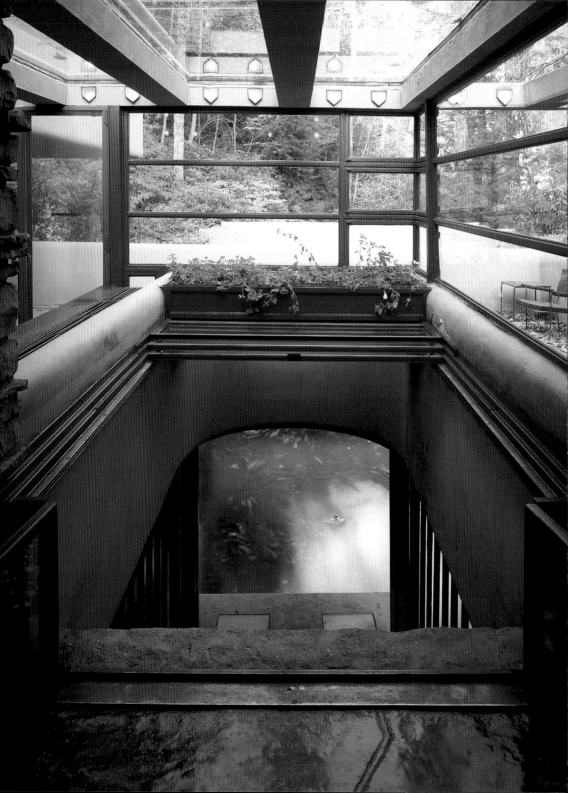

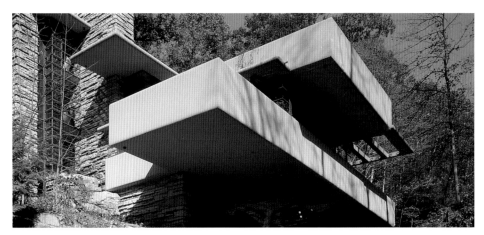

TERRACE FROM DOWNSTREAM.

The cantilevers at Fallingwater can be described as nothing short of daring. The house seems to soar in all directions, defying the laws of gravity. From the planning stages of the design these expansive cantilevers were a source of worry and consternation both to Kaufmann and to his contractor. But not to Wright. He was aware of how this new force—reinforced concrete—supported by generous stone and concrete piers—could be exploited in a manner never seen before in a private residence—and only rarely in any commercial building of this first half of the twentieth century. The engineering was radical —almost unacceptable by the standards of the day. A structural engineer at M.I.T. recently remarked that it was indeed fortunate that Fallingwater was built in a rather remote country setting: "There is not a city in the United States, even today some fifty-seven years later, where one could obtain a building permit to erect Fallingwater."

The beauty and drama of Fallingwater's streamlined design has earned it a place in architectural history as the most significant residence built in the United States. But the real achievement of Fallingwater is the simple, quiet, and yet magical way in which the building sets man in nature. Wright uncharacteristically praised himself for this:

*Fallingwater is a great blessing—one of the greatest blessings to be experienced here on earth. I think nothing yet ever equalled the coordination, sympathetic expression of the great principle of repose where forest and stream and all the elements of structure are combined so quietly that really you listen not to any noise whatsoever although the music of the stream is there. But you listen to Fallingwater the way you listen to the quiet of the country.*[3]

Indeed, he frequently expressed his "jealousy" over Fallingwater: "Anyone can build a big house for the rich man, but design a beautiful home for the man of moderate means,—ah—that will show the mettle of the architect."

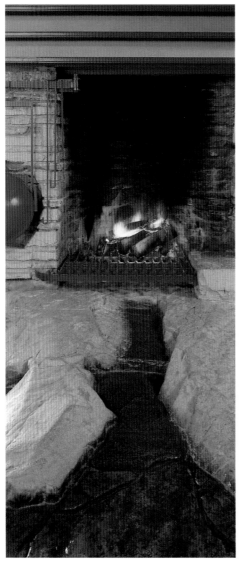

LIVING-ROOM FIREPLACE.

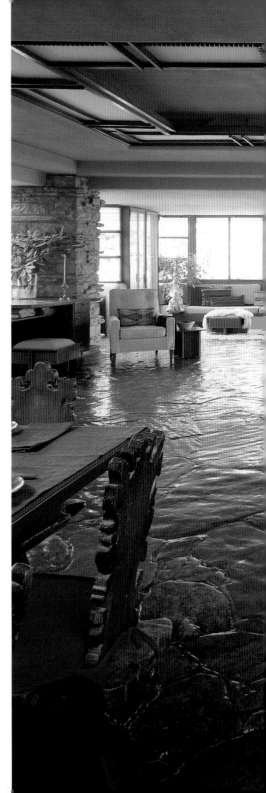

LIVING ROOM.

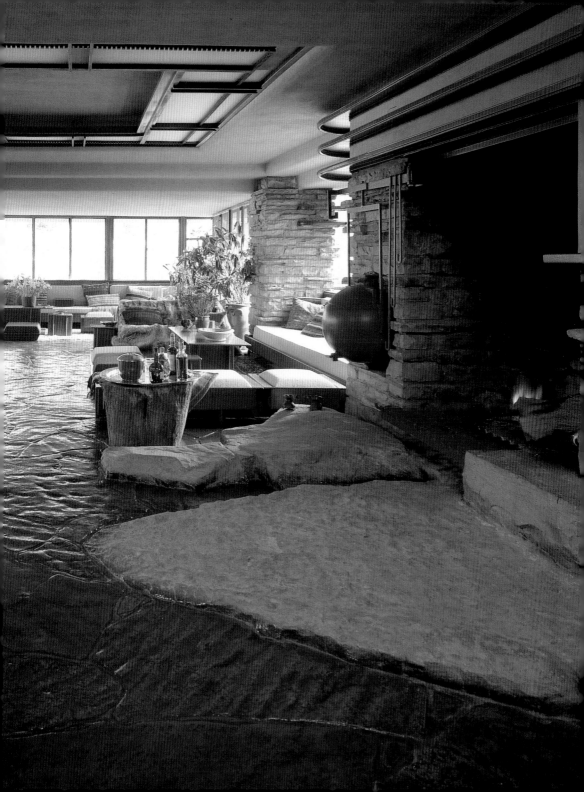

# HERBERT JACOBS HOUSE, 1936  Madison, Wisconsin

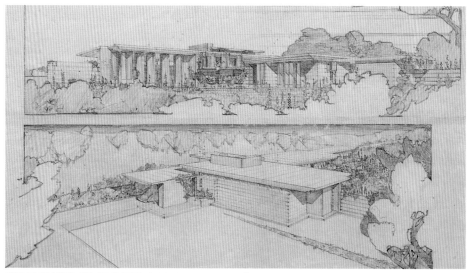

PERSPECTIVES. PENCIL AND COLOR PENCIL ON TRACING PAPER, 22 x 33". FLLW FDN#3702.002.

The first of the Usonian houses to be built was for Herbert Jacobs in Madison, Wisconsin, in 1936. By the time Wright was working on the plans for this house, his Usonian system was resolved and ready for application.

The house offered a simpler way of living. The L-shape plan places the living room in one wing, the bedrooms in the other, the two wings meeting in the workspace and dining area. To conserve on plumbing costs, the workspace and bath are kept adjacent to this juncture as well and, in place of a basement, a small area was excavated beneath the kitchen to house the furnace. The ceiling height in the workspace is higher than the rest of the house, to provide both for ventilation and clerestory lighting—this area having no outside windows. The housewife, too, was no longer relegated to the kitchen, cut off from the rest of the house. In her new position she had easy access to and a view into both wings. As Wright explained:

*We did a great deal in the open plan when we took the hostess out of the kitchen and made her attractive as a hostess. She was no longer a cook in the kitchen, we made her a feature of her establishment.*[1]

The old-fashioned "parlor" is gone, as is the redundant "reception room," and in their places the living room emerges as the main space for the life of the family.

EXTERIOR WALL, LIVING-ROOM WING.

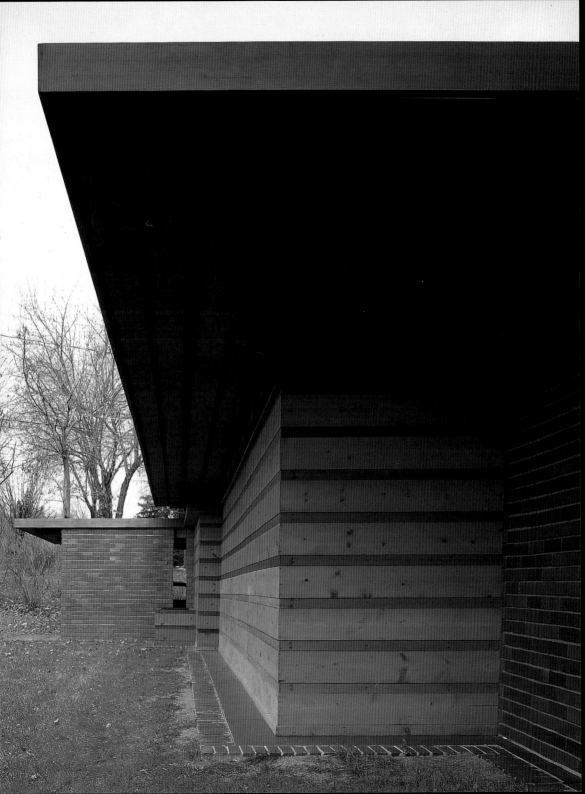

The L-shape plan allows the house to sit at the extreme corner of the lot, not in the normal, centered position, and both bedrooms and living room open, via French doors, onto terraces that look into the landscaping and gardens outside.

The sandwich walls—plywood core, building paper (for insulation and waterproofing) on each side, and then the boards and battens—likewise on each side—are truly screens in the finest sense of the word: they are non-supporting, acting solely as space dividers, both to protect the house from the elements and to segregate and define the various functions within. The supporting elements of the Usonian houses are mainly masonry walls of stone, brick, or concrete block. But to strengthen further the screen walls of board/batten structure, Wright cleverly bent the walls, having them turn corners, like folding a sheet of paper so that it can stand upright. The same stiffening effect was achieved by building bookshelves, cabinets, and cases into the wood walls.

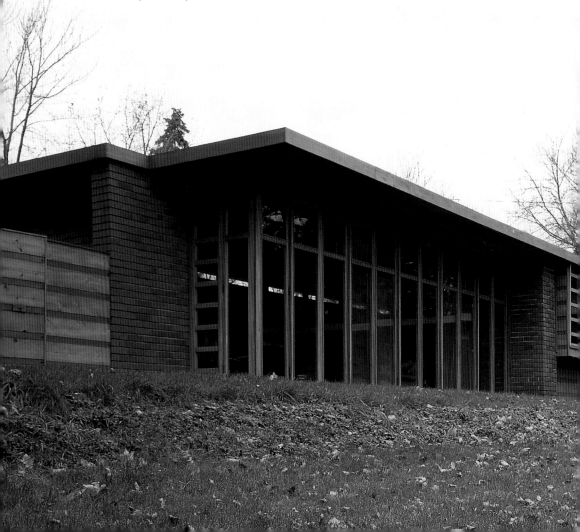

A study of the Usonian plans reveals how Wright consistently let the angles of the walls not only work for him as stiffening, but to create lovely nooks and intimate spaces throughout the plan. Nothing was done for effect alone, but charming effects arise as the result of a structural necessity. To Wright's way of thinking, the structural necessity and the aesthetic result were always one and the same. Here he carried Sullivan's dictum "form follows function" into his own interpretation: "form and function are one."

Frank Lloyd Wright found the L-shape plan so successful in the Jacobs house that he employed it in several subsequent Usonian houses. He did not use it as a predetermined design, but modified its application, addressing the different site conditions, requirements, and desires of each client. The Jacobs house, by necessity, was limited in its "luxuries" by a very constricted budget: $5,000 for the construction and $500 for the architect's fee.

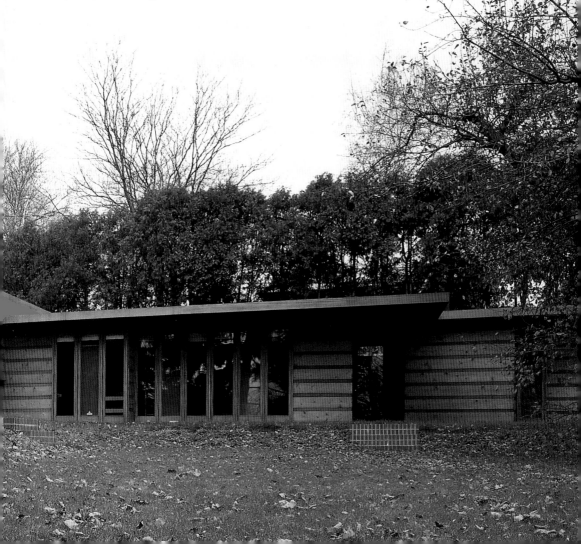

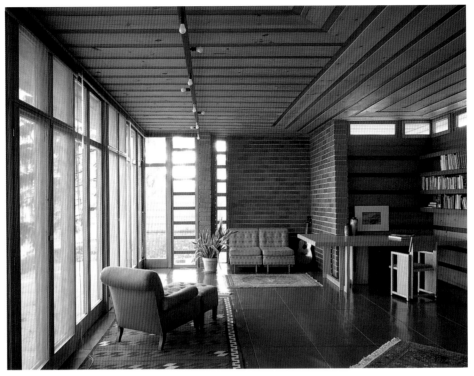

LIVING ROOM.

But when Wright had the opportunity, he expanded the L-shape plan with additions and variations, constantly exploring new resolutions. Houses for Stanley Rosenbaum (Florence, Alabama, 1939) and Melvin Maxwell Smith (Bloomfield Hills, Michigan, 1948) are fine examples of this development. Other refinements were made, such as more varied roof levels for clerestory lighting and indirect lighting inserted into perforated boards in the ceilings. Naturally, it was mainly a matter of each client's particular budget that shaped and guided Wright's refinements.

The Jacobs house is the true prototype of the Usonian houses that were built over the next twenty years. As a house designed for the middle-class family, its method of construction, which required stone and brick masonry as well as carpentry—the most economical of the building trades—addressed the economic realities of the time. But Wright also found it consistently advantageous to send out one of his own apprentices

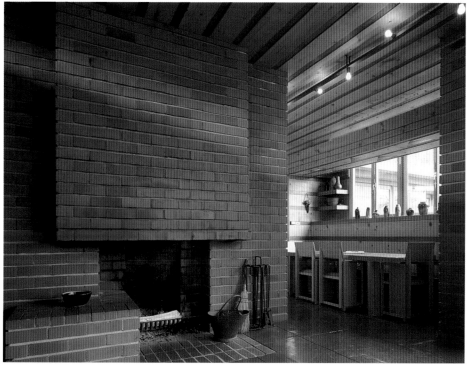

LIVING-ROOM FIREPLACE AND DINING AREA.

to serve as a supervisor on these sites, as local contractors often had difficulty understanding these new ideas. More important, however, an on-site coordinator insured that the integrity of the architect's design would be respected.

The furniture for these houses was designed to be made of plywood; a client somewhat skilled with a table saw, or the local contractor, could easily fabricate the chairs, bed frames, tables, hassocks, and whatever other pieces of free-standing furniture were required. Sometimes the apprentice on site as supervisor was also capable of helping in the making of the furniture. And as with his earlier work, Wright made ample use of built-in furnishings, including cabinets, wardrobes, tables, shelves, and bookcases. Now, some sixty-one years after its construction, the Herbert Jacobs house has undergone a fine and sympathetic process of restoration.

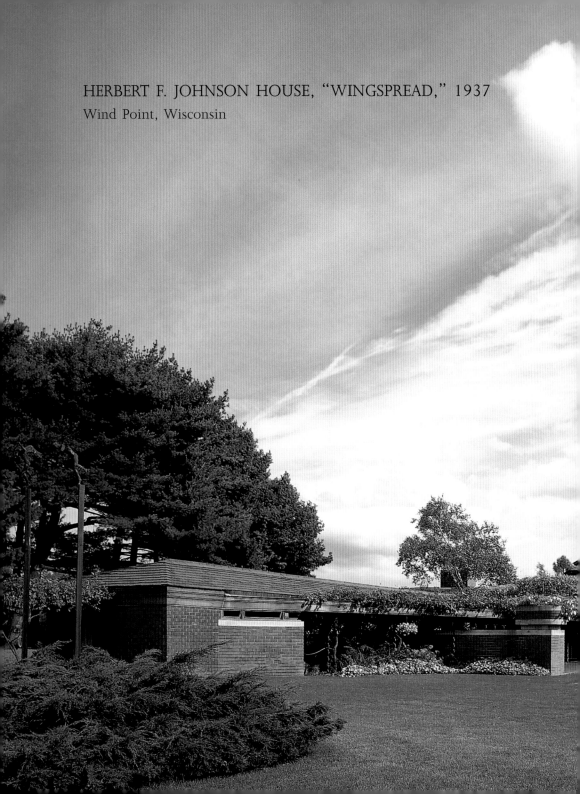

HERBERT F. JOHNSON HOUSE, "WINGSPREAD," 1937

Wind Point, Wisconsin

Wright claimed that "Wingspread," the home he designed for Herbert F. Johnson, president of the S. C. Johnson & Son Company, was the last of his prairie houses. Indeed, before it was landscaped, the large site for the house was a treeless expanse of flat prairie land—but with the distinct advantage of a small pond bordering the property and a winding ravine leading out from the water. This ravine provided Wright with the particular feature next to which he placed the house. A wigwam-like living room, rising up three stories, is the central element of the plan, with four long, low-lying wings spreading out in four different directions for the other functions of the house: one wing for the Johnsons; another for the children, terminated by a playroom with a swimming pool outside; a third wing for guest rooms; the last wing for kitchen, pantry, and servants' quarters. Three of the wings are on the same level, but to create a more interesting sense of scale and space, the master wing is raised up to the second-floor level (with storage space beneath), bordered by a large terrace overlooking the terrain, and ending with a dramatic narrow wooden balcony that soars out beyond the brick supporting walls and over the lawn. The proportions of the house afford a seemingly intimate association with the prairie landscape on a site much larger than even that of the 1906 Avery Coonley house.

GARDEN VIEW FROM THE NORTHWEST.

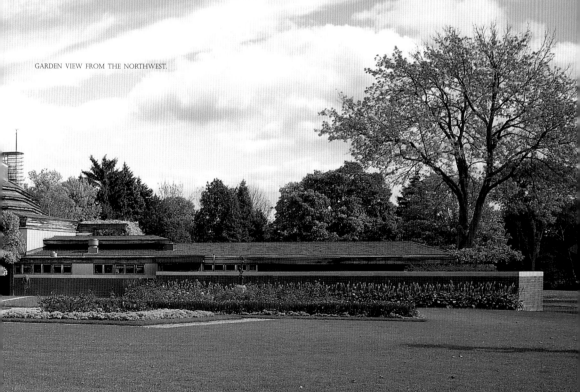

GREAT HALL.

On the plan the central living room is called the "Great Hall." But the room maintains an intimate sense of human scale by the way in which it is divided. A dramatic chimney mass provides for five fireplaces, and the space is apportioned for an entrance, family living room, library, and dining room. The entire area is open to a height of three stories and is lit by tall, two-story French doors on three sides and an ingenious series of clerestory windows wrapped in three continuous bands, one above the other, around the central chimney mass.

Wright also referred to this plan as "zoned," stating that it was the natural development of his other great "zoned" house, the Coonley house. In Wingspread's plan the zoning is far more apparent. Where one would expect from the plan an axial and static house, confined to its central core and four wings, Wright instead varied the wings, both in level and in plan detail, to create certain delightful surprises. The children's playroom breaks away from the extended plan at one angle, the mezzanine joining the great hall from the master-bedroom wing presents another. The change of levels in the great hall from entry to family room to library creates definite divisions of spaces, but within one larger space. With the mezzanine extending over the family area, the one place in the great hall where the ceiling is low, this area is more contained and therefore more intimate for the grouping of family around fireplace and piano.

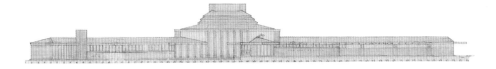

ELEVATION. PENCIL ON TRACING PAPER, 36 x 43". FLLW FDN#3703.076.

GREAT HALL, WITH CLERESTORIES, FIREPLACE, AND VIEW TOWARD LIBRARY (RIGHT) AND FAMILY AREA (LEFT).

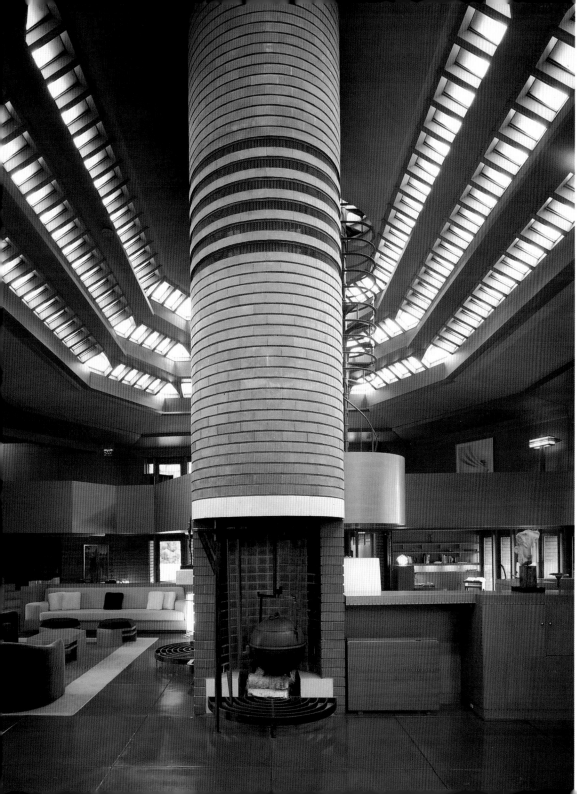

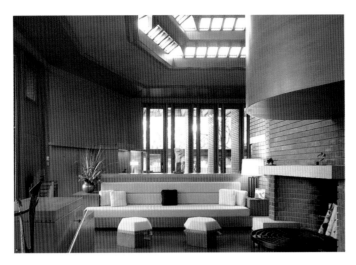

VIEW OF LIBRARY
TOWARD DINING AREA.

The house possesses a quiet elegance within. Wright claimed that the brick masonry work in the house was the best he had ever seen. Combined with the high quality of the wood-work and the fine plaster work, Wingspread is one of the best built of Wright's houses.

In designing some of the exterior elements of the house Wright again demonstrated his superb gift for creating the unexpected. The large pergola-trellis that runs along the entire guest wing is supported by slender metal pipe columns, while running out from the building to the end of the trellis is a brick wall, screening the area for privacy, which is topped with a planting box of brick and white stone. Ordinarily, such a wall would be the obvious support for the large trellis. But here the trellis soars over the wall. The juxtaposition of lightness and solidity creates a contrast and a feeling of freedom. The same effect occurs again where the upper terrace that runs along the mezzanine and master-bedroom wing rides over another wall. Again, the obvious method of support for this long terrace would have been the wall below. Instead, the terrace is a cantilever, its support coming from within the building itself, and a dramatic sense of lightness and grace is achieved.

In his autobiography, Wright wrote at length about Wingspread and its place on the prairie:

This extended zone-wing-plan lies, very much at home, quiet and integral with the prairie landscape which is, through it, made more significant and beautiful. In this case, especially, green growth will eventually claim its own; wild grapevines swinging pendent from the generously spreading trellises; extensive collateral gardens in bloom, extending beneath them, great adjoining masses of evergreens on two sides and one taller dense dark green mass set on a low mound in the middle of the entrance court—the single tall associate of this spreading dwelling on the prairie. Lake Michigan lies well off ahead but within the middle distance, and is seen over the wild-fowl pool which stretches away in the direction from just below the main terrace of the house. A charming foreground.[1]

SPIRAL STAIRWAY FROM MEZZANINE TO OBSERVATION DECK.

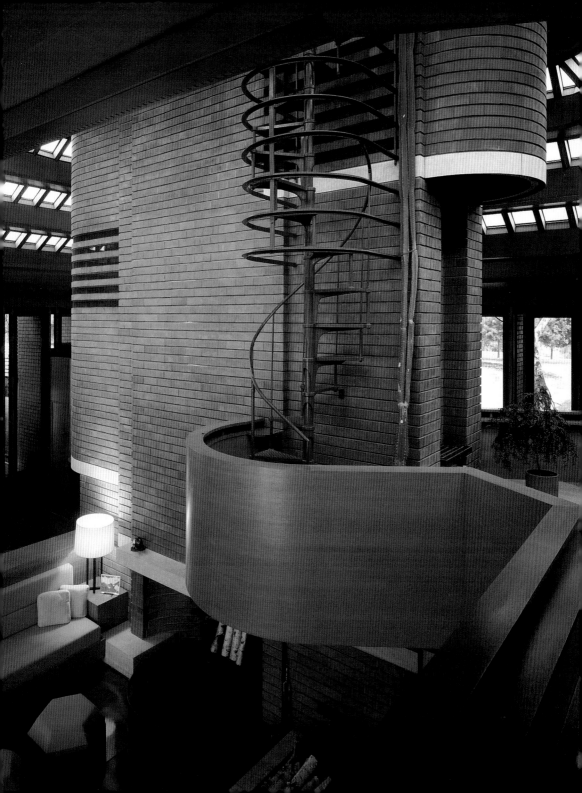

# C. LEIGH STEVENS HOUSE, AULDBRASS PLANTATION, 1939
Yemassee, South Carolina

The name "Auldbrass" was coined by Wright from "Old Brass," which, so the story goes, had been the name of an old slave on this plantation in the last century. During William Tecumseh Sherman's trek north to Columbia, South Carolina, after his devastating march across Georgia in 1865, the plantation was burned, and "Old Brass" escaped and built himself a shack at the landing.[1] C. Leigh Stevens acquired this property in the 1930s and proceeded to commission Frank Lloyd Wright to design a country residence for him. Stevens desired a complex that would reflect the plantation life of antebellum days, complete with main residence, guest house, caretaker's house, farm buildings, stables, barn, cabins for workers, and a special barge, moored to the guest house, for floating on a swamp that was on the property. An engineer with offices in Baltimore, Maryland, Stevens wished to use the plantation primarily as a retreat for excursions during the riding and hunting seasons of the year.

   Frank Lloyd Wright was not about to reinterpret the pre-Civil War architecture of white colonnades and Greek Revival facades. Instead, Wright placed the plantation close to the ground, creating a low profile across the flat wetlands. This strategy was in direct contrast to the placement of his prairie houses forty years earlier. Here there is no reason to raise the building off the ground level so as to provide privacy and views. To the contrary, the views are best appreciated in close association with the terrain. Auldbrass, in many ways, is similar to Wright's own Taliesin West, the architect's winter home on the Arizona desert: it is camp-like and informal in character, a complex of buildings loosely connected together.

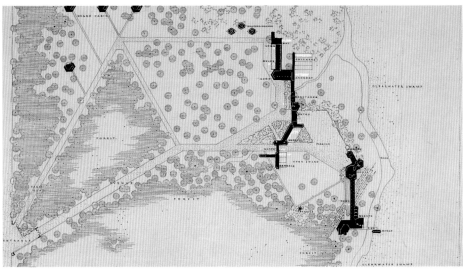

PLOT PLAN. INK ON TRACING PAPER, 23 ⅛ x 29 ½". FLLW FDN#4015.056.

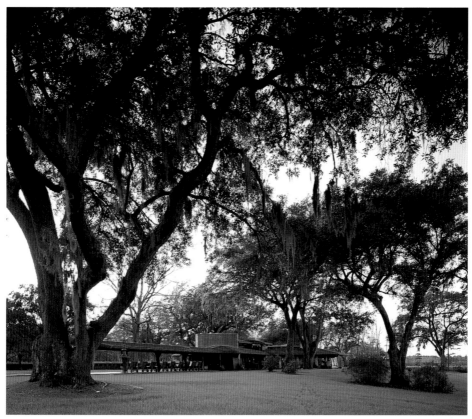

MAIN HOUSE FROM NORTHEAST.

Wright began the commission in 1939, and by 1941 the main house and some of the farm buildings were constructed. Only part of Wright's master plan was executed, and over the years, through neglect by subsequent owners, the buildings fell into terrible disrepair. Joel Silver, present owner of the John Storer house, found them in a ruinous state: roofs were leaking, woodwork was stained and rotted, the property overgrown and uncared for.

Silver acquired the property in 1987 and proceeded to rebuild many of the structures that were lost in a fire in 1959. He is now completing the other Frank Lloyd Wright designs that Stevens did not build, including, among other buildings, the guest house and the charming little barge. Wright's grandson Eric Lloyd Wright was hired as the restoration architect.

OVERLEAF: VIEW FROM SOUTH OVER POOL AND TERRACE.

133

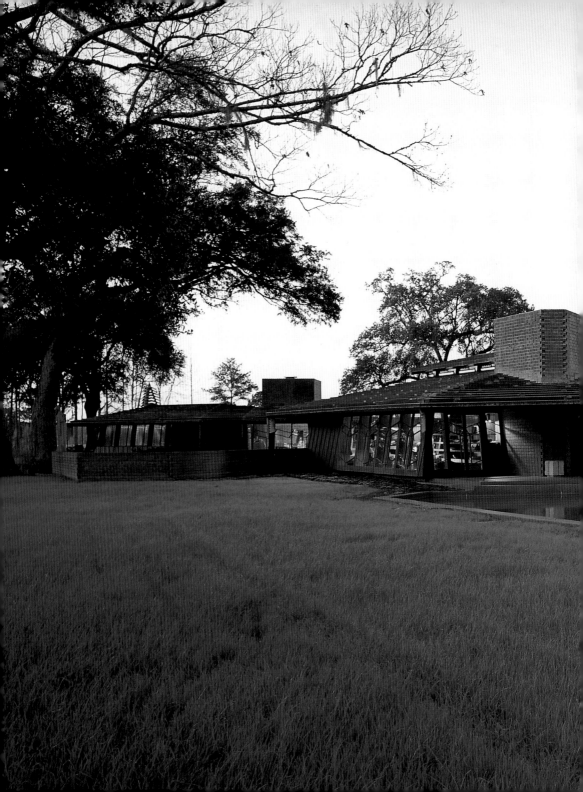

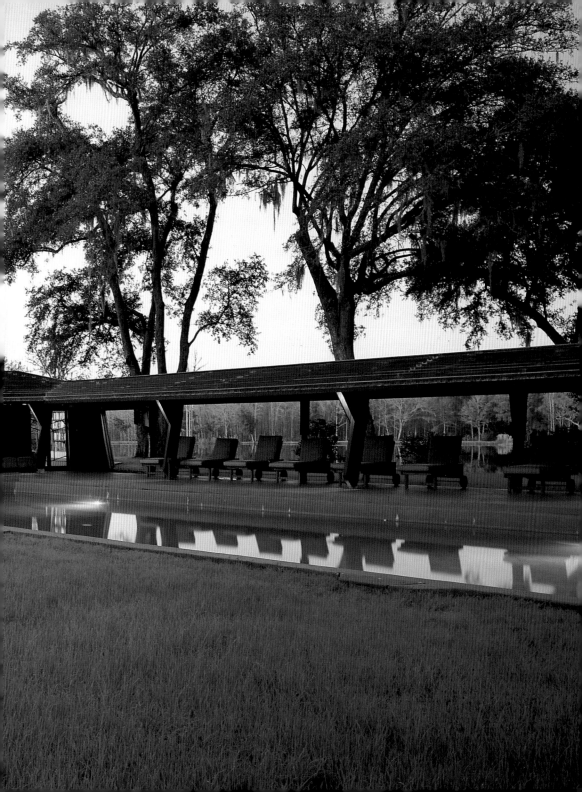

BEDROOM TERRACE.

Like Taliesin West, Auldbrass seems to
have no precedent. It responds directly to the
environment, to the cypress trees growing
out of the nearby swamp, to the hanging
moss in the oak trees. At Taliesin West the
stone walls slope noticeably, in some cases
rising one way and then changing direction
partway up. This was Wright's way of
responding to the distant mountain ranges,
which became a backdrop for the buildings.
The other walls and screen partitions, of
either wood or glass, rise vertically. The
opposite occurs at Auldbrass, where the
brick walls rise vertically and the wooden
ones are sloped.

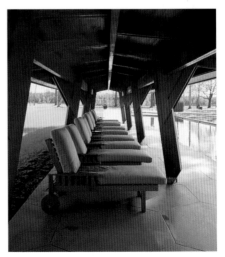

PERGOLA.

136

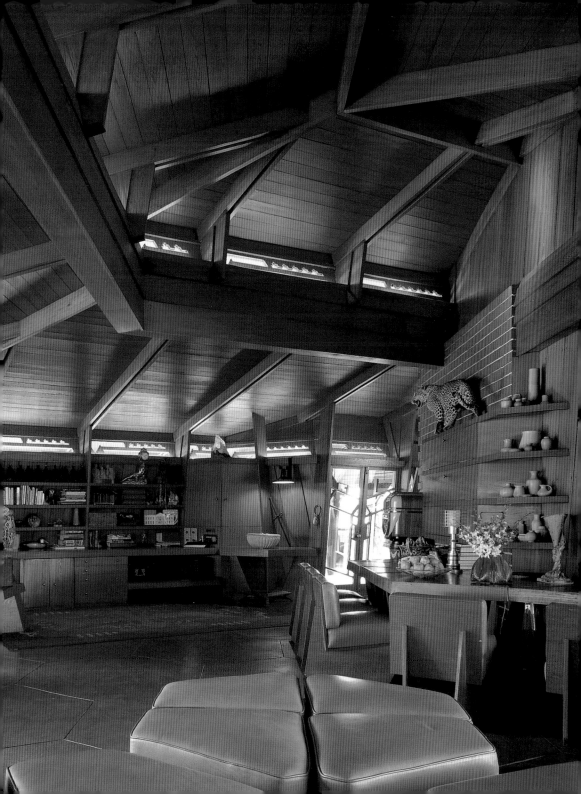

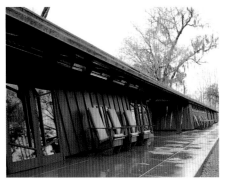

CARETAKER'S HOUSE AND PLANTATION OFFICES
(ORIGINAL CHICKEN COOP).

The living room of the main house has two bands of clerestory windows wrapping around the room. The narrow windows are formed by perforated boards, an abstract design consistent in all of them, producing a light source along the sloped ceiling to balance the light from the French doors on both sides. The walls not only slope, but the cypress boards slope from left to right as well. This might have suggested restlessness, but just the opposite is the result.

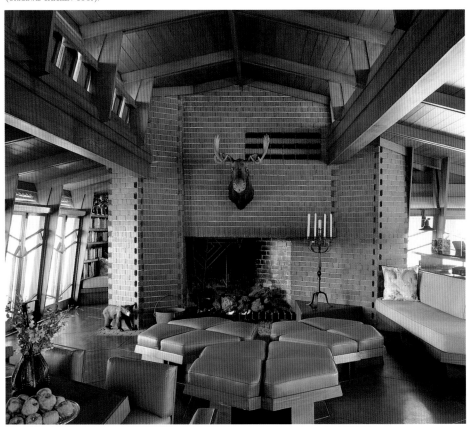

LIVING ROOM.

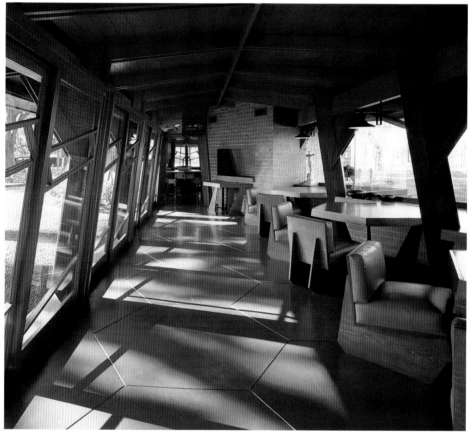

DINING ROOM.

A tranquil graciousness is achieved, with copper roofs and copper rainspouts fashioned into an elaborate abstraction of the hanging Spanish moss. In this humid climate, a system of fenestration boards lets in air at floor and ceiling levels, with the openings screened off, to generate a natural draft.

In 1958, in a talk to the Taliesin Fellowship, Wright spoke eloquently of the nature of materials, in particular of wood and of his freedom to use it as he wished, in concert with the surroundings, at Auldbrass:

*Wood, of course is the most friendly of all materials. Nothing is so friendly to man as the tree. And the tree is wood. Wood has certain qualities—certain characteristics—and if you use it according to those characteristics and are especially in love with them yourself, you'll come out with a wooden structure that really is beautiful.*[2]

THE FINAL YEARS
1943–1959

DURING THE LAST SIXTEEN of Wright's seventy-two years as a practicing architect he designed nearly five hundred projects. In these years, starting with the Guggenheim Museum in 1943, he created almost half his entire output—an incredible record of accelerating creative energy. The Guggenheim Museum introduced a new development that had roots in the S. C. Johnson & Son Company Administration Building, with the use of the dendriform columns and curved elements, and also in "Fallingwater," with his molding of curved concrete edges. Such buildings from this period as the museum, the Price Tower, the Beth Sholom Synagogue, and the Marin County Civic Center reveal Wright as an innovative engineer as well as a genius of design. His alternative now to the old post-and-beam construction, which he so berated, was a vigorous sense of the "plastic" in architecture: molding buildings by means of steel and reinforced concrete, wedding engineering and architecture together in an inseparable, organic entity. These buildings, Wright hoped, would appear to be like flowers or trees, reflecting that concept of natural, harmonious growth "from within outward."

The Usonian house of the 1930s and 1940s was fast becoming uneconomical. The nation was in economic upswing and the Second World War had boosted the industrial and agrarian businesses across the land, rapidly increasing labor costs. As Wright had developed a building system in 1936 for the homes of moderate-income families, he now began, thirteen years later, to work out a new system, which he called the "Usonian Automatic," to circumvent the spiraling costs of construction. Turning yet again to the concrete block that had been the center of his interests in the 1920s in southern California, he simplified its application to adapt it to climates and regions throughout the United States.

Numerous ambitious, but unexecuted projects were designed these last sixteen years, also offering a wealth of architectural forms and spaces that still astound the imagination: hotels, civic centers, museums, opera houses, resorts, bridges, parking structures, apartment towers, hospitals, and universities. Yet still the greatest bulk of his work was for residences: he seemed destined, he said, to be a "residential" architect. Wright wore this as a badge of honor; it reflected his deeply felt conviction that the architect must always serve society, starting with the most essential unit: the home. Writing in 1945, when he was launched into this final era, he noted of his goals:

*Human values are all life-giving. None is life-taking. Only when Man builds all his buildings, builds his own society, builds his very Life inspired by Nature in this interior sense which we shall call Organic; meantime training his imagination to see Life as an Architect should train his imagination to see the nature of glass as Glass; see a board as Board; see a brick as Brick; see the nature of steel as Steel, and seeing the nature of Time, Place, and the Hour; meantime eager to be honest with himself and to others, deeply desiring to live harmonious with Nature, live in Nature as the trees are native to the wood or the grass to the field—only then can the individual arise as the safe Citizen in the communal life of the only safe, creative Civilization: Democracy.*[1]

MARIN COUNTY CIVIC CENTER.                    OVERLEAF: GUGGENHEIM MUSEUM, ROTUNDA INTERIOR, WITH SKYLIGHT.

141

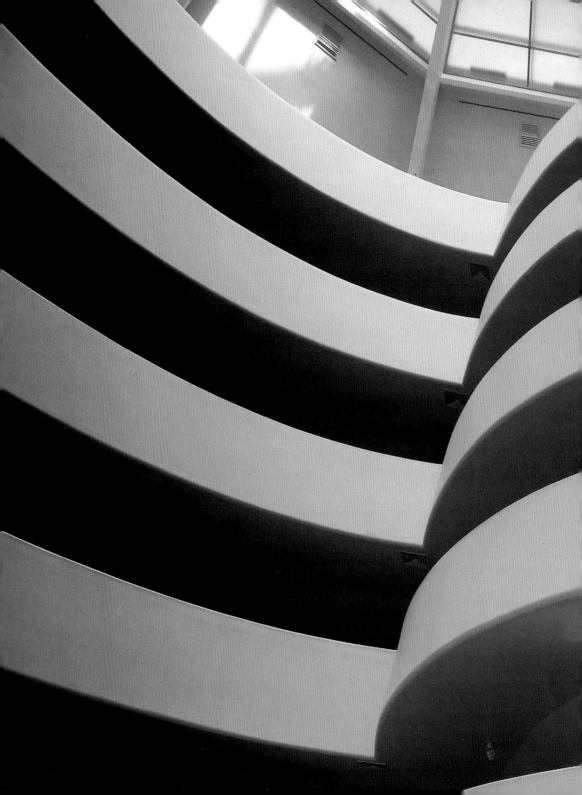

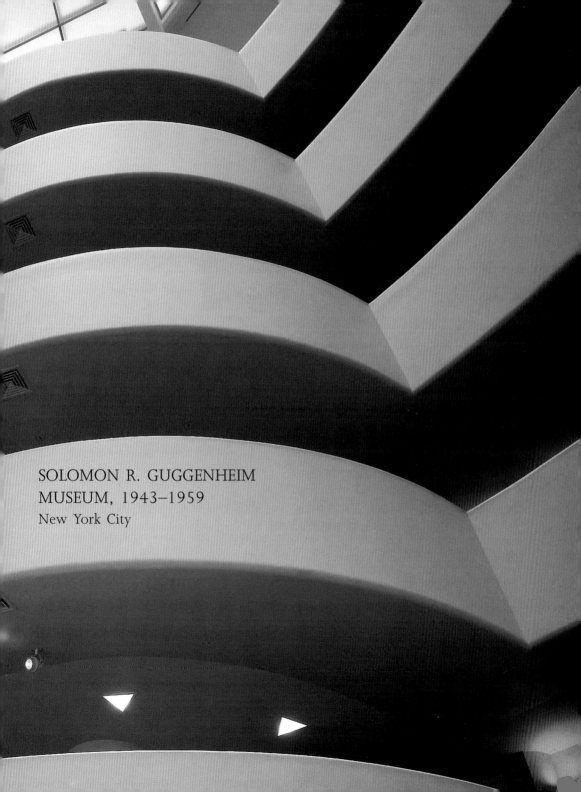

SOLOMON R. GUGGENHEIM
MUSEUM, 1943–1959
New York City

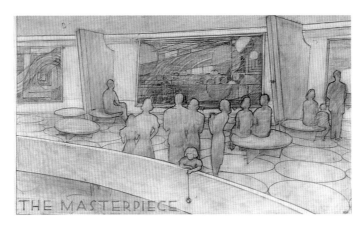

THE MASTERPIECE

PERSPECTIVE.
PENCIL AND COLOR PENCIL
ON TRACING PAPER, 30 x 40".
FLLW FDN#4305.010.

The Guggenheim Museum is Wright's most famous building. He would have denied the attribution; whenever he was asked, "What is your masterpiece, your greatest work?" he invariably replied, "My next one." But in many ways the Guggenheim Museum is the apotheosis of Wright's concepts of organic architecture, and as such history will continue to praise it. It is also a forerunner of what architecture can become in the next century through innovative use of concrete and steel. The Guggenheim Museum is a plastic structure: concrete is molded into curvilinear forms, reinforced by steel. The trabeated architecture of the past is abolished. As Wright said:

Here for the first time architecture appears plastic, one floor flowing into another (more like sculpture) instead of the usual superimposition of stratified layers cutting and butting into each other by way of post and beam construction. The whole building, cast in concrete, is more like an egg shell—in form a great simplicity—rather than like a crisscross structure. The light concrete flesh is rendered strong enough everywhere to do its work by embedded filaments of steel—either separate or in mesh. The structural calculations are thus those of the cantilever and continuity rather than the post and beam. The net result of such construction is a greater repose, the atmosphere of the quiet unbroken wave: no meeting of the eye with abrupt changes of form. All is as one and as near indestructible as it is possible for science to make a building.[1]

Here the very form, as well as the space, of the structure is so connected with the structure itself that there is no longer a distinction between them. To Wright's sense of flowing horizontal space a vertical flow has been added as well. The interior space is a multileveled presence, enveloping, enclosing, encircling, and yet liberating. Wright intended that the museumgoer would enter the building, take an elevator to the top of the great ramp, and begin a slow, comfortable descent. At any station along the ramp the visitor could see where he has been and where he is going. He could take the elevator to skip a ramp or walk back up to revisit a level, as he desires. When the tour is finished, he is once again where he began, at the door to the building. He may exit, stop in the bookstore, or visit the café. But there is no necessity to retrace his course.

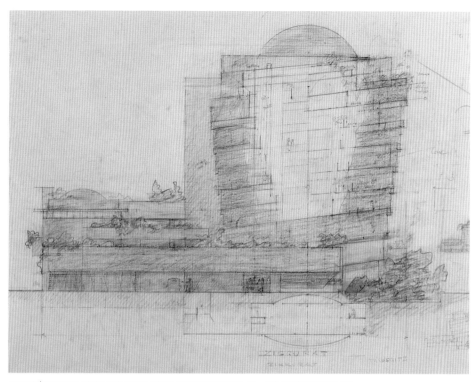

SECTION/ELEVATION. PENCIL AND COLOR PENCIL ON TRACING PAPER, 27 x 32". FLLW FDN#4305.014.

Wright made the walls of the building slope gently back, as though the paintings were on the easels on which artists created them. A continuous band of skylights, with incandescent light sources supplementing the natural light, follows this curved, sloped wall to illuminate the paintings. The variation in the quality of light was intentional: Wright maintained that no artist, working with natural light, ever saw his painting twice in exactly the same light conditions. Time of day, the passing of clouds, the particular season—from winter to summer—brought about changing conditions.

When the building first opened to the public in October 1959, Wright had been dead for six months, and during that time many unwarranted and highly destructive changes had taken place under the command of an unsympathetic director, who cared for neither the architect nor for the structure. But in 1991 and 1992 the museum was closed in order to undertake a vast restoration program that better reflects Wright's original concept.

OVERLEAF: FIFTH AVENUE ELEVATION, WITH ROTUNDA,
MONITOR (LEFT), AND ANNEX (1992; BEHIND).

145

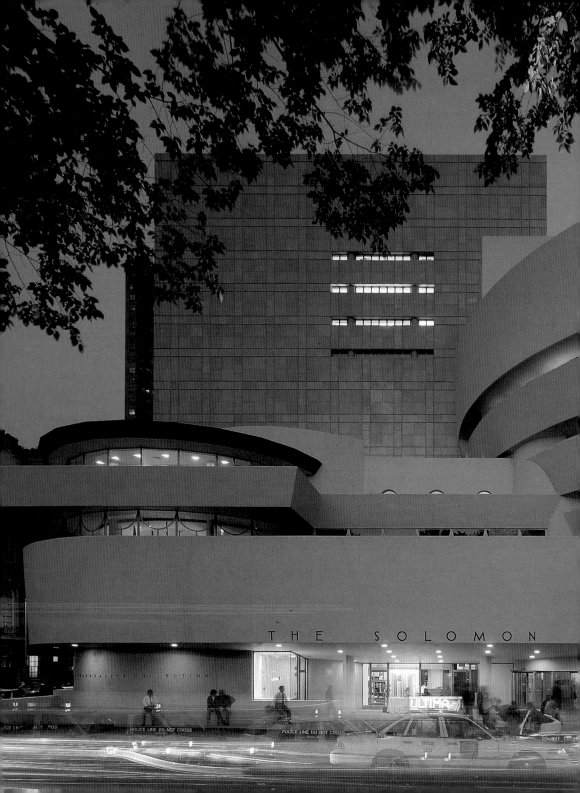

THE SOLOMON

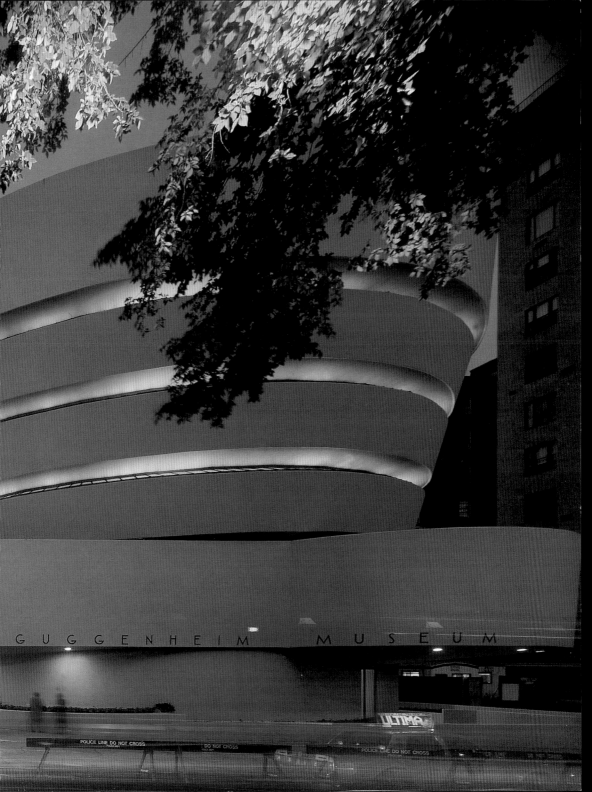

GUGGENHEIM MUSEUM

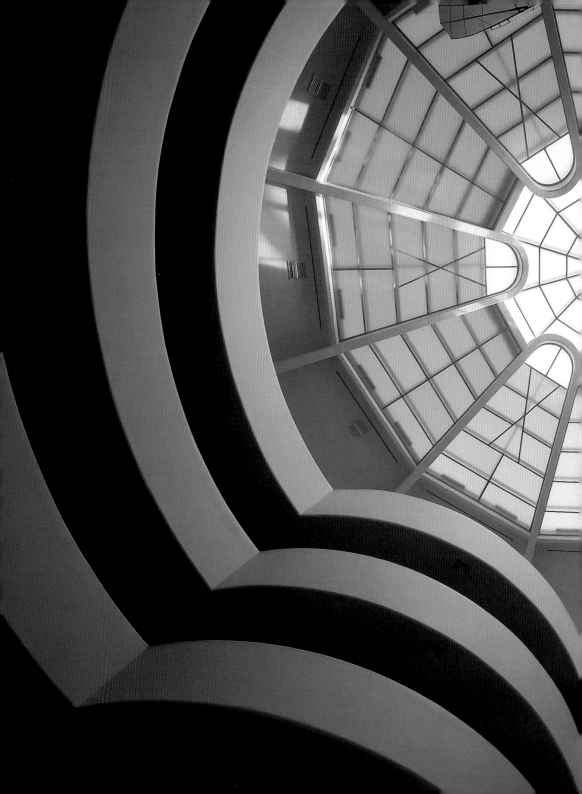

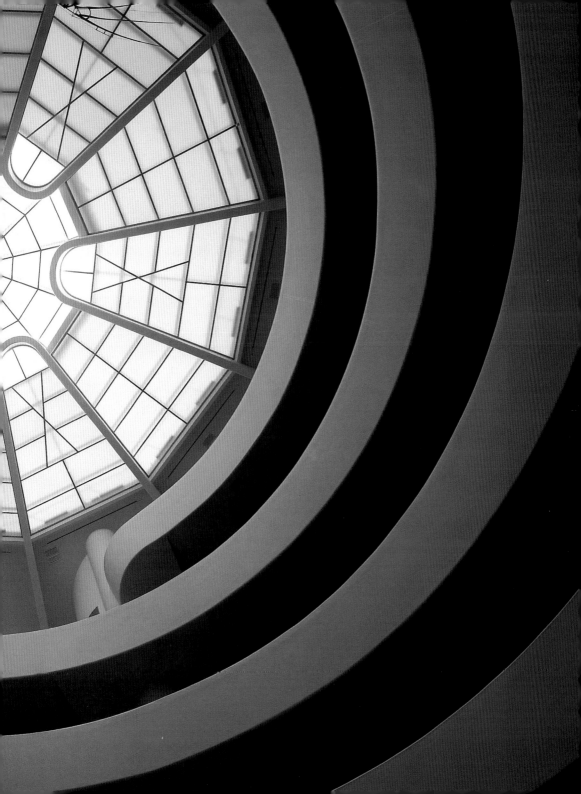

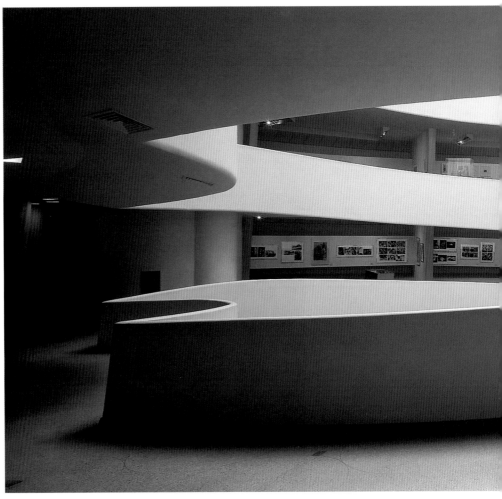

TYPICAL RAMP VIEW IN ROTUNDA.

The building brings upon itself not only praise but also controversy. Is it suitable for paintings? Is the building itself such a great work of art that everything else within it is diminished? Even before its construction was begun, those complaints and fears were heaped on Wright and prompted him to reply: "It is not to subjugate the paintings to the building that I have conceived this plan. On the contrary, it was to make the building and the painting an uninterrupted, beautiful symphony such as never existed in the World of Art before."[2]

PRECEDING PAGES: VIEW OF SKYLIGHT ABOVE ROTUNDA.

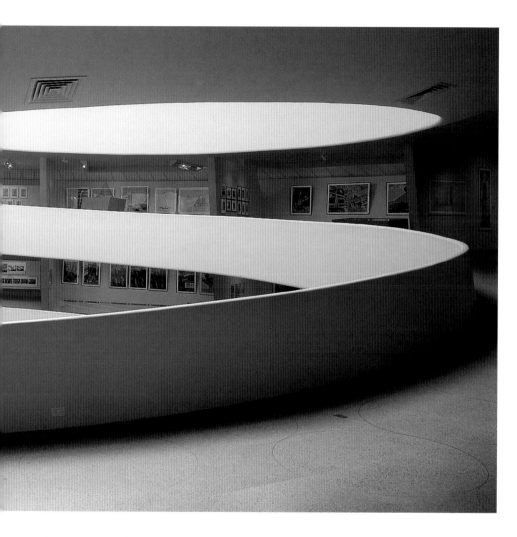

The commission for the museum building first came to Wright early in the summer of 1943 in a letter from Hilla Rebay. The Baroness von Rebay was the curator of the "non-objective" painting collection she had encouraged Solomon R. Guggenheim to purchase. Among the artists represented were Wassily Kandinsky, Pablo Picasso, Fernand Léger, Paul Klee, and Marc Chagall. Guggenheim desired an architectural environment in which to present these new works that would be as revolutionary as the painting themselves.

In 1924 Frank Lloyd Wright had designed a large spiral building for Sugarloaf Mountain, Maryland. The client was a Chicago developer named Gordon Strong, and the purpose of the building was to be a tourist objective. It combined ramps on the exterior and a planetarium inside with restaurant and other tourist facilities. The ramps permitted visitors to drive to the top of the structure, where they could turn their cars over to parking attendants, who took the cars down to a parking space via another ramp. The visitors could then descend by foot along the outside of the building, on a special ramp, and view the countryside from this promontory. Wright's use of the spiral ramp in 1924 has often been compared with his use of it some nineteen years later for Guggenheim. But the distinction between the two is obviously apparent. In the Gordon Strong building it is an exterior device only; in the Guggenheim Museum it is the rationale of the interior space.

GORDON STRONG PLANETARIUM. VIEW
AND SECTION. PENCIL ON TRACING PAPER,
15 x 21". FLLW FDN#2505.018.

Although the property for the museum was not acquired until nine months after Wright was first approached with the commission, the architect had a hunch that the site would be a city lot in Manhattan. He realized that the design for a new building would have to proceed along vertical lines rather than horizontal. He telegrammed Rebay:

"BELIEVE THAT BY CHANGING OUR IDEA OF A BUILDING FROM HORIZONTAL TO PERPENDICULAR WE CAN GO WHERE WE PLEASE. WOULD LIKE TO PRESENT THE IMPLICATIONS OF THIS CHANGE TO MR. GUGGENHEIM FOR SANCTION. IF HE WILL AUTHORIZE TRIP TO NEW YORK WILL COME IMMEDIATELY."[3]

Wright had already settled on the idea of a continuous ramp, but so as not to alarm either Rebay or Guggenheim, he merely hinted at his solution in a letter to her on January 20, 1944:

I've been busy at the boards—putting down some of the thoughts concerning a museum that were in my mind while looking for a site. . . . A museum should be one extended well-proportioned floor space from bottom to top—a wheelchair going around and up and down, throughout. No stops anywhere and such screened divisions of the space gloriously lit within from above as would deal appropriately with every group of paintings or individual paintings as you might want them classified. . . . When I've satisfied myself with the preliminary exploration I'll bring it down to New York before going West and we can have anguish and fun over it. The whole thing will either throw you off your guard entirely or be just about what you have been dreaming about.[4]

Accordingly he made several preliminary drawings and presented them to Guggenheim and Rebay. They both were enormously pleased with Wright's solution. "I knew you could do it," Guggenheim said, "but I had no idea you could do it this well!"

Although Rebay herself selected Wright as the architect for Guggenheim's new museum, she continually expressed doubts about the building. Her letters were often acrimonious

and insulting. But Wright dealt with her patiently over the years, from 1943 to 1952, when she retired from the museum. Typical of his way to try and mediate with Rebay is this letter of September 12, 1947:

*My dear Hilla:*

*If you go contrary to the agreement made with me in the presence of S.R.G. you are making the mistake of your managerial career. The course you are pursuing means there will more than likely never be a new museum. You will makeshift as before, the rest of your natural life. Because of your insults to me over the telephone this afternoon I do not think you realize the nature of your obligation to me or mine to you. How foolish to let your jealousy rule your ambitions and alienate your truest friends! Your actions are now those of a house divided against itself. That house cannot stand. Deliberately you invite defeat of your holiest feelings and best wishes. Why? If you persist in what you now propose I am definitely out of the Guggenheim employ as a matter of course: a rather disastrous ending of bright hopes?*

*Sincerely,*

*Frank Lloyd Wright*

Guggenheim was always supportive of Wright, but his death in 1949, six years after the project was begun, dealt a severe blow to the plans. The trustees were mostly at odds with the idea of the building, and the new directorship that replaced Rebay was downright opposed to it. It took thirteen years of patient struggle on the part of Wright to finally see his building start in construction, and even through the construction stages—from 1956 to his death in 1959, six months before the museum opened—the struggle waged on.

The building that stands in New York today is very different from those early studies of 1944. The general concept of the building—one continuous ramp—remains, but with the acquisition of more parcels of property on the site and with the change of the program of the museum itself, different architectural solutions were required along the way. Seven complete sets of workings drawings were prepared until finally, on August 16, 1956, ground was broken and construction begun. During the sixteen years that this commission dragged on, it was to prove to be the most difficult and the most time-consuming of all Wright's work. Not even the years in Japan, traveling frequently across the Pacific from 1916 to 1922 to oversee the Imperial Hotel construction, could compare to the struggle and effort it took on the part of Wright to get his building built the way he intended. Guggenheim did not live to see the building he loved started in construction; Wright did not live to see it completed.

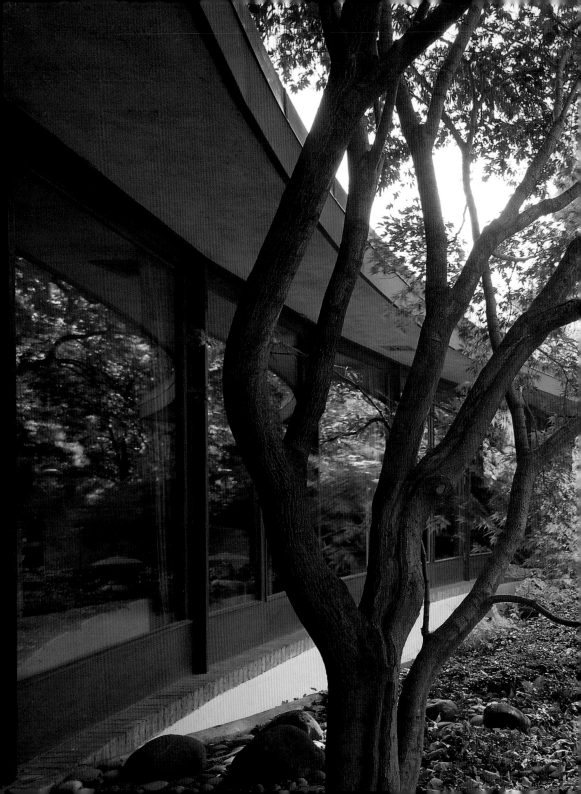

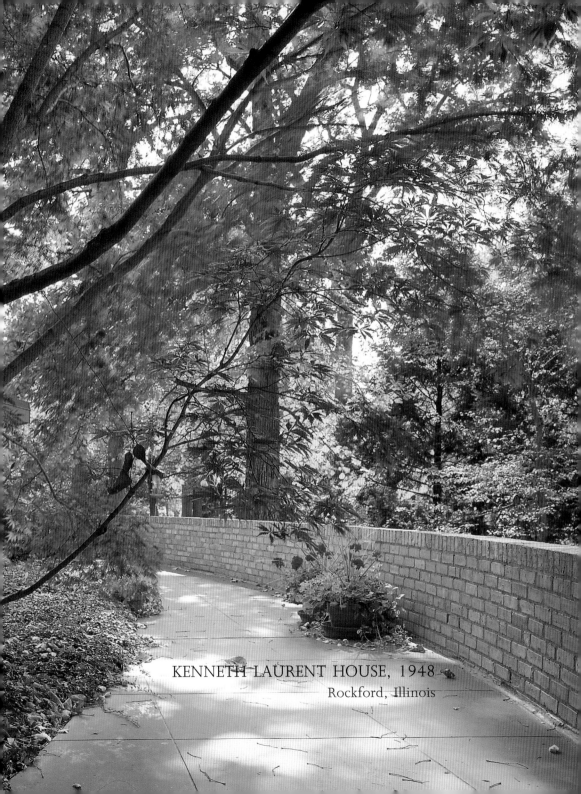

KENNETH LAURENT HOUSE, 1948
Rockford, Illinois

PLAN. PENCIL AND COLOR PENCIL ON TRACING PAPER, 25 x 36". FLLW FDN#4814.001.

On August 23, 1948, Kenneth Laurent wrote to Frank Lloyd Wright asking him to design a house for himself and his wife. The letter contained a list of his requirements, his proposed budget, and a description of a corner lot at the edge of the city. His foremost need, he explained as follows: "To give you an idea of my situation, I must first tell you that I am a paraplegic. In other words due to a spinal-cord injury I am paralyzed from the waist down and by virtue of my condition I am confined to a wheelchair. This explains my need for a home as practical and sensible as your style of architecture denotes." Laurent had been reading Wright's autobiography and studying the plans of some of his houses. Given his confinement to a wheelchair, he rightly concluded that the open plan, flowing space, and minimum number of interior partitions would be the perfect solution for his home.

As for the corner lot at the edge of the city, which measured 100 feet by 145 feet, Wright urged him to give it up and to build instead in the country, where there was more acreage with trees and meadows. "It was just about the best advice he ever gave me," Laurent later recollected.

The plan of the house was the first in a series of "football" designs Wright executed: two gentle curves meeting at the ends. One curve, or arc, forms an outdoor terrace, the other forms a long gallery, or loggia, that connects the living room, at one end of the house, to the master bedroom, at the other. In between these two arcs is a garden and small decorative pool, both positioned on the circumference of the plan. But combined with these curved portions of the plan are dominant square elements: a cove for the living room, with fireplace, seating, and a space for the dining room, and the master bedroom with its own fireplace. The doorways throughout the house are generously wide. In some of the

156

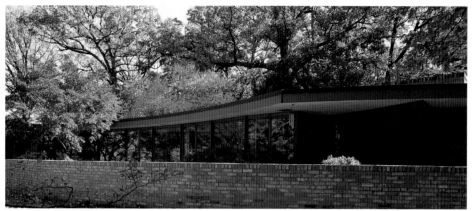

LIVING-ROOM WING FROM STREET.

subsequent applications of this type plan, Wright used circles and semicircles for the other elements, contrasting with the overall "football plan." But here is an example of his mastery in combining geometric shapes that would seem, at first glance, to be in conflict but actually can reinforce and augment each other.

The material specified for the masonry was originally limestone, cut in the manner of Wright's own home, Taliesin, with some stones allowed to jut out from the wall, forming a sculptural surface, which, according to the architect, abstracted the manner in which the stone was found in stratified layers in the quarries. Frequently, however, one masonry material was substituted for another during the construction: in this case, common brick in place of limestone. This was due both to cost and to the relative availability of the materials. But the combination of the rather crude brick and the finely crafted woodwork works well in the overall scheme of the house. Its simplicity, its rather small size—as originally planned—and its employment of the "football" plan work together to render this among Wright's finest residential designs.

The house has been beautifully maintained over the years, with further additions designed by Wright to accommodate the Laurents' expanding needs and desires. Most of the furniture was built to Wright's designs, and the atmosphere inside is tranquil, due mainly to the generous proportions and the lack of cluttering furnishings. Low and subdued, the house appears to weave itself among the great trees around it. The Laurents carefully landscaped their house: not by overlandscaping, but by letting the walls of the building rise naturally out of the ground, with an occasional flowering tree inside the terrace wall or adjacent to it. This quiet respect lets the building speak for itself, and the result is an idyllic harmony between house and land.

OVERLEAF: LIVING-ROOM WING.

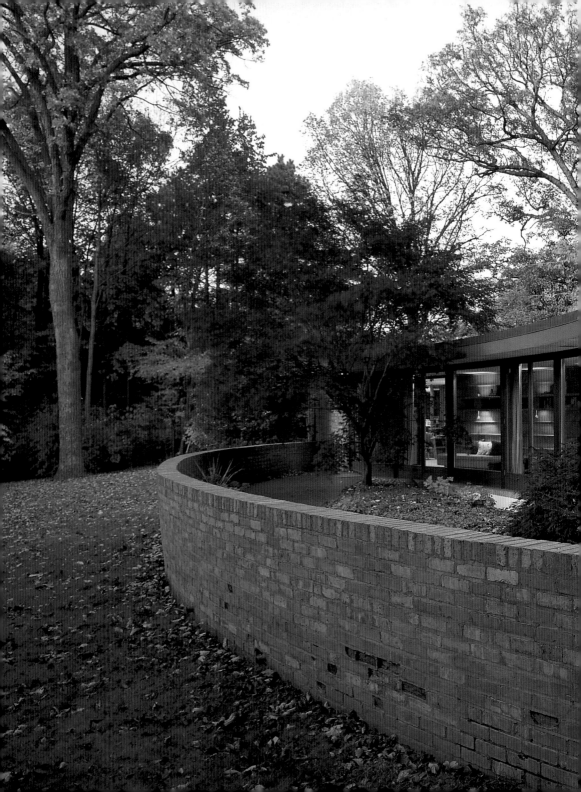

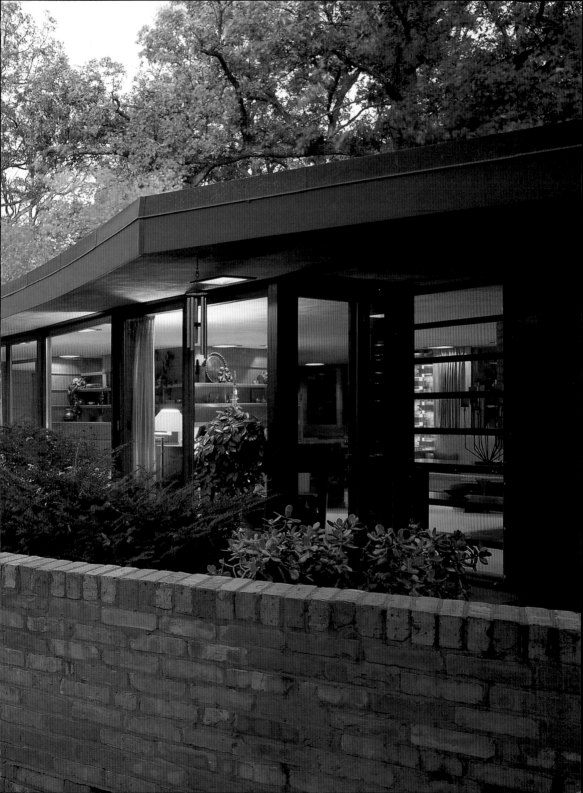

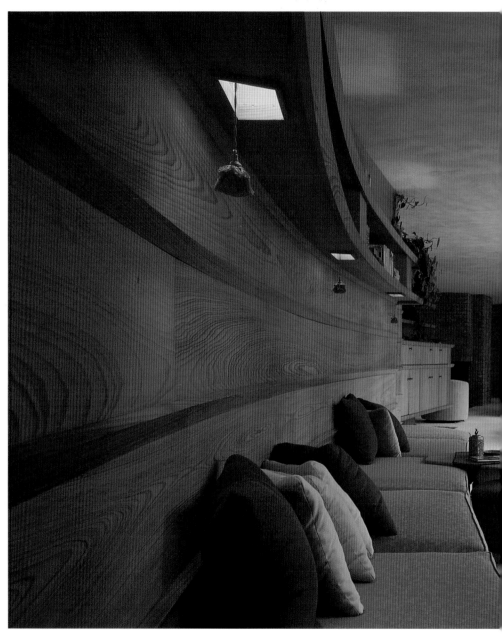

VIEW OF TERRACE FROM LIVING ROOM.

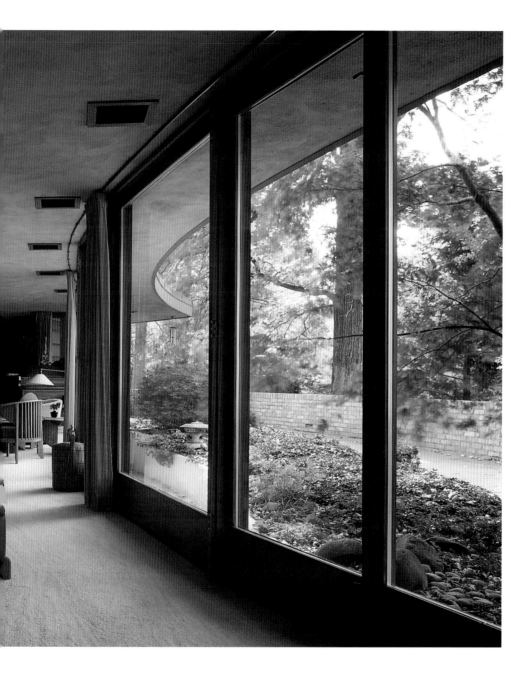

# UNITARIAN CHURCH, 1947   Shorewood Hills, Wisconsin

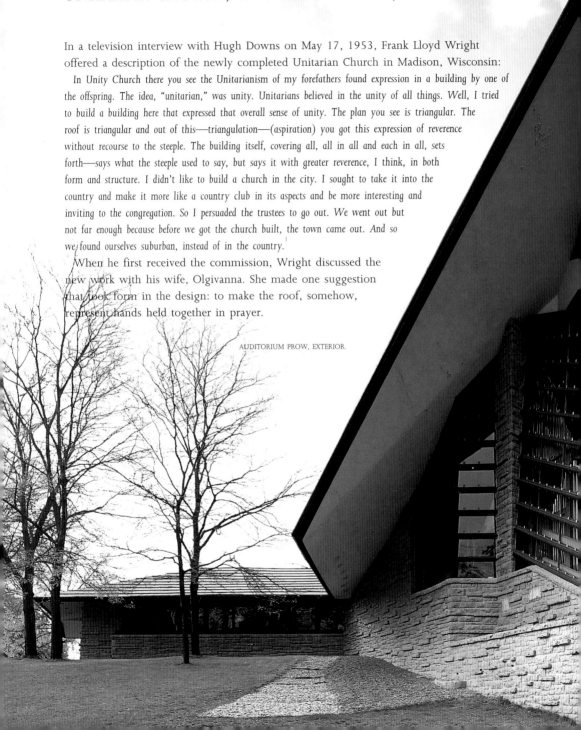

In a television interview with Hugh Downs on May 17, 1953, Frank Lloyd Wright
offered a description of the newly completed Unitarian Church in Madison, Wisconsin:

*In Unity Church there you see the Unitarianism of my forefathers found expression in a building by one of
the offspring. The idea, "unitarian," was unity. Unitarians believed in the unity of all things. Well, I tried
to build a building here that expressed that overall sense of unity. The plan you see is triangular. The
roof is triangular and out of this—triangulation—(aspiration) you got this expression of reverence
without recourse to the steeple. The building itself, covering all, all in all and each in all, sets
forth—says what the steeple used to say, but says it with greater reverence, I think, in both
form and structure. I didn't like to build a church in the city. I sought to take it into the
country and make it more like a country club in its aspects and be more interesting and
inviting to the congregation. So I persuaded the trustees to go out. We went out but
not far enough because before we got the church built, the town came out. And so
we found ourselves suburban, instead of in the country.*

When he first received the commission, Wright discussed the
new work with his wife, Olgivanna. She made one suggestion
that took form in the design: to make the roof, somehow,
represent hands held together in prayer.

AUDITORIUM PROW, EXTERIOR.

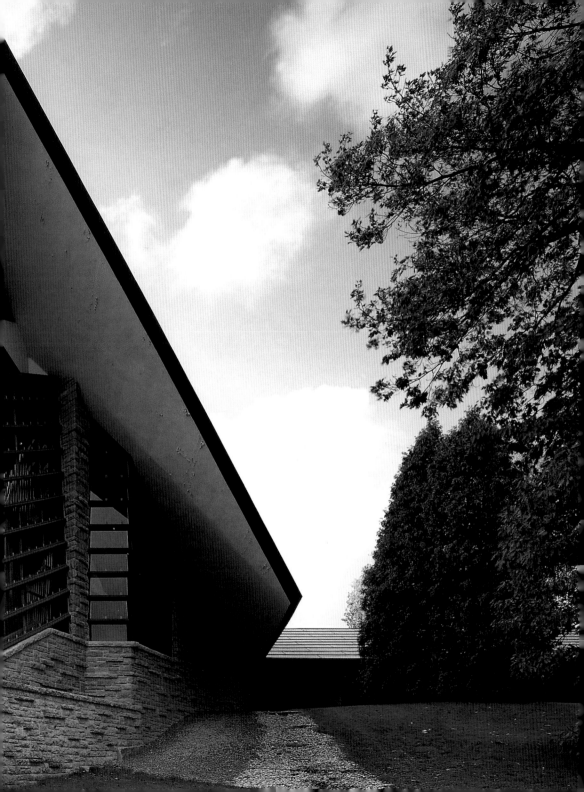

The building committee wanted a church—called a meeting house—that would have a flexible plan so that the hall, or auditorium, could be used for functions other than religious services, including conferences, concerts, or secular meetings. In his design for Unity Temple in Oak Park, Illinois (1905), Wright was faced with the problem of protecting the congregation from the noise and din of the traffic outside, whereas in Madison the property the church purchased was on a gradual slope of fields and oak trees and looked out to Lake Mendota in the distance. Wright situated the building at the top of the rise, with the great prow facing the view of the lake.

The entrance from the parking lot is via an open porch, roofed with a great sheltering cantilever. From this porch there is a view down the slope, past the oak trees, and off to the lake. Inside the low wing, which holds offices and church publications as well as acting as a general reception area, the windows along one wall continue the vista first seen at the porch. But in the main auditorium, the space dramatically expands as the ceiling rapidly rises from a large limestone fireplace to the vast triangular window wall of the prow.

The pastor's pulpit is raised on a stone dais in this prow, with a balcony for the chorus directly above. A tympanum of wood and plaster reaches out over the chorus so as to direct the sound of the music toward the congregation rather than up into the higher regions of the prow. Originally Wright planned for this window area to be made of perforated blocks with stained glass. But this solution proved too costly, and Wright supplanted it with the design of sloped windowsills and clear glass. Considering the beauty of the landscape outside, the alternative proved to be the better solution. The building is of native limestone, of the same type and method of construction as Taliesin. Over these solid masses of yellow stonework floats the copper roof, sheltering and protecting, as it rises toward the prow and the great expanse of glass. The rough stone contrasts well with the smooth plaster surface of the ceiling, and the recessed lighting of the ceiling gives a star-like quality to the high space. At the other end of the auditorium, the low ceiling and large limestone fireplace give a more home-like, intimate feeling to the room. A dividing curtain permits the entire space—both the low area with full-length glass windows looking onto a garden and the larger auditorium—to be used as one room or to be partitioned as desired. The Sunday school wing, off the main auditorium in the opposite direction from the entry, is—like the entry—covered by a comparatively low roof in contrast to the triangular, soaring roof over the auditorium.

Building a public building can be very complicated because the client usually turns out to be a "building committee." Wright, in particular, had little faith in committees because they invariably chose the "middle road." In this commission Wright not only was faced with decisions being made by the proverbial committee, but also the cost of the building

ran well over the estimate and the contractor was young and relatively inexperienced. As the church was nearing completion, funds ran out, and it seemed as though the building would languish unfinished. Wright recruited his own apprentices to come each morning into Madison from Taliesin, some thirty-six miles away, during the summer of 1951. They worked until late in the evening, plastering, painting, completing the furniture, and putting the finishing touches on the interiors, with Wright on site each day to supervise the work. The church was eventually opened with a lecture by Wright and a concert by members of the Taliesin Fellowship.

Several times thereafter Wright was called to the Unitarian Church, as it was named, to address the congregation. He brought with him the Taliesin chorus and ensemble to complete the "sermon" with music. In one talk he gave there he described the Unitarian faith and the building he designed for it:

*A love of the beautiful is the divine spark in the soul of man never to be extinguished. And in this little building, this little meeting house, it's a small affair, but it is significant of the faith it represents. This is some-thing quite natural. And when we say that, we speak of working and talking and thinking according to principle; according to nature is according to principle always. According to principle is according to nature. So in designing this little building for you, we have given you what? A tangible expression of what the Unitarian faith meant to me as a boy, what it meant to Thomas Jefferson, what it must mean to all of you who are here today. And that is the unity of all things. In the unity of all things comes the inspiration for the thing we call the Declaration of Independence, our faith—it is the very soul of a democracy and it is the centerline of everything we have. . . . Here the feeling for reverence will never die, and the feeling for reverence is something elemental to beauty and to religion, to the feeling of the human mind as it grows here on the earth, increases, I think, I hope, advances. So here you will see an expression that is best shown to you perhaps by the hands folded this way and the expression and feeling of prayer subjective—not objective prayer. If you look at this building from the outside, you will see them. And those expressions are in themselves features of architecture.*[2]

None of the usual features associated with church design is incorporated into the Unitarian Church: no steeple, no facade, no harking back to other eras and other forms. It is truly an American original, and perhaps its most apparent quality is its unpretentious simplicity.

OVERLEAF: AUDITORIUM SIDE VIEW.

PAGES 168-169: AUDITORIUM INTERIOR, VIEW TOWARD PULPIT. CHOIR BALCONY ABOVE.

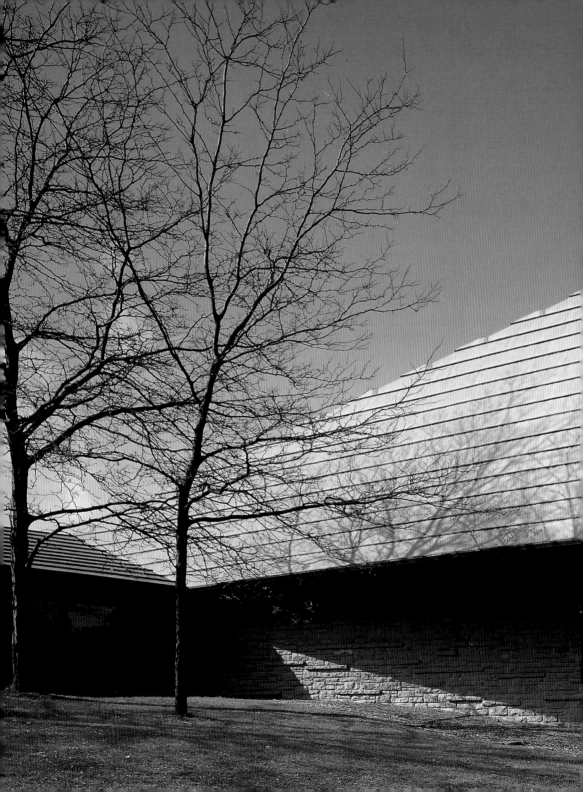

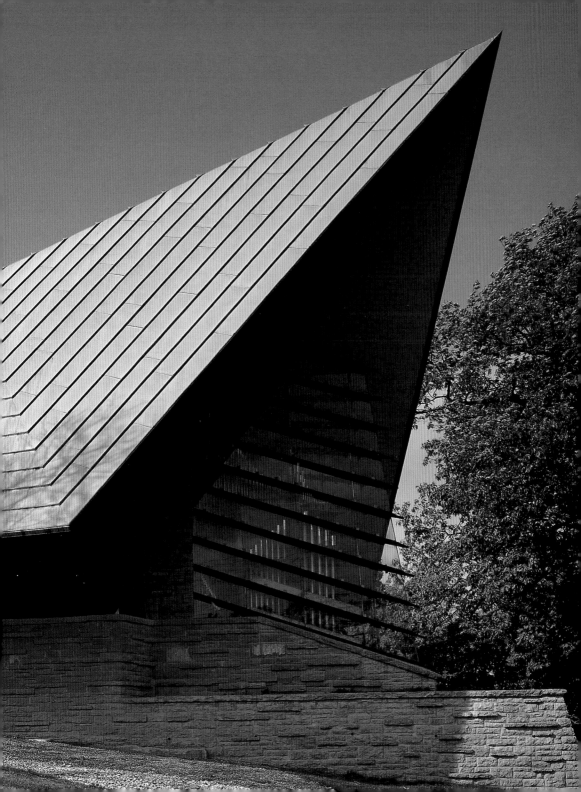

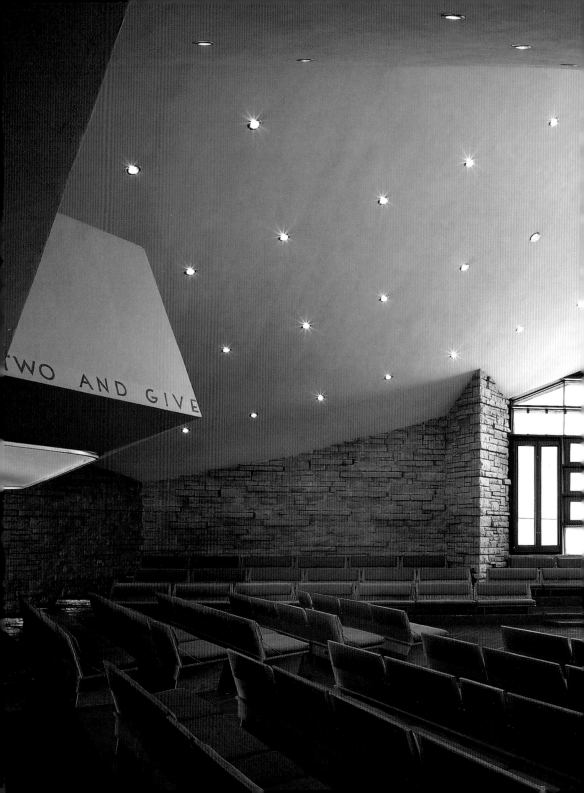

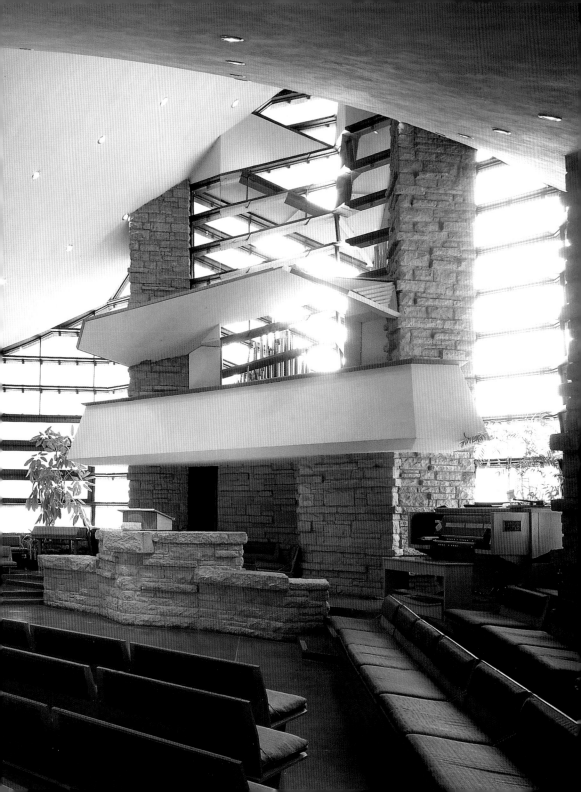

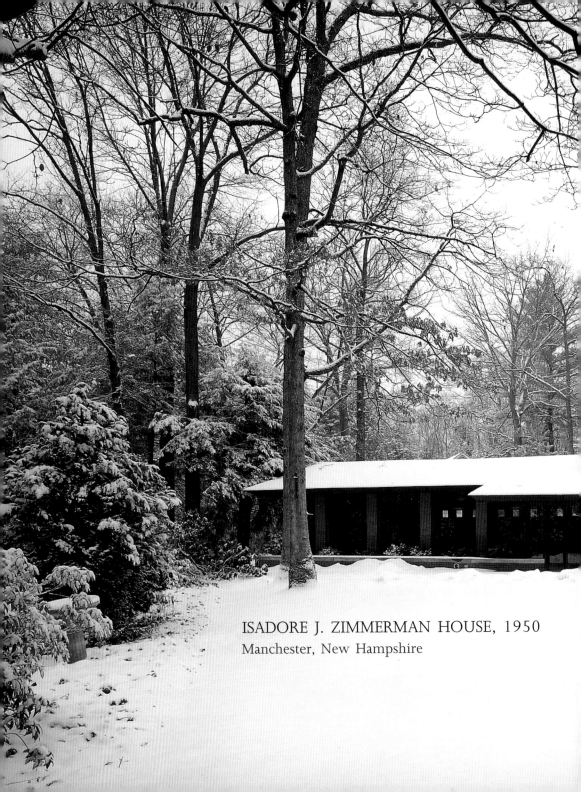

ISADORE J. ZIMMERMAN HOUSE, 1950
Manchester, New Hampshire

STREET VIEW.

Recently a substantial number of Frank Lloyd Wright residences have undergone extensive conservation and restoration: the Home and Studio in Oak Park, the Dana house in Springfield, Illinois, the Meyer May house in Grand Rapids, Michigan, the Barnsdall and Storer houses in Los Angeles, the Jacobs house in Madison, Wisconsin, the Auldbrass Plantation in Yemassee, South Carolina, and, most recently, the Isadore Zimmerman house in Manchester, New Hampshire.

Many others are in need of such care and consideration, and even more have seen, as the years go by, original Frank Lloyd Wright furnishings removed and replaced by other, less appropriate objects. Landscaping was also an essential aspect of each house's original design, carefully planned by Wright and usually executed by the client at the time the building was first built. As the original interiors have been, often harmfully, modified, so too much of the landscaping has been altered to the detriment of the original concept.

172

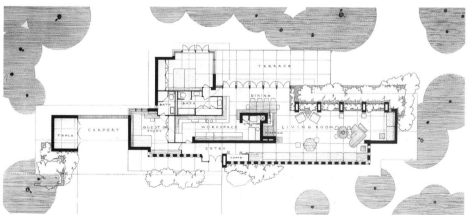

PUBLICATION PLAN. INK ON TRACING PAPER, 25 x 36". FLLW FDN#5214.001.

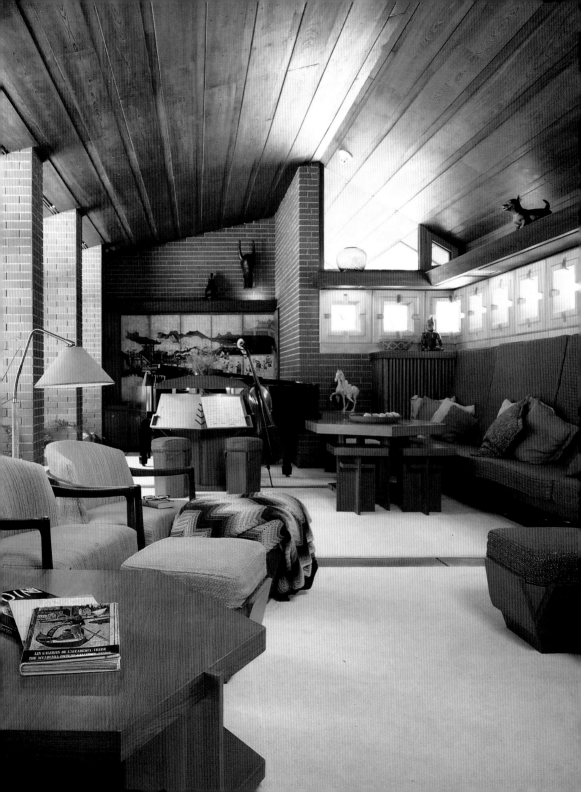

Lucille and Isadore Zimmerman came to Wright in 1950 having read his writings and seen his residential work in various publications. Located in New England, far from Wright's studios in Wisconsin and Arizona, the design and construction of the house were supervised by Taliesin fellows.

The Zimmermans realized from the beginning that a Wright house was something out of the ordinary. As they had no children, they were determined that it not pass into unsympathetic ownership. To secure both its protection and its accessibility to the public, they elected to donate it to the local art museum, The Currier Art Gallery. While they were alive, they generously shared their home with anyone interested in seeing it. Mrs. Zimmerman once remarked, "We never refused to show anyone our house; we often served lunch or dinner to the occasional Frank Lloyd Wright fans who came by, and in some instances we invited them to spend the night in our guest room."

SQUARE WINDOW BAY.

The house is basically a Usonian design, but the materials and execution are more elaborate than most of the early Usonian houses of the late 1930s and 1940s. It is not a large dwelling, but typically has delightfully unusual and unexpected elements. In this case, one feature in particular deserves mention: the four square window bays in the living room. Instead of setting plate glass between brick piers, Wright fashioned a "suspended" window frame, hung in the center of the bay with the wood members surrounded by glass that is fixed— these do not open, while the center pane does. The lower pane of fixed glass gives onto a long, low planting box; the upper pane fits directly into the cypress ceiling boards without any further millwork construction, creating an unbroken ceiling line from inside to out. The side panes of glass are set into the wood on one side and directly into the brick piers on the other sides. This further diminishes the barrier between interior and exterior. This treatment of the three square windows allows us to envision them as "paintings" hung in space, framing the wooded landscape outside.

LIVING ROOM, WITH WRIGHT-DESIGNED MUSIC STAND.

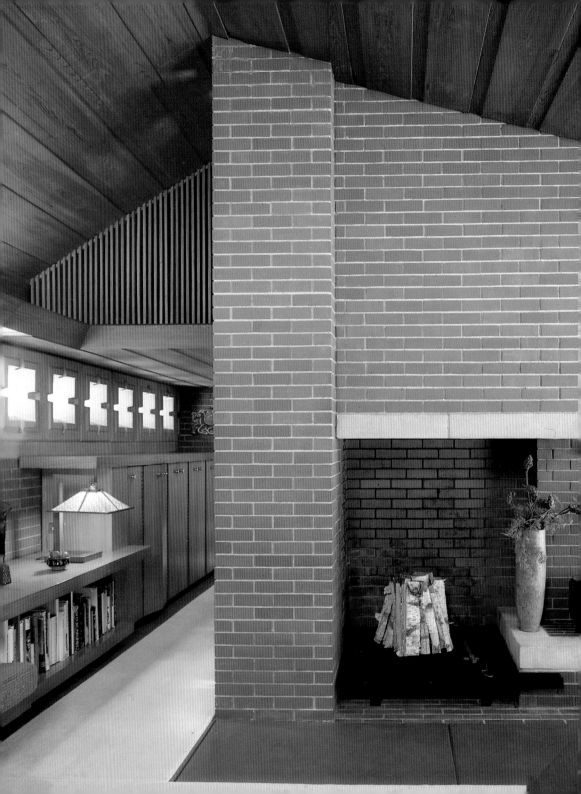

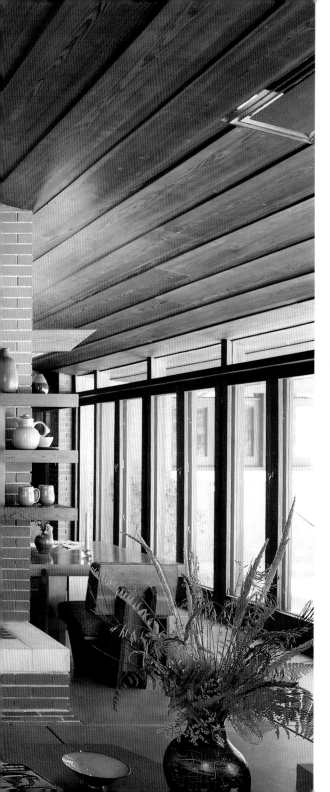

The window bays demonstrate once again Wright's versatility in designing fenestration. Usually he also employed French doors. And in the Zimmerman house there are five pairs of French doors that border the end of the living room next to the dining area and give onto a large concrete terrace outside. But in the music section of the living room, an area more private and somewhat secluded, the wide, square window bays act as a lens focusing on the scene outside. Rather than simply inserting plate glass into the bays, this combination of wood mullions and fixed glass also provides for out-swinging windows.

LIVING-ROOM FIREPLACE.

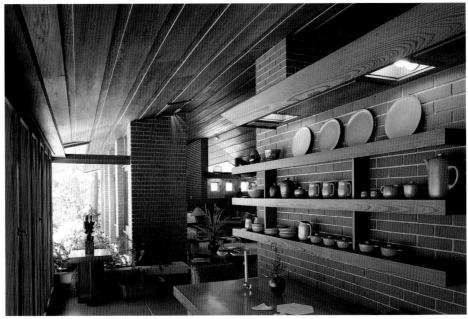

DINING ROOM.

By the time that the Currier Art Gallery received the house, restoration work was required—a painstaking process helped by the extensive documentation also left in trust with the house. The most critical aspect of the restoration was the reinstallation of the gravity heating system. All the interior furnishings had to be removed, the floor broken up, old steel pipes replaced with new flexible plastic tubing, and a new floor poured.

The term "gravity heat" Wright coined himself. Beneath the concrete slab are coils of pipe that circulate warm water, thus heating the slab. As heat rises, it pushes the cold air near the ceiling back down the slab to be heated. It should not be confused with the term "radiant heat," which is best represented by the old-fashioned radiators in homes across the nation. In that system the heat radiates into the room. Gravity heat, which Wright first discovered during his sojourn in Japan, creates no drafts, but what he called a "climate." The first large building he employed it in was the S. C. Johnson & Son Administration Building (1936); the first residence was the Herbert Jacobs house (1936). He used it extensively, except in climates such as those of Arizona or southern California, where air-conditioning was essential and heat only a minimal consideration. But in colder climates it was ideal: the floor is warm and the air above not too hot. Unfortunately sometimes certain soil conditions interact with the metal of the heating coils and begin to erode them.

178

This was the case with the Zimmerman house and the reason for the extensive repairs required.

The house is now restored to its former elegance, and the interiors glow with indirect lighting. The quartet music stand in the living room was originally requested by the Zimmermans because of their love for chamber music. Wright patterned the design after one he had made in his own home, Taliesin. A lover of chamber music, he disliked the familiar rickety wire music stands with improvised lighting arrangements. This stand was his solution. A broad "roof" contains the lights for the music, and there is a recessed area for flowers or plants, lit from below from the same source that lights the music. To Wright's way of thinking, it made music as beautiful to look at as it was to listen to.

When the house was finished in June 1952, the Zimmermans wrote to their architect:

Dear Mr. Wright:

We are now living in the new house, an experience we would not miss for all the monetary riches in the world. The beauty of the house defies verbal description, while utility is so married to beauty that the two become one. Even our New England neighbors love it. (And now you have the answer to the question you asked us on our first approaching you, "What will your neighbors think?") We are certain that you too, when you see the house, will judge it among your most beautiful creations. And now a word about him without whose help your beautiful plans could not have been brought to perfect fruition. John Geiger[1] did a superb job in carrying out your intentions. . . . Every day we see things about the house that would not be here for us to enjoy but for John. Knowing John, we can well understand your pride in your Fellowship. With the meaning of superlatives weakened by present-day usage it would be difficult to express our gratitude to you. However, none can understand better than you what this house means to us and the simple "thanks" must suffice as the symbol of something felt more deeply than words can express.

> Gratefully yours,
> Isadore Zimmerman/Lucille Zimmerman[2]

Twice each year, on Wright's birthday—June 8—and at Christmas, the Zimmermans sent their architect Vermont maple syrup. This continued from the time they first met him until his death in 1959. And on one occasion he thanked them thus:

Dear Zimmermans:

The maple syrup was—as always—the sweetest addition to the birthday and a pleasant reminder of the Zimmermans. Thank you.

> Faithfully,
> Frank Lloyd Wright
> June 16, 1953

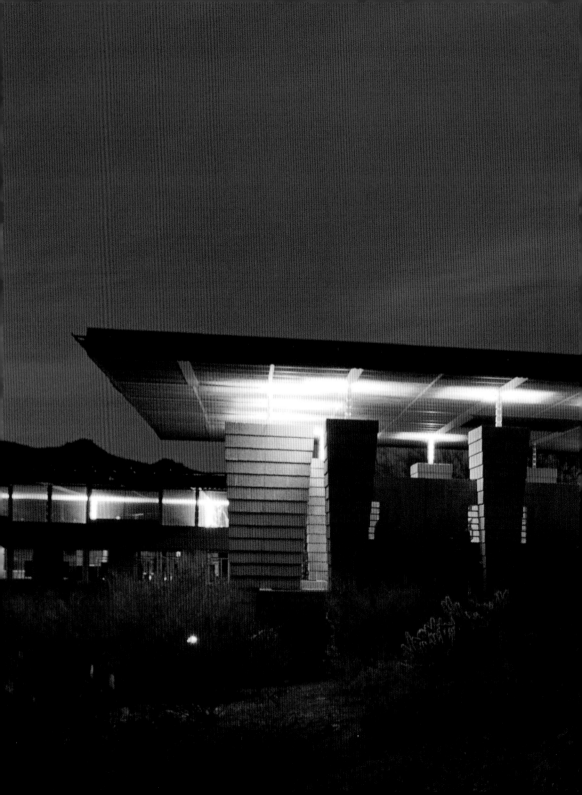

HAROLD PRICE, SR., HOUSE, 1954  Paradise Valley, Arizona

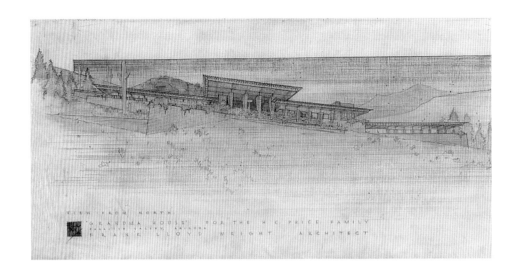

PERSPECTIVE. PENCIL AND COLOR PENCIL ON TRACING PAPER, 20 x 51". FLLW FDN#5419.001.

While Wright was working on the design of the Price Tower (Bartlesville, OK, 1952), the Prices made several winter trips to Scottsdale, Arizona, to confer with their architect. They fell in love with the desert and began spending more of their winters there. They had five young grandchildren who came to Phoenix during Christmas and spring vacations from school. When the Prices finally decided to build a home of their own in Arizona they approached Wright for a design. Marylou Price explicitly asked for "a large enough house so that all the grandchildren can come and stay with me, where they can play in the sun, yet be protected from the desert." On the preliminary drawings for the house, Wright called the plan "Grandma House," in deference to Mrs. Price's wishes.

The house demonstrates quite magnificently what can be done with standard, rather inexpensive materials. The gray concrete block is treated in Wright's characteristic fashion: stepping out each course, one above the next, or stepping in, producing a sculptural quality to walls that would otherwise be rather bland and ordinary. As the columns of concrete block rise up to engage the ceiling, they surprisingly stop short and a thin pipe column rises out of them. The roof seems to hover over the structure, barely supported, like a bird in flight suddenly frozen in space. To further dramatize this effect, lights set inside the block piers shine onto the ceiling, highlighting the floating roof and giving the room another source of indirect lighting.

182

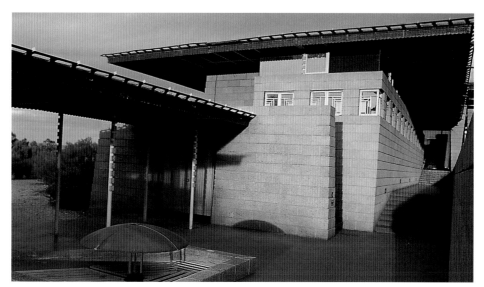

WALKWAY AND STEPS TO HOUSE ENTRANCE.

The covered atrium, protected from the elements, is ideal for social events as well as for children's play. There is a fountain pool in the center and a generous fireplace off to one side. At the end of the bedroom wing, a special play yard for the children was walled in to keep out desert creatures. Along the western exposure of the house is a grass expanse and swimming pool. When the children were grown up and no longer needed the enclosed play yard, Wright converted the space into a more luxurious master-bedroom suite for the Prices.

The plan places the large, open atrium at the center of the scheme. This is also the entrance to the house, via a long flank of steps and walkway from the car court. Stretching out in one direction is the bedroom wing, with four bedrooms and master bedroom. In the other direction are the living–dining room and workspace. A detached wing beyond contains servants' bedrooms and carport.

The simplicity of the house, both in plan and elevation, is immediately evident in the combination of concrete block walls and piers, the flat roof with copper facia bearing a stamped-metal design, and the turquoise-painted metal pipe columns. The house's two predominant colors are gray and turquoise, offering a pleasing contrast to the desert landscape. The house nestles on one side into a rising hill; on the other, the ground slopes away to a spectacular view of distant mountains.

OVERLEAF: LIVING ROOM.

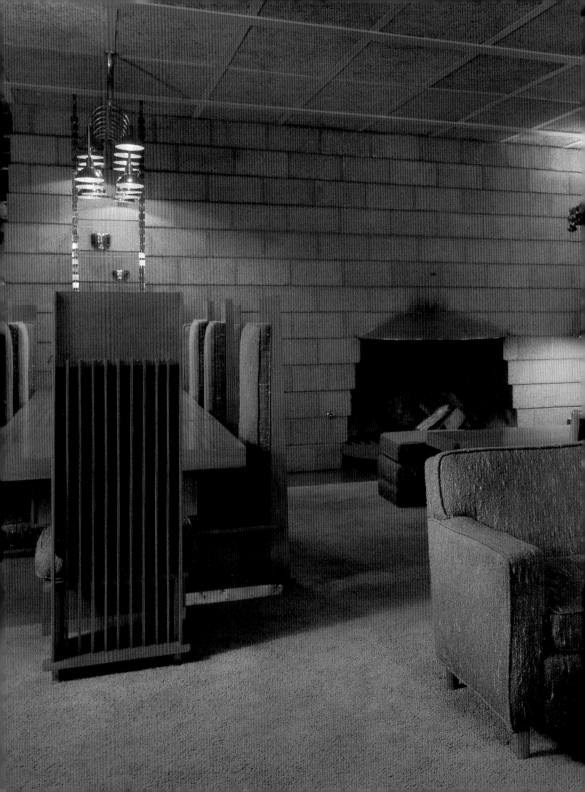

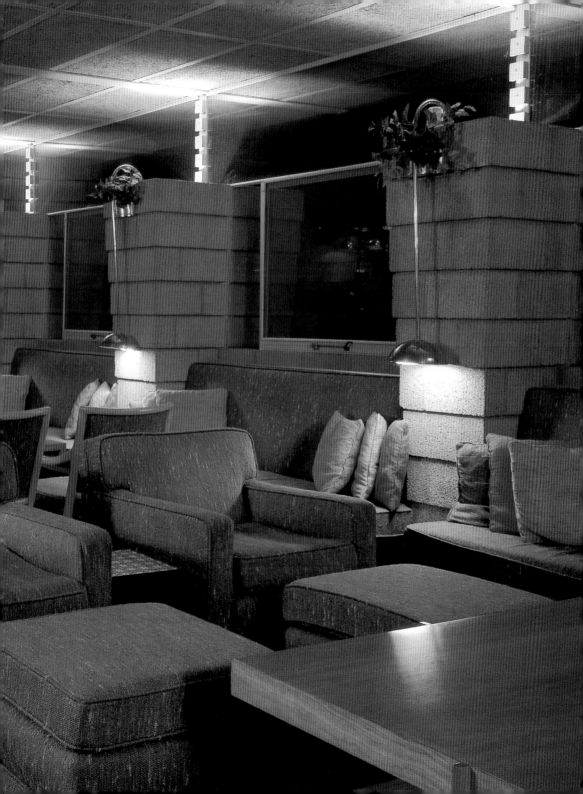

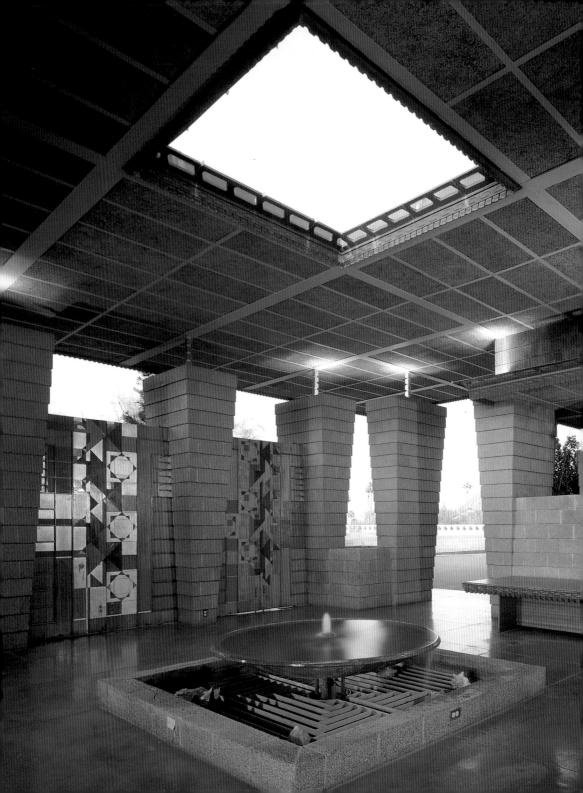

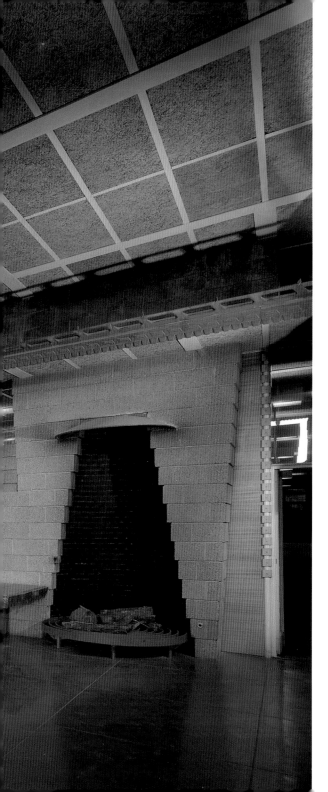

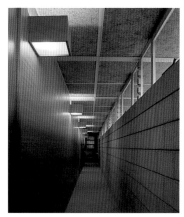

HALLWAY, BEDROOM WING.

In this last decade of his life, Wright's work, both residential and commercial, took on even greater simplicity, particularly as finely skilled labor and master craftsmen became scarcer and too costly for his clients. Gone is the era of stained-glass windows, of carved ornament, of custom carpets and fabrics. In one or two instances Wright designed custom carpets, but these are rare exceptions. Yet the "Grandma House" shows how standardization and simplification, when combined with imagination and good design, can produce beautiful architecture befitting the time and the place in which it is built—and giving richer opportunities and expression to those living within.

ATRIUM, WITH FIREPLACE, FOUNTAIN,
AND DOOR MURALS
(BY EUGENE MASSELINK).

187

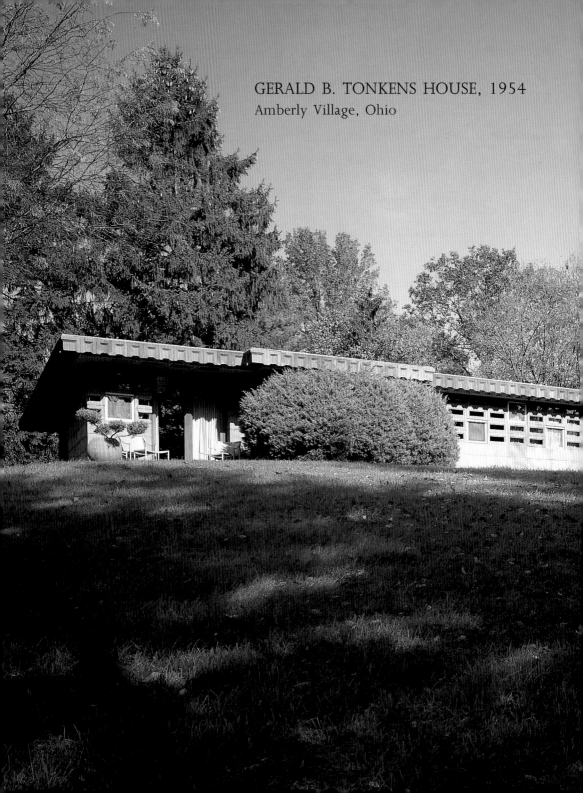

GERALD B. TONKENS HOUSE, 1954
Amberly Village, Ohio

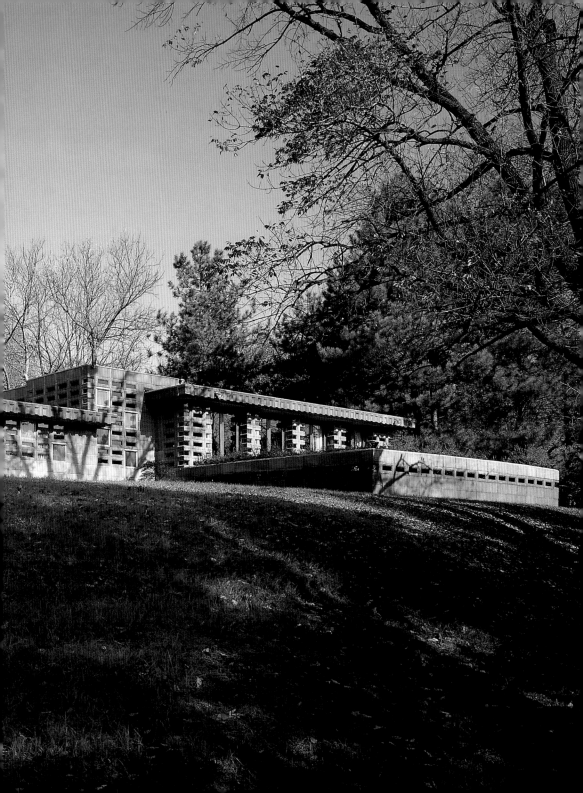

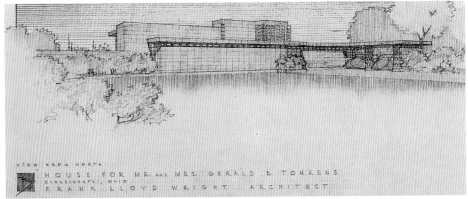

PERSPECTIVE. PENCIL AND COLOR PENCIL ON TRACING PAPER, 24 x 34". FLLW FDN#5510.001.

By the time that the William Palmer house (Ann Arbor, MI, 1950) and the Isadore Zimmerman house were being built, in the early 1950s, it was apparent to Wright that the Usonian building system as described in 1938 was no longer cost-effective. Red tidewater cypress, the beautiful honey gold wood that Wright favored, had become scarce and costly. The advantage of cypress was that it was impervious to rot and vermin, therefore, as Wright wrote, "best left alone" and not coated with varnishes or stained. But its use had become a luxury. Houses with foundations of crushed rock, elaborate stone or brick, and concrete-block masonry were likewise no longer cost effective due to the rising prices of skilled labor. It was time, Wright now realized, to create another building system that could serve the family of moderate income.

As in 1923, he focused his attention on the concrete block. For the four block houses in California of 1923–1924 he had devised a block with pattern and beauty, but also a block that would not require skilled labor. The traditional way of laying up a block wall, like a brick wall, is to have courses of the material set into a mortar bed as the wall rises. Keeping the wall level requires skilled, time-consuming laying of strings, or levels.

But with the block work in the California houses he eliminated the need for the mortar courses. The blocks, set upon themselves, were positioned and strengthened by thin steel rods set on the inside edges of the blocks and mortar was poured into the cavities containing the rods. In this manner the mortar and the rods are concealed, and there was no need for a string set on each course to insure it being level—nor for the skilled work needed to make exposed mortar correct and well-executed.

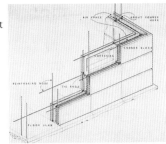

BLOCK CONSTRUCTION.
INK ON TRACING PAPER, 24 x 22".
FLLW FDN#5612.114.

190

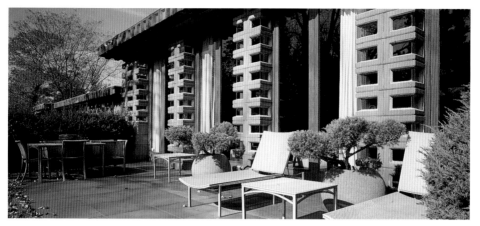

LIVING ROOM, EXTERIOR AND TERRACE.

In 1949 Wright began to make a series of sketches for a concrete block construction that he called "The Usonian Automatic." The block was not as ornamental as those of the California houses in the 1920s. A new simplicity was in order, and the system was to be geared toward that simplicity. Wright explained that the block had to be of a size and weight that one man could easily carry and work with. If it required two men to move a block, the system would defeat itself. He intended the Usonian Automatic to be so simple that the client could participate in the actual construction of his home.

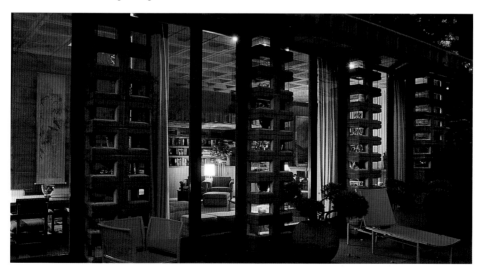

LIVING ROOM, EXTERIOR AND TERRACE.

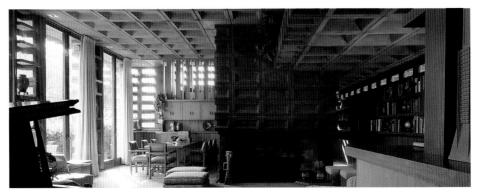

VIEW OF LIVING-ROOM FIREPLACE AND DINING AREA.

The basic block size for these houses is one foot by two feet. The block is coffered, to reduce its weight but still to provide a wide section on all ends into which to place the steel reinforcing rods and pour the grout. Wright developed several other types of blocks to fulfill the entire design and all its varying conditions: corner blocks, perforated blocks on outside walls, facia blocks for the edge of the roof, and corner blocks that are mitered and perforated with glass inserts. The jewel-like quality of the house is achieved by these perforated blocks, as sunlight filters through in the daytime or the interior lights shine through at night. The ceiling is formed by standard blocks, one foot by two feet, anchored by means of steel reinforcing to a lightweight insulating concrete slab above.

The house that Frank Lloyd Wright designed for Gerald Tonkens is one of the earliest uses of this new building system. But in the case of the Tonkens house, the system was employed to construct a most elegant and beautifully finished house. Several interior walls, when not left as block, are finished in fine Philippine mahogany. The ceiling blocks in the gallery along the bedrooms are gilded with gold leaf. This combination of the concrete block and wood grain is subdued yet surprisingly rich.

The apparent elegance of the Tonkens residence notwithstanding, the system was  intended to answer the need for moderate-cost housing. Wright's concept was to make  the molds for the blocks widely available to lumber companies, as the molds were the key to the entire endeavor; when executed on a house-by-house basis, the making of the molds constituted the greatest single cost. If these could be factory-manufactured, argued Wright, then their production costs would be greatly reduced. Plans, elevations, sections, and all details could also be purchased. The files in the Frank Lloyd Wright Archives hold many versions of plans tailored to the individual requirements of each homebuilder. Even the luxurious Tonkens house's floor plan in the working drawing set carries in Wright's own lettering the assignation "Series Usonian G, American Architecture."

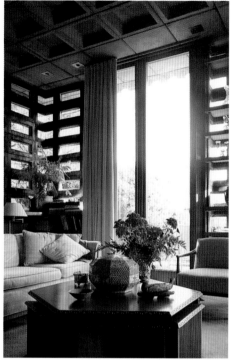

LIVING ROOM.                                    HALLWAY FROM MASTER BEDROOM TO ENTRY.

The Tonkens house was contractor-built, from molds to blocks to finished details, with Wright's apprentice and grandson, Eric Lloyd Wright, supervising. Wright himself visited the site from time to time to inspect the work. In the case of some of the other Usonian Automatics that were built, the clients did participate in the actual construction to keep costs down. One client in particular made one block a day for two years, stockpiling the finished blocks and then turning the process of building with them over to a contractor. The pouring of the concrete roof slab, with its interior surface of coffered blocks, requires a sound knowledge of building construction, even though the specifications for concrete mix and steel reinforcing are set down on the plans.

The Usonian Automatic building system was far ahead of what the building industry would accept in the early 1950s. And it remains to be revived and put into production. Were the blocks themselves factory-manufactured, the system could confirm Frank Lloyd Wright's perception that the key to moderate-priced housing is to let the factory go to the home.

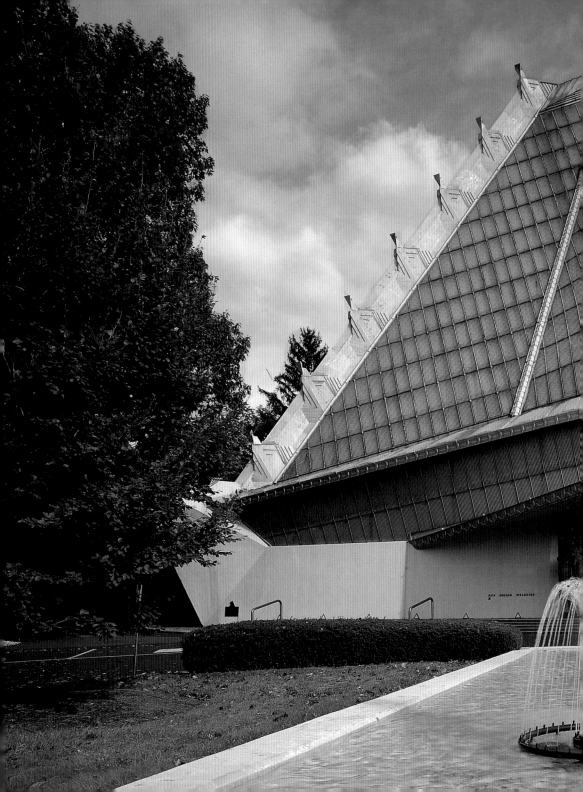

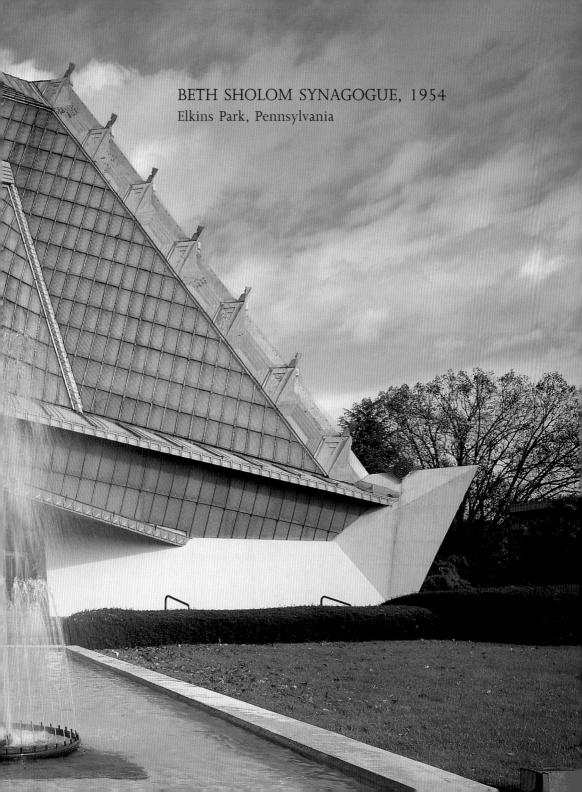

BETH SHOLOM SYNAGOGUE, 1954

Elkins Park, Pennsylvania

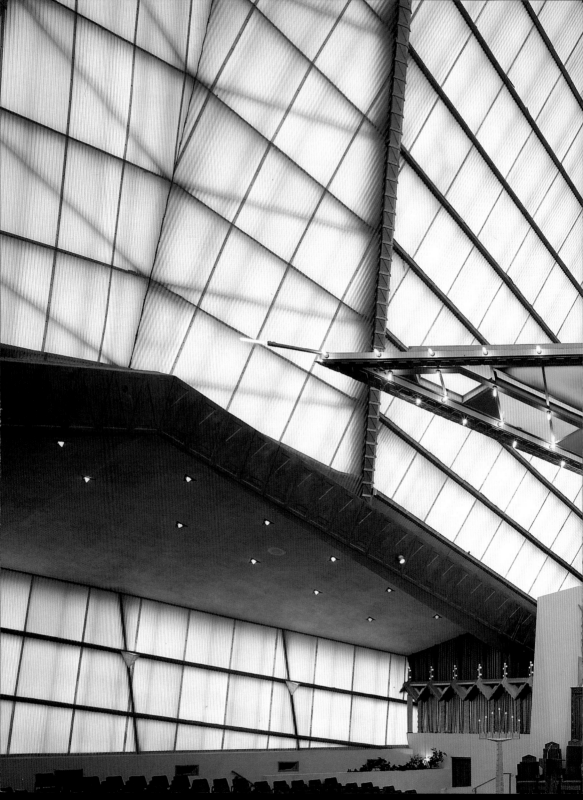

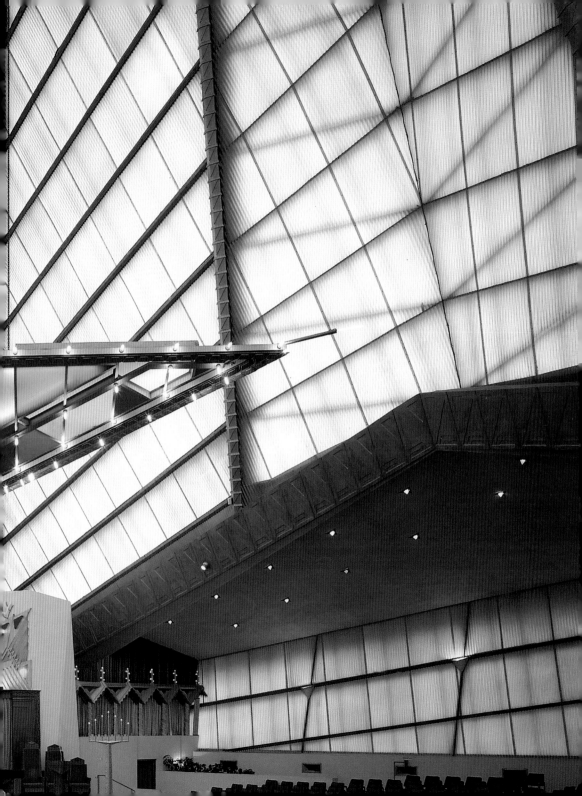

On March 15, 1954, when he mailed him the preliminary drawings for the Beth Sholom Synagogue, Frank Lloyd Wright wrote to Rabbi Mortimer Cohen:

*Herewith the promised "Hosanna," a temple that is truly a religious tribute to the living God. Judaism needs one in America. To do it for you has pleased me. The scheme in plan is capable of infinite variation, and could be expanded or diminished and made into different shapes as might be desired.*

*The scheme is truly simple. Construction is modern as can be. Stamped copper shells erected for structural members filled with concrete in which the necessary steel rods are embedded for stresses. The tops of the shells are removable for this purpose, thus no forming is necessary.*

*The building is set up on an interior temporary scaffold. The outer walls are double: wire glass outside, a blue-tinted plastic inside—about an inch air space between. Heat rises at the walls from the floor. The stained-glass windows could be composed of scenes from the Bible.*

*Here you have a coherent statement of worship. I hope it pleases you and your people.*

*Faithfully,*

*Frank Lloyd Wright*

The usual concrete cantilever construction associated with the work of Wright is not present in this building. In its stead a tripod rises from three main concrete masses at ground level. This enormous tripod, ornamented with designs of the menorah in stamped metal, supports sloped glass screens that make up the greater part of the temple; as the pyramid rises there are virtually no solid walls at all, but instead a great structure of light. The main auditorium is raised about eight feet off the ground level, approached by two staircases from the entry level.

Inside the entrance a wide doorway leads into two lounges and a chapel beyond. The access to the main auditorium is especially dramatic: the lofty ceiling can be seen high above, yet the wall running alongside the stairs partially obscures a full view of the space until the auditorium level is reached. Then the ceiling seems to soar over the viewer, luminously silver in the morning light, golden in the afternoon. The floor levels of the auditorium gently slope from three sides to the bema, or platform, from which the Torah is read. When Wright designed the synagogue, he said he wanted to "create a kind of building that people, on entering it, will feel as if they were resting in the very hands of God."

The seeds of the design for the synagogue can be found in a project twenty-eight years earlier. In 1926 Wright designed a vast cathedral for his friend and client William Norman Guthrie, pastor of the St. Mark's-in-the-Bouwerie church in lower Manhattan. He proposed to Wright a large interfaith cathedral that would contain six major churches and several minor chapels, all under one roof. The resulting design, called by Wright "The Steel Cathedral," was an immense pyramid of steel and glass rising above the concrete structures, with a central court within called "Hall of the Elements." It was a staggering conception and again portrayed Wright as an innovative engineer, but it was never realized.

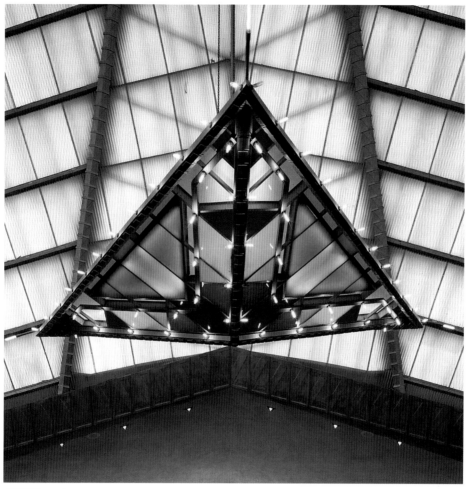

AUDITORIUM, VIEW FROM BEMA.

Not one to turn his back on what he considered a good idea, the architect resurrected this scheme and modified it to serve the needs of the Beth Sholom congregation.

Rabbi Cohen responded to the preliminary drawings of Beth Sholom by writing, "You have taken the supreme moment of Jewish history—the revelation of God to Israel through Moses at Mt. Sinai, and you have translated that moment with all it signifies into a design of beauty and reverence. In a word, your building is Mt. Sinai."

# MARIN COUNTY CIVIC CENTER, 1957
## San Rafael, California

By and large, government buildings are designed to be impressive: but they often have a contrived monumentality. The federal buildings in Washington, D.C., are vast in scale and built of expensive materials, yet represent a culture that in no way is intrinsic to American soil. After a talk that Frank Lloyd Wright delivered at the National Cultural Center in Washington, D.C., he was asked how a new government building should be designed. When the chairperson queried, "Is it architecturally possible to relate this building [Frank Lloyd Wright's design], for example, to the architecture of the Lincoln Memorial?" Wright immediately answered: "It is not! The Lincoln Memorial is related to the toga and the civilization that wore it. And I think it would be absurd to try and maintain the weakness and follies of the old lack of culture. Now, the Lincoln Memorial is not an indication of culture. It's an indication of a lack of it. The old Capitol is not an indication of culture, although I'm in favor of preserving these old mistakes—these old evidences of the old life in order that the new life may shine the brighter."[1]

In his design for the Marin County Civic Center, a government complex with county administration offices and a hall of justice, he exhibited his characteristic concerns: the use of twentieth-century technology and material resources, integrating the buildings with the landscape, and serving people in the noblest way. In both the Larkin and the Johnson & Son Company buildings he had created environments intended to be beneficial and inspiring to the worker. This was also his intention for the employees of Marin County.

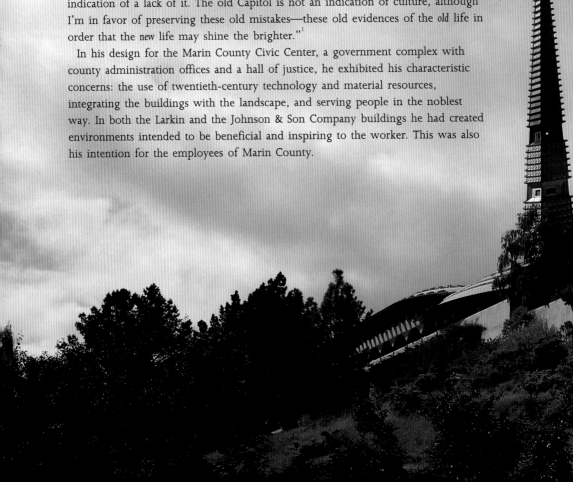

When Wright first visited the site it was suggested to him that the three hills, the predominant topographical feature of the area, be leveled so as to provide space for his building. He preferred to leave them, and "bridge these hills with graceful arches."[2] This is exactly what he did. In fact, the complex is a remarkably simple structure: the large arches on ground level support the building as it springs from hill to hill. The upper arches, however, are placed at the slab edges, and are non-supporting. Instead, they are pendants—hung from the slab edge—forming a series of arcs and circles that act as a sun-shade for the windows set back a few feet behind them. The building is of steel-reinforced concrete.

Running down the center of the two wings—in which are county administration offices and the hall of justice—is a mall, planted at ground level and protected from the elements by a continuous skylight. This allows every office to have a view either onto this garden mall or out to the terrain of distant lagoon and hills; many offices in fact have both views.

Where the two wings meet, a circular public library stands in the center of the complex, under a gentle dome and with an outdoor balcony looking onto a garden terrace and a view of the surrounding landscape.

EXTERIOR VIEW, PROW AND TOWER.

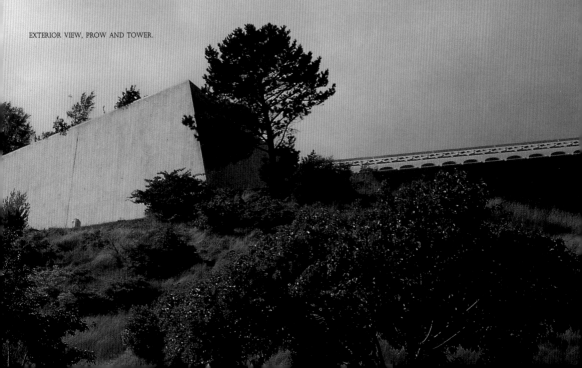

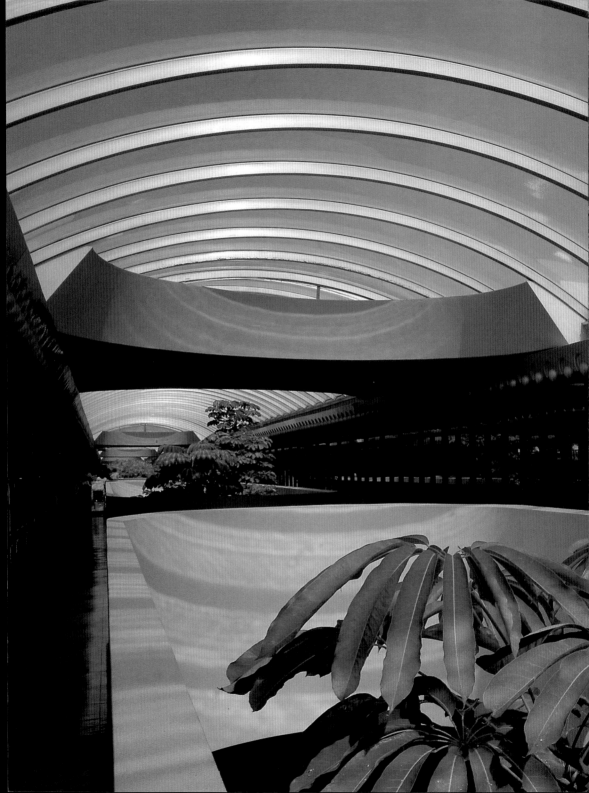

DETAIL OF ROOF AND EXTERIOR WALL.

Spanning the entire length of the building, over the central mall, is a continuous glass skylight. Wright planned the mall to be a long garden, open to the sky above, but he finally conceded to having it enclosed as a protection from inclement weather. The facia edge of the roof, both as it faces out to the landscape and into the mall, is decorated with an extended pattern of spheres. The purpose of this decoration is quite simple: it would be next to impossible to construct an absolutely level or straight facia edge on a structure as long as this building. There were bound to be variations and discrepancies. The spheres, however, break up the straight line and conceal these imperfections, creating at the same time a dynamic pattern and, in the sunlight, the consequential delicate shadows.

The first phase of the complex to be completed was the administration building, opened in October 1962. This was followed by the construction and completion of the hall of justice, which opened on December 13, 1969.

Aaron Green was the associated architect. He had trained first as a Taliesin apprentice for several years and later opened an office in San Francisco as the West Coast representative of the office of Frank Lloyd Wright. From the time Green opened his office in 1951 until the completion of the Marin County projects, he supervised all Wright's work in the San Francisco area. Reinforcing his confidence in Green to manage his work, Wright wrote to one West Coast client when construction had just begun:

SKYLIT MALL.

203

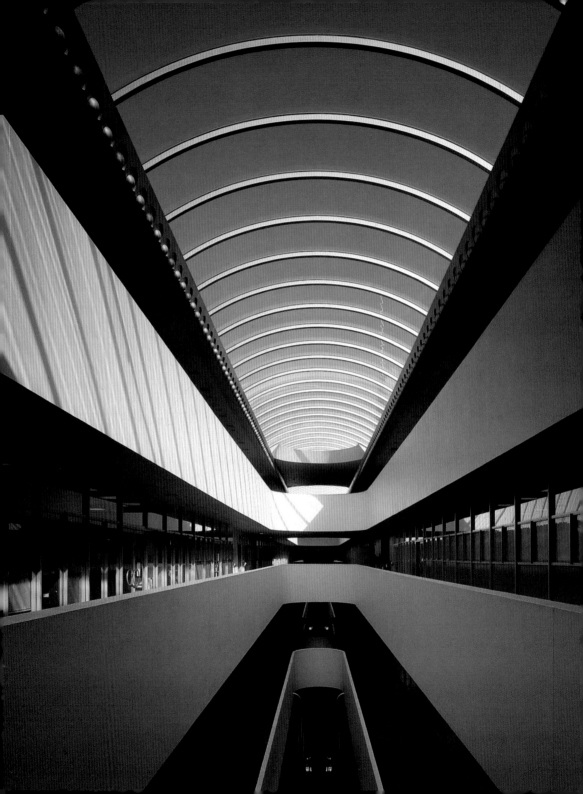

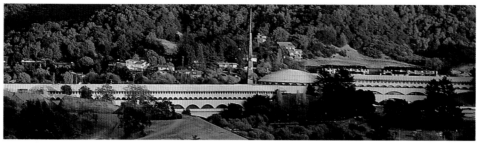

VIEW FROM WEST.

The stone-work is very badly done. Evidently the mason has no feeling for this sort of thing. No feeling. Aaron Green is my representative in San Francisco now and Walter Olds [a Taliesin apprentice] is superintendent. I wish both might see the masonry and make suggestions as I have made some of them. I can hardly believe you have allowed the builder to make changes from the plans, as the affair of a house as a work of art is a sensitive affair, as you well know and the contractor does not. I say the outside entrance to the North violates the charm and practicability also, I may say, of your opus. Once the builder gets out of hand the chance of perfection or anything approximate is gone. Do be guided by the counsel of the boys trained by me in getting my work done.

> Sincerely alarmed,
> Frank Lloyd Wright[3]

The Civic Center, riding gracefully from hill to hill as seen from the lagoon below, has an arcadian timelessness: it seems to have been with the landscape forever. Wright had in mind this marriage:

When organic architecture is properly carried out no landscape is ever outraged by it but is always developed by it. The good building makes the landscape more beautiful than it was before the building was built.[4]

From the beginning of his career Wright believed in the "miraculous" quality of steel:

Steel is another instance that came to us when all we had was the old 18th- or 19th-century bridge engineer. All the bridge engineer knew how to frame, to build, was to frame up lumber. He framed the lumber and the lumber was in beams, in posts, and very little value was attached to the strip and no value whatever in tension. I do not think there is a building ever built where wood in tension had any significance or could have except as it was bolted together. It was in that bolting together, in that framing, that the architect of the 19th century got his education. . . . Now comes steel. He did not know what the properties of steel were—he did not realize that here was the spider spinning and the material it had in its tensile strength . . . as a new property entirely in the whole world today. Nothing had existed like that in the architectural world of the ancients. The Greeks never knew it—and none of the old architects knew anything about that tension property of steel. Now you could get a building you could pull on. How marvelous! That changes the whole history of architecture—begins to change, or should . . . but hasn't. That saved the Imperial Hotel, and that is the principle I used in building it. . . . Put it together and there it stayed—no matter what came. . . . And that is the Museum [Guggenheim] in New York. Tension. In it there is a tremendous economy also because think what a telegraph wire will do, think of what has been released into the world of architecture.[5]

MALL.

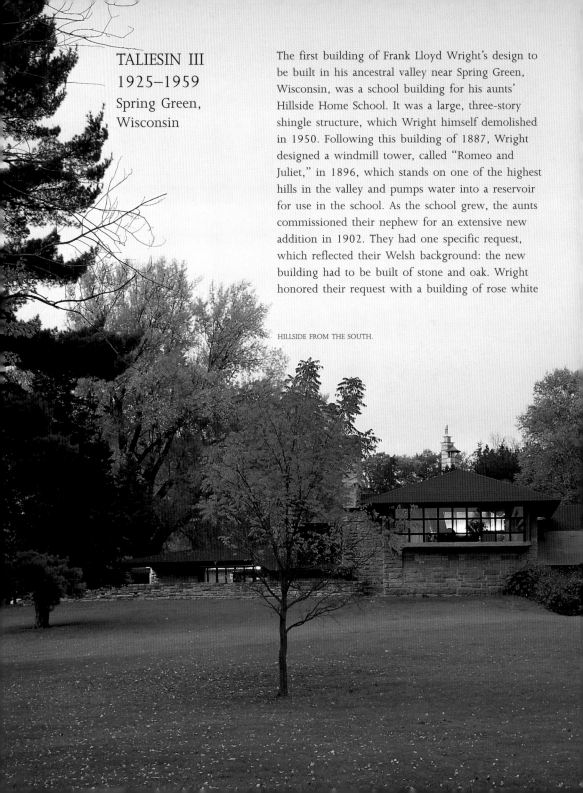

# TALIESIN III
## 1925–1959
### Spring Green, Wisconsin

The first building of Frank Lloyd Wright's design to be built in his ancestral valley near Spring Green, Wisconsin, was a school building for his aunts' Hillside Home School. It was a large, three-story shingle structure, which Wright himself demolished in 1950. Following this building of 1887, Wright designed a windmill tower, called "Romeo and Juliet," in 1896, which stands on one of the highest hills in the valley and pumps water into a reservoir for use in the school. As the school grew, the aunts commissioned their nephew for an extensive new addition in 1902. They had one specific request, which reflected their Welsh background: the new building had to be built of stone and oak. Wright honored their request with a building of rose white

HILLSIDE FROM THE SOUTH.

sandstone and great oak beams, left exposed and
stained dark brown. Situated nearby the older "Home"
building, this new school contained an assembly room,
classrooms, gymnasium, science laboratory, and art
studio. By 1915 the aunts had retired from the school
and the buildings were vacated, falling into disrepair.
Before their deaths they asked that their nephew
somehow keep the buildings in use and carry on the
educational work they had begun. After Wright had
built his own home, Taliesin, on another hill in the
same valley, he gradually began to acquire various
parcels of the original Hillside Home School property.
By 1932, when he and his wife established the
Taliesin Fellowship, he was ready to fulfill the promise
to his aunts:

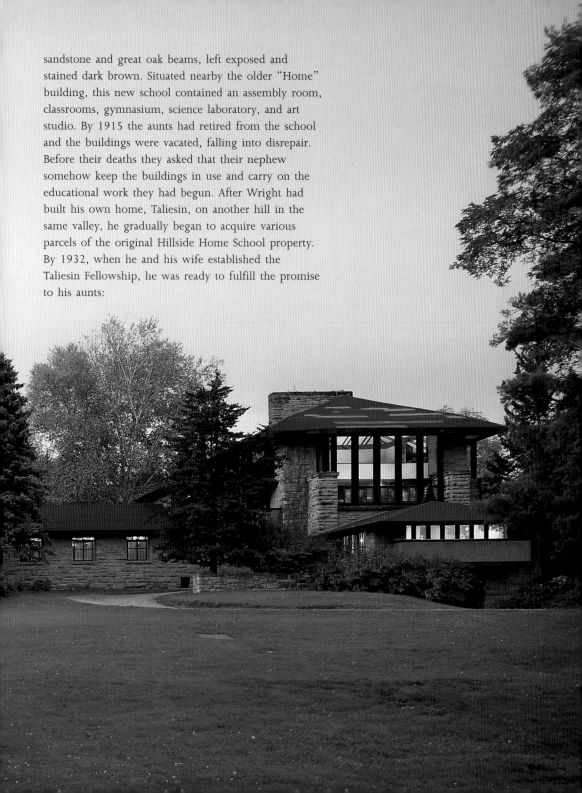

"ROMEO AND JULIET"
WINDMILL TOWER.

*I have made many promises in my life, always intending to keep them. I think I never made one that I didn't intend to keep. But my corner of hell will be paved with those that turned out to be only intentions. Time and circumstances destroy promises as distance dims one's view. But one promise would not let me go. My love for my mother and my aunts, my admiration for their grand gray heads and the dignity of their beautiful persons which age had brought were bound up in that promise as though they lived on in the promise: a promise I had made to see their educational work go on at the beloved Hillside on the site of the pioneer homestead. That filial promise would go along with me wherever I went. If I settled down, it settled down with me. In course of time it became a subjective urge as well as an objective. If I lived I was sure to keep the promise whether I wanted to or not. I became an Instrument of Fate. No matter what reason might dictate I would keep that promise in good time. And since I was what I was, I would keep it in my own way. As yet I had no idea in what way: procrastinating as always, this time for many years, I had faith in myself or whatever it is that keeps the promises we make. And I believed now, from within, that whatever I deeply enough desired I should have, because first it had me.*[1]

Wright spent much of his boyhood in this region, and even while practicing architecture in Chicago and Oak Park, he frequently visited the Hillside Home School, partaking in the school's dances, parties, picnics, and other social events.

In 1928, after Wright had acquired the property, he drew up a prospectus for a school that would make use of the Hillside buildings, to be known as "The Hillside Home School of the Allied Arts." But this ambitious plan finally had to be abandoned.[2] Following the stock market crash in 1929, several large commissions on the boards at Taliesin were shelved. It would be several years before work would begin to flow into his office again. But instead of remaining inactive, Wright and his wife decided, once more, to found a school for architects. They named this school the Taliesin Fellowship and opened its doors in October 1932, using Wright's home as a base of operations. With his apprentices as a workforce, as well as hired carpenters and masons, Wright renovated the Hillside buildings. As commissions came in, and with them the funds for more construction, a large drafting room was built on the north end of the building, complete with sixteen apprentice rooms, running eight each along each side. The roof of the drafting room was made of oak trusses and clerestory windows, the light falling onto the drafting tables through a network of wooden beams. Wright liked to call this drafting room "an abstract forest." At one end was a massive sandstone fireplace, large enough to stand up in. Following a strong Lloyd Jones tradition of placing various mottoes in the building, Wright inscribed the following words on the facia of the balcony at the other end of the drafting room: "WHAT A MAN DOES THAT HE HAS."

HILLSIDE, DRAFTING ROOM.

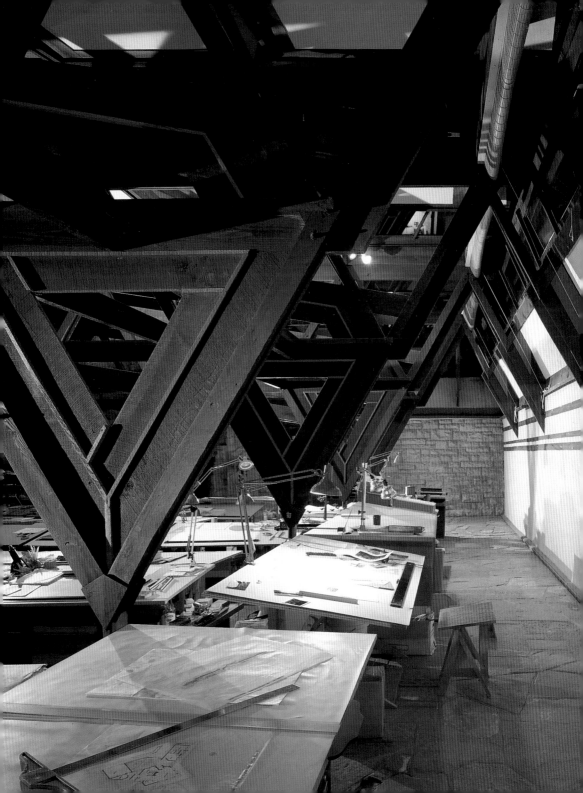

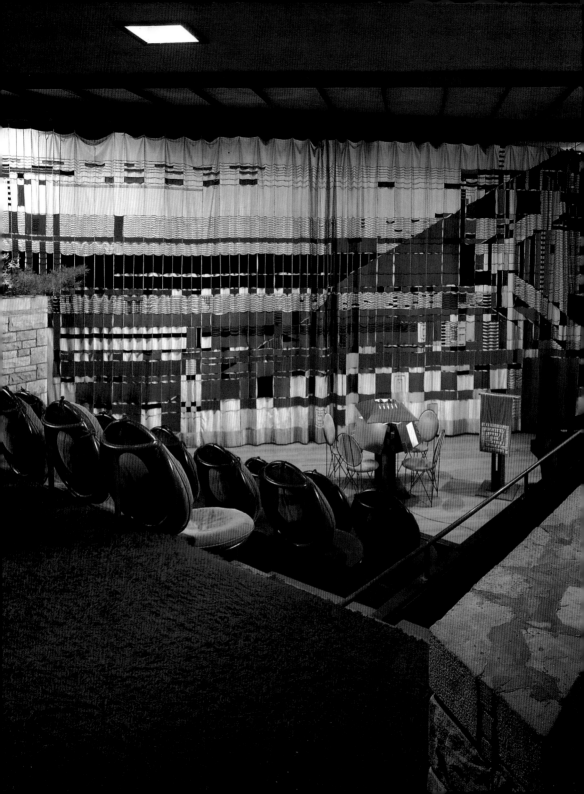

And when Wright had completed the theater conversion from the original gymnasium, on a large plaster wall to the right of the stage was lettered, in gold leaf, a poem by Walt Whitman that begins, "Here is the Test of Wisdom." Thus the apprentices of the fellowship were daily reminded of the Lloyd Jones roots from which this new life had sprung. Indeed, Wright's promise was amply fulfilled, and to pay homage to the aunts he set a smooth sandstone plaque on the side of a low stone wall, which reads: "To Aunt Nell And Aunt Jane The Lloyd Jones Sisters, Founders Of These Buildings In 1886. The Frank Lloyd Wright Foundation In Loving Remembrance 1932."

During a spring cleanup of leaves and brush in 1952 at Hillside, Wright was setting fire to piles of dead leaves when a gust of wind swept the flames up and under the eaves of the theater. Within minutes the theater, dining room, dormitory rooms, and weaving corridor were consumed in the third major fire on his Taliesin property. The living room was spared, as were the rooms extending north of it, including the drafting room and the two galleries that contained all Wright's drawings. Shortly after the fire, reconstruction began, with Wright modifying the theater. He seemed pleased with the opportunity to rebuild it, considerably changing its proportions, stage, and seating arrangements. The dominant feature is the large stage curtain, fifteen feet high and thirty-four feet long. Made of Belgian linen, with sections of felt in red, black, brown, and green, along with gold, brown, and black cords, the tapestry depicts the Wisconsin landscape: its red barns, plowed fields, flocks of blackbirds, and green hills. Working from Wright's design, the apprentices themselves cut the materials and applied them to the background. Just as he changed his buildings while living in them, Wright also went to work from time to time to alter this large and romantic abstraction.

HILLSIDE THEATER, THEATER CURTAIN,
AND HAND-LETTERED WALT WHITMAN POEM.

211

Halfway between Taliesin and Hillside another set of buildings was assembled, called "Midway." It consists of barns, granary, stables, dairy, machine shed, and farmer's cottage for the fellowship's agricultural produce. The farm animals that once occupied Taliesin were moved there. In between the two complexes—Hillside and Midway—were contoured farmlands that made up the kitchen gardens. Other fields around the property were planted in rotating crops of alfalfa, soybeans, corn, wheat, grain—for use in the farm as well as for sale on the market.

MIDWAY BARNS.

Wright's own home, Taliesin, rebuilt after the fire of 1914, was made significantly larger, with more provisions for draftsmen and workmen living on the estate. In the early 1920s several Europeans and Japanese couples joined Wright in his work. Many of them were musicians, and musical evenings invariably followed dinner in the living room at Taliesin. Although these new arrivals who formed around Wright were primarily draftsmen, the atmosphere was informal, familial, more in the nature of apprentices working with Wright rather than draftsmen working for him. While this cosmopolitan group was in residence at Taliesin, Wright met the woman who was to become his third wife, and who also was to become a powerful and dominant influence during the last thirty-five years of his life. Olgivanna Lazovich Hinzenberg was born in Cetinje, the capital of Montenegro, but received her education mainly in Czarist Russia, where she remained until the outbreak of the Revolution in 1917. Shortly before the Revolution, while living in Batoum, on the Black Sea, she made the acquaintance of the philosopher and educator G. I. Gurdjieff and decided to join his group of students. Separated from her husband, who was a Russian architect, she eventually managed to escape from Russia along with several others led by Gurdjieff. For the next seven years she remained with Gurdjieff in his school at the Château du Prieuré in Fontainebleau-Avon. This school, called the "Institute for the Harmonious Development of Man," offered a rigorous experiential training for its pupils, many of them famous French, English, and American men and women of letters.

In 1924 Olgivanna left Gurdjieff and shortly thereafter met Wright while attending a matinee performance of the Russian Ballet in Chicago. Although both were seeking divorces, they decided to take up life together. She was to be enormously influential in instigating and then maintaining the agenda for the Taliesin Fellowship.

In the early spring of 1925 Taliesin itself for the second time was victim to fire: an electrical storm shorted faulty wiring and soon the living quarters of Taliesin were ablaze. Wright was deeply hurt by tragedy once again.

*Everything of a personal nature I had in the world, beside my work, was gone. But . . . this time—how thankful—no lives lost except those images whose souls belonged and could now return to the souls that made them—precious works of Art. Yes . . . poor trustee for posterity, I had not protected them. But they should live in me, I thought. I would prove their life by mine in what I did.*[3]

214                                    TALIESIN, LIVING ROOM AND BIRDWALK.

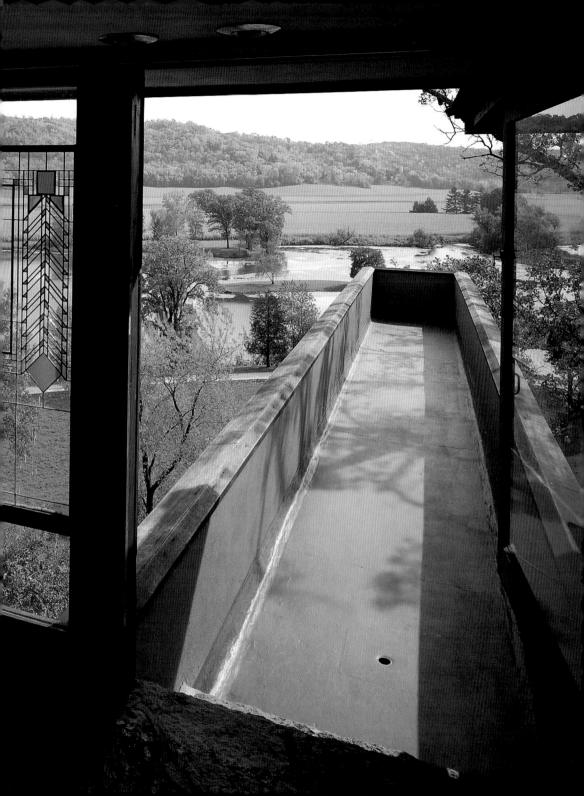

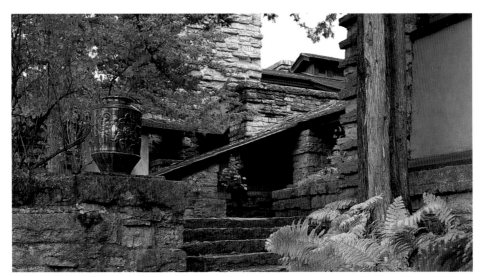

TALIESIN, STEPS LEADING FROM LOWER COURT UP TO FRANK LLOYD WRIGHT'S RESIDENCE.

Wright rebuilt the living quarters, enlarging them extensively more than after the 1914 fire. The adjacent studio was also expanded. On his eighty-second birthday—June 8, 1949—Wright had breakfast in this studio with his family and apprentices. After breakfast he reminisced about the studio and the work done therein. He pointed to the doorway that leads from the studio to a breezeway connecting to the living quarters. "Each time the fire destroyed Taliesin, we were able to stop it before it came upon the studio, right there at that door. It is as if God questioned my character, but not my work!" This was not tossed off as a mere quip, but rather expressed Wright's deep concern about the mission of the architect to build a beautiful environment for humanity: "There is no such thing as an architect who is but one thing, or limited in his views, in his outlook. He must be the most comprehensive of all the masters, most comprehensive of all the human beings on earth. His work is the thing that is entrusted to him by way of his virtue, is most broad of all."[4]

From 1925 until his death in 1959, Wright modified Taliesin each year. In 1953 he altered the entire south elevation of his living quarters, making a more horizontal composition in place of the rather vertical one that had preceded it. A "bird-walk" was added to the living-room porch, a long, narrow protruding balcony that shot out into the branches of the oak trees growing on the hill slope.

TALIESIN, FRANK LLOYD WRIGHT'S STUDY/BEDROOM.

216

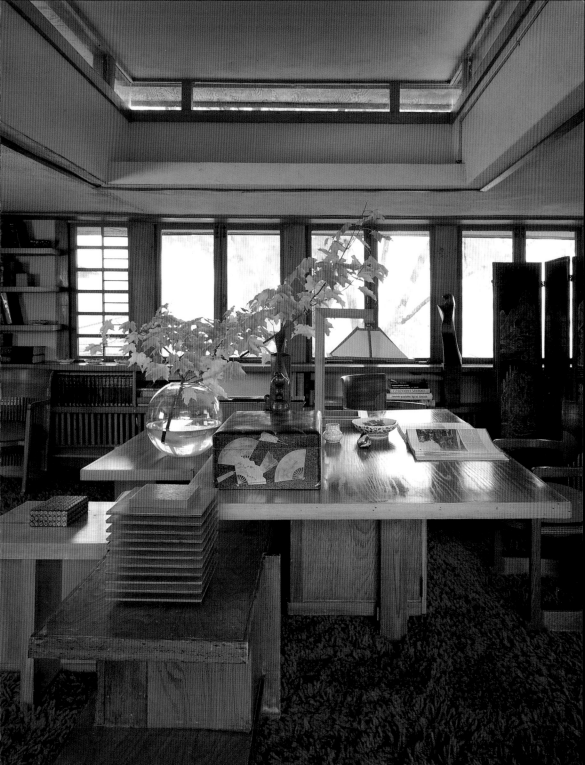

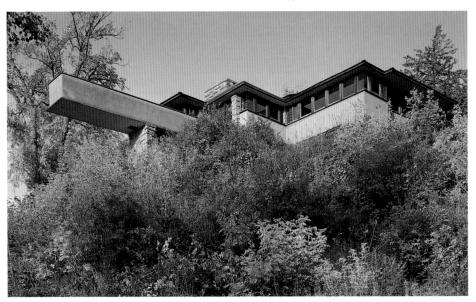

TALIESIN, LIVING ROOM AND BIRDWALK, EXTERIOR.

When the Taliesin Fellowship was founded, Wright made a drastic change from his previous way of practicing architecture. He abolished, forever, the hiring of draftsmen. Only in special instances would he hire consultants, and then mainly for engineering, air conditioning, electrical work, and the like. Most of the apprentices who came to Taliesin in those first years were university or college graduates, many with skills in drawing and engineering. From 1932 until his death in 1959, the apprentices would constitute his professional office. They paid a nominal tuition fee, and for this arrangement he was criticized by outsiders. In a talk to his apprentices on December 20, 1952, he remarked:

*Now we are not educational. We are, we hope, cultural. And we do feel that unless we turn you out better looking, better thinking, better able, when you get through your term with us here, we haven't done much for you. And if we haven't done much for you we haven't done much for ourselves, have we? . . . I have been looked upon as a wise old gentleman who succeeded in setting up a system whereby he got his work done for nothing. Well, all it cost me to get my work done for nothing was all I ever earned in my life, all I will ever earn, all I could possibly earn, and all I can do is to share that with boys and girls who want to come in here along a quest for something I myself haven't finished with. You see, I am still in it. So is Olgivanna. We are working and learning. It occurred to me the other day—I don't know what brought it up—something that made me feel that I could still learn faster, learn quicker, and by way of the years that I have lived, learn more, faster, than anybody here, that I was getting more out of this fellowship than any of you were getting in*

just that way of learning. I think, of course, that this is the richest thing that could possibly have happened to us, that we have an opportunity to learn by way of your learning.[5]

He often referred to himself in connection with his association with Louis Sullivan as "the pencil in his hand." But he described the apprentices at Taliesin as "the fingers of my hand," illustrating a closer and more personal relationship.

But the first years of the fellowship were indeed lean and difficult ones, with the absence of architectural work to bring in commissions. The tuition of the first group of apprentices helped pave the way for the remodeling of Taliesin and Hillside, but soon the money ran out. Apprentices worked on the farm, worked on the buildings, carried on the maintenance of Taliesin and the Hillside buildings, and in the field of architecture worked on the preparation of the Broadacre City model, as there was little architectural work to speak of until "Fallingwater" and the Herbert Johnson buildings in the mid-1930s.

Jenkin Lloyd Jones, of Tulsa, Oklahoma, the son of Wright's cousin Richard Lloyd Jones, recently recollected those early years of the Taliesin Fellowship in a letter to one of the fellowship members:

I was a senior at the University of Wisconsin, Madison, in the fall of '32 when Wright started his school. But, as Frank's second cousin, I was a frequent moocher at Sunday night suppers at Taliesin from the fall of '29 until my graduation.

When I understood what Wright proposed, I was sure it couldn't last. Slave labor has been outlawed in the United States since 1863, and here was slave labor with refinements undreamed of by Simon Legree. Not only were the young laborers paid nothing for growing food crops and restoring buildings in advanced states of decay but they were charged for the privilege. I shamefully underestimated the magic of Frank and Olgivanna. I watched the peasants labor in a drafting room made of green lumber because Frank couldn't afford kiln-dried. I saw them eagerly consume concentration camp cuisine. In spite of gross exploitation they gathered worshipfully around their two gurus, male and female, and the talk was not only stratospheric but often incomprehensible to me. Here was Plato. Here was Joan of Arc. No matter that Frank was far overdue on payments for his front-wheel-drive Cord automobile. No matter that the Sunday supplement scribblers were still nipping at his heels. There was a spurious opulence in the midst of near-starvation. Bittersweet and pussy willows, gathered in the bog across the road, adorned the living room. Apples from the orchard overflowed the bowls.

Oscar Wilde once sniffed a rose and said, "I have had my dinner." A pragmatic Oklahoma college kid was amazed at the power of style. Wes Peters, an Indiana editor's son, was one of the first disciples. He never left. There may have been nothing on the table but soup and dark brown bread, but Olgivanna would trot out a jar of Montenegren plum jam which she called pavidla and we all feasted.

It was my personal privilege to see Frank Lloyd Wright at the nadir of his fortunes and live to die at the height of his fame and fortune. It was no tribute to my intelligence, back in 1932, that, when I watched a handful of my contemporaries hammering, sawing, whitewashing under conditions of a Spartan camp, I couldn't imagine what held them together.[6]

But this is not to say that the life of the fellowship was all toil and grim work. The Wrights believed that all kinds of culture should be built into the daily life of the fellowship. An apprentice working in the fields on a tractor in the morning might well find himself dressed in black tie and attending a concert at Taliesin that very evening. Music, especially, was an important part of the life at Taliesin. Saturday evenings were formal occasions, with dinner in the theater followed by a film. Wright was an avid devotee of the cinema, and he booked in films from all around the world. Sunday evenings were also formal affairs, with dinner served in the Wrights' living room at Taliesin followed by a concert. A chorus and chamber music ensemble were composed of apprentices, and usually there were some fine solo musicians also drawn from the fellowship. Wright enjoyed the music and was proud to have it produced by his own apprentices. Many times he gleefully remarked to his guests that the evening would end with a performance "by our farmer-laborer quartet."

Living within Taliesin proved to be a daily inspiration to the Wrights, their family, and their apprentices. The very upkeep of the interiors was, and is to this day, part of each apprentice's training. Not just the sweeping, dusting, cleaning, and vacuuming, but also the decorating: bringing in bowls of fresh flowers from the gardens or wildflowers, antimony and bittersweet from the surrounding fields and forests; placing large branches of oak and pine on the ample decks, especially in the autumn with the brilliant vermillion sugar maples turned by the early frost—all the exuberance of nature outside reiterated within. Beyond the exquisite beauty of the building as a work of art, these touches of interior arrangements are what constitute the heartbeat of Taliesin.

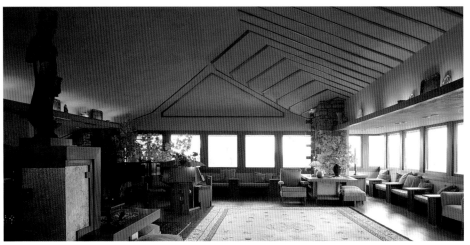

LIVING ROOM.

LIVING ROOM.

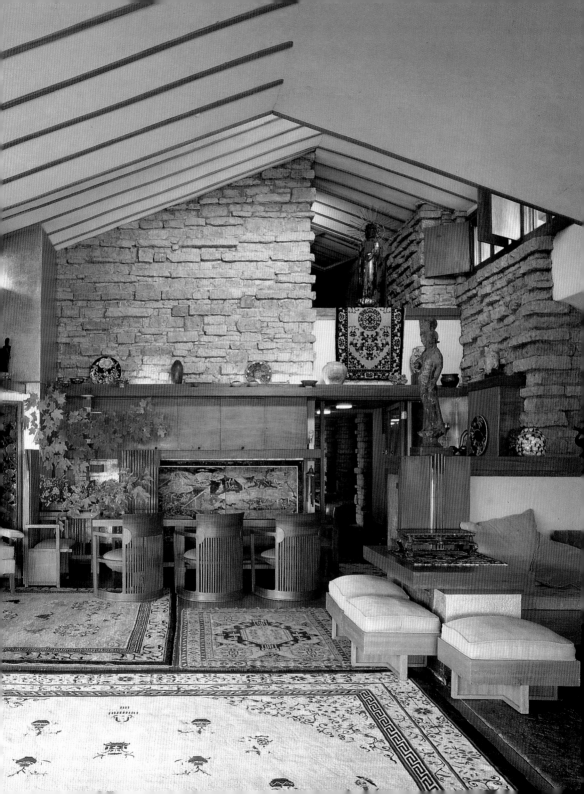

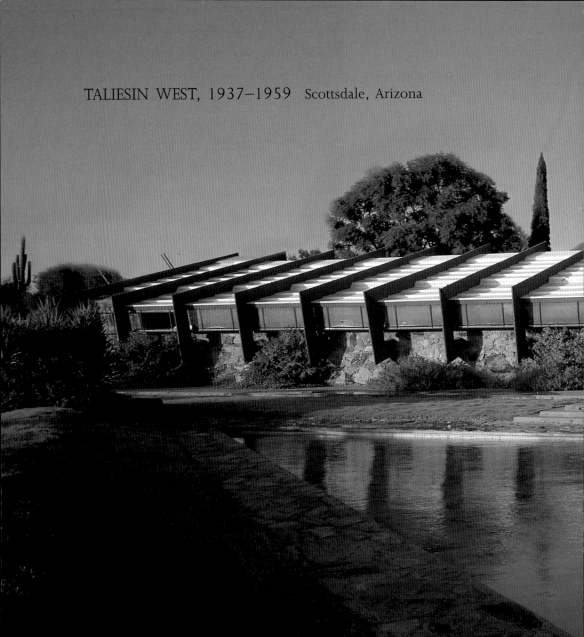

TALIESIN WEST, 1937–1959   Scottsdale, Arizona

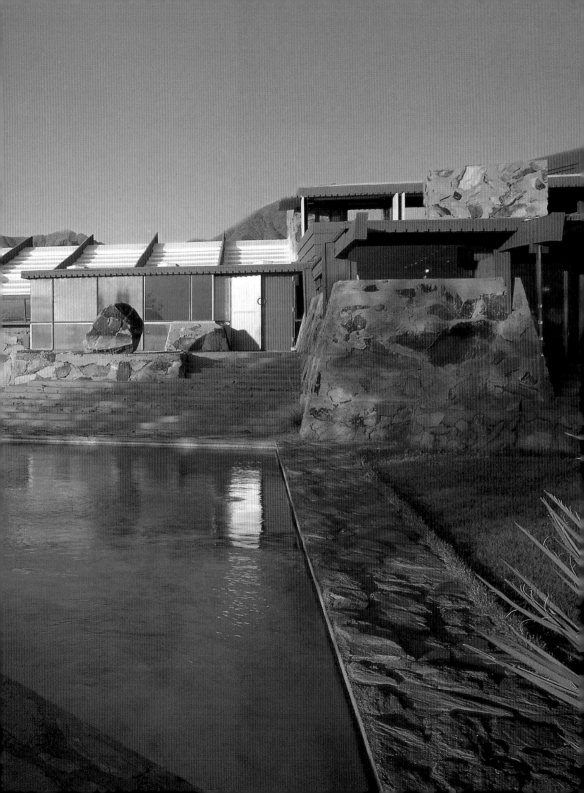

Frank Lloyd Wright first encountered the Arizona desert in 1927, when he consulted on the design of the Arizona Biltmore Hotel. During that time he and his small family lived in the downtown Phoenix area. But during his next visit, when he was commissioned by Dr. Alexander Chandler to design a resort hotel called San Marcos-in-the-Desert, he brought his family and a corps of draftsmen from Wisconsin. Rather than renting quarters, he elected to set up a camp-like structure of his own design, and he lived for several months in close proximity to the desert. The experience of living in a tent-like building (box-board walls topped by pitched canvas roofs) opened up the glory of this region to him:

> Out here obvious symmetry soon wearies the eye, stultifies the imagination, closes the episode before it begins. So, there should be no obvious symmetry in building in the desert, none in the camp—we later called it "Ocatilla" and partly for this reason—nor anything like obvious symmetry in the new San Marcos in the Desert, as we named the new structure to be. . . . Arizona needs its own architecture. The straight line and broad plane should come here—of all places—to become the dotted line, the textured, broken plane, for in all the vast desert there is not one hard undotted line! Arizona's long, low, sweeping lines, uptilting planes, surface patterned after such abstraction in line and color as find "realism" in the patterns of the rattlesnake, the Gila-monster, the chameleon, and the saguaro, cholla or staghorn—or is it the other way around—are inspiration enough. But there lie her great striated and stratified masses, too, noble and quiet. The great nature masonry rising from the mesa floor is all the noble architecture she has at present.[1]

In 1934–1935 the fellowship members lived for part of the winter in Chandler, Arizona, a town south of Phoenix, where they rented space in the Hacienda Inn. Here they lived and worked on the models for Broadacre City. The next year, back in Wisconsin, Wright contracted pneumonia. After he recovered, Olgivanna urged him to get out of the below-zero Wisconsin winter and revisit Arizona to recuperate. Wright became so attached to the Phoenix area, that he decided to build a winter home in Arizona.

DESERT MASONRY DETAIL.

BELL TOWER ABOVE KITCHEN, STAIRWAY TO GUEST DECK.

CONFERENCE ROOM AND WATER TOWER, LOOKING EAST.

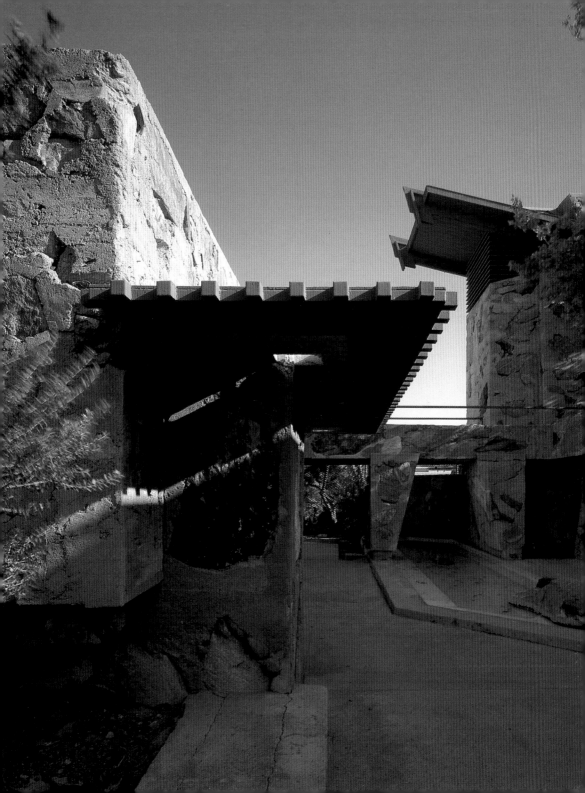

"The Conquest of the Desert" is the way Wright described the building of Taliesin West. In their search for the property on which to build a winter home and workshop, the Wrights traversed Phoenix's large Paradise Valley, an area rimmed with mountain ranges. About twenty-six miles northeast of Phoenix, they came upon a tract of land that was inexpensive. Wright acquired, through outright purchase and state land lease, about 800 acres of unspoiled, cactus-ridden, and rock-strewn desert at the foot of the McDowell Mountain range, with a view which he described as "the top of the world. Magnificent—beyond words to describe! Splendid mystic desert vegetation."[2] Hardly any roads existed in that part of the region, and he had to build several miles of his own road just to get to the building site.

Wright was seventy years old, but he was determined to live in the desert while Taliesin West was being built. At first the Wrights lived in tents, and then in a small wood and canvas shelter he called the "Sun Trap." Flat canvas roof flaps were opened on winter days to embrace the warmth of the sunlight. Stone fireplaces kept him and his family warm at night. The thirty members of the fellowship likewise built shelters on the other side of the building site. There was no water or electricity, and as the cost of the property and the lease took what little money he had, Wright was forced to find a construction solution that would be as cheap as possible. But, as for the design of this new home and studio he was contemplating, he said:

*I was struck by the beauty of the desert, by the dry, clear sun-drenched air, by the stark geometry of the mountains—the entire region was an inspiration in strong contrast to the lush, pastoral landscape of my native Wisconsin. And out of that experience, a revelation is what I guess you might call it, came the design for these buildings. The design sprang out of itself, with no precedent and nothing following it.*

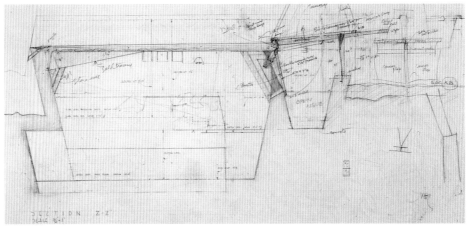

CABARET THEATER. SECTION. PENCIL ON TRACING PAPER, 29 x 36". FLLW FDN#3803.002.

226

CABARET THEATER, LOOKING FROM STAGE TO PROJECTION BOOTH.

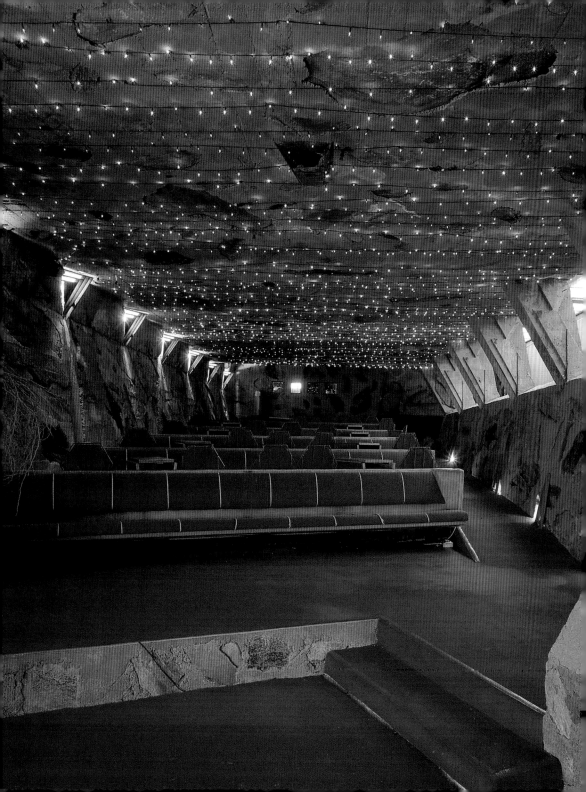

In the camp structure made of wood and canvas, called Ocatilla, that he had designed and built near Chandler, Arizona, during the winter of 1929, he had experienced living in a structure with a translucent textile roof overhead. He was determined to get that same effect—that gentle top light—again in the new complex, but instead of using a wood wall for the base, he now made use of the plentiful stone cast across the desert. The stones, of richly varied colors—burnt red, umber, black, purple, and combinations of them all in some stone—were set into constructed wooden forms. The flat surface of the stone was set against the inside face of the form. Sand dug out from nearby washes, or dry rivers, was mixed with cement to form the concrete that would hold the stones together until the concrete hardened. The form was then stripped and moved over to continue the same process until the wall was complete. The sloping angles of the walls, sometimes rising with an inward slope, sometimes outward, sometimes a combination of both, reflected, Wright believed, the slopes of the mountain ranges. Over these massive walls was set a network of redwood trusses, and in between the trusses were frames with stretched white canvas. Some roofs were flat, composed of redwood and built up roofing—tar and gravel. Some roofs, such as in the small dinner theater, which he called the "Kiva," and a later cabaret theater, were of poured concrete and stone.

The first unit to be built was the kitchen, followed by the drafting room nearby, which, in the early stages of construction, served as social room, dining room, and music room until more of the camp was completed. At one end of the complex, near the entrance court, was Wright's office. At the other end were private living quarters for the Wrights, facing south and east. A court surrounded by rooms for the apprentices lay directly behind the Wrights' own quarters. Small pools, accented throughout the plan, gave the luxury of water and fountains in contrast to the dry desert. In fact, the gardens and courts form an oasis within the complex, but outside the enclosing walls the desert landscape remains untouched.

As with Taliesin, in Wisconsin, Wright changed and modified Taliesin West each season he returned to it. For the first two or three weeks he would walk through the buildings, followed by apprentices with crowbars, shovels, hammers, and saws, ready to carry out his instructions, which usually were given with a sweep of his cane and only the barest of sketches on paper. He directed the building, remodeling, demolition, and rebuilding as a conductor directs a symphony orchestra.

CONFERENCE ROOM AND COVERED WALKWAY.

FRANK LLOYD WRIGHT'S OFFICE, EAST END.

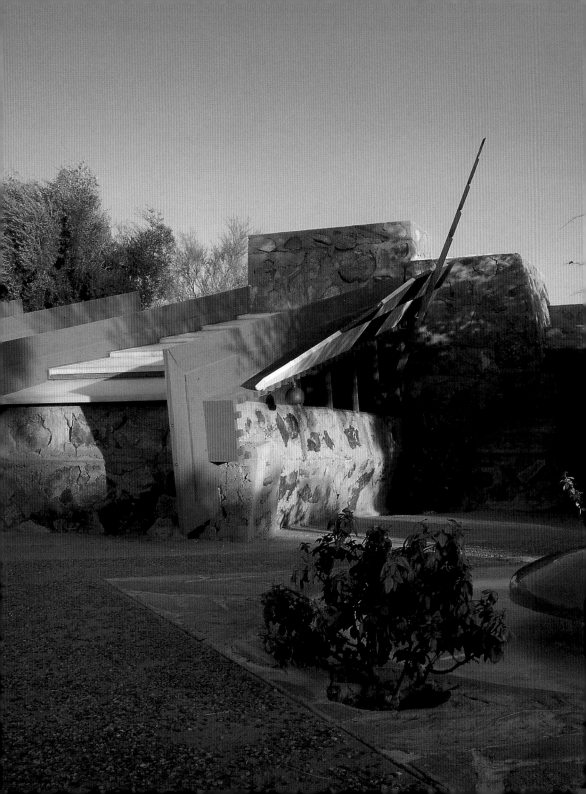

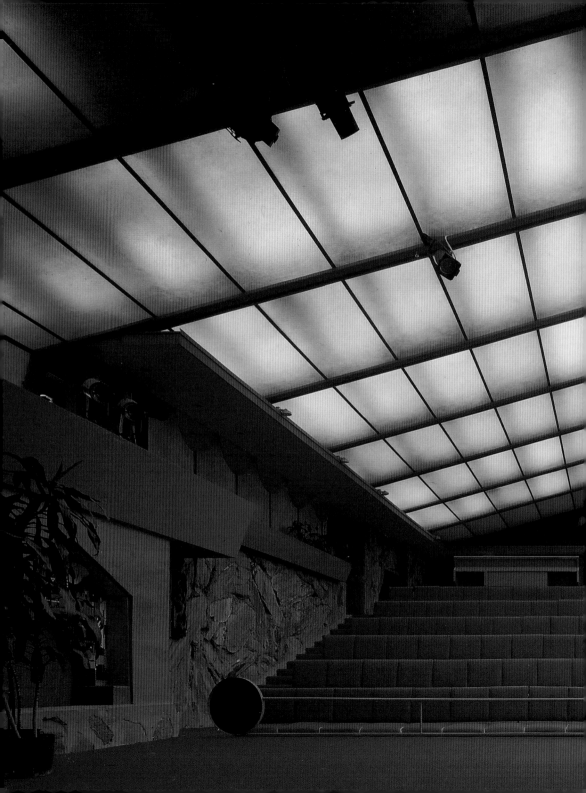

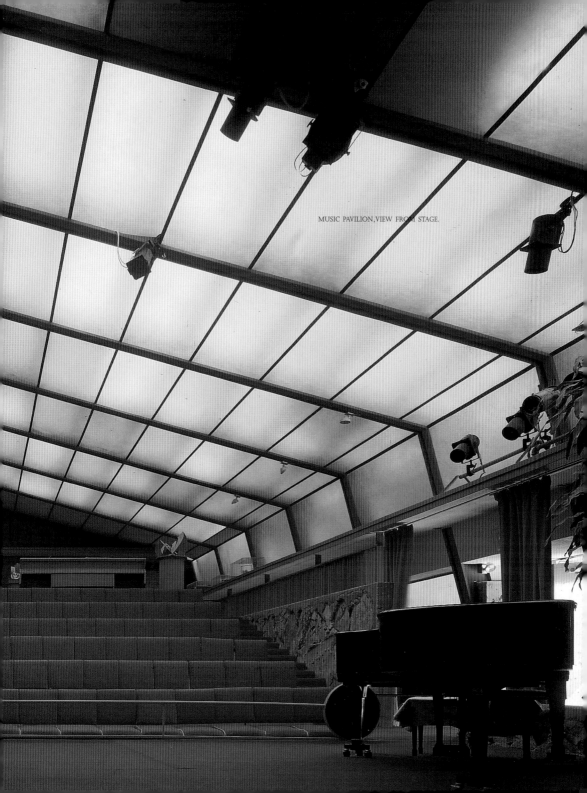

MUSIC PAVILION, VIEW FROM STAGE.

There were occasional unexpected hardships: heavy rains brought desert floods through the buildings and penetrated the overhead canvases or seeped in through the flat roofs. But hardships seemed always to provoke a special challenge in his life, and he believed that if he—from the age of seventy—could endure them, certainly the young men and women of the fellowship could do so as well:

*When we first came out here the idea of the fellowship itself was a rough-it camp. We intended to come out from luxury in the East to a hard life in the West. We never intended to live soft. We intended to eat hearty, but not particularly fine or elegant. And I had an idea that roughing it, in contrast to a little softer way of living in the East, would be a good thing. In fact, the whole fellowship was based upon the idea of change, continually in a state of change. Because I believe that when you are learning and in a state of becoming, which is what learning is, the state of becoming is always a state of change.*[3]

Taliesin West was built with little outside labor, mostly with the participation of the apprentices. A diesel plant supplied the electricity; a well was drilled for water; heat was provided mainly by generously large fireplaces and individual kerosene heaters; a sewage system was provided with septic tanks and a leech field.

CONFERENCE ROOM, INTERIOR.

Although the structure was camp-like at first and intended only for use in the winter months, Wright planned for the buildings to become more permanent as he returned each season. He brought in glass, and steel was used to reinforce the wooden trusses. The rather ephemeral buildings were becoming more a solid, permanent home and studio each year. "What I have built here," he told his wife, "is merely a thumbnail sketch. It is up to you and the fellowship to complete it after I am gone."

The last winters of Wright's life saw him beginning to make the drastic changes that would indeed insure Taliesin West more permanency. He enlarged the fellowship dining room with glass bays looking north to the McDowell Mountains. The former dining room he converted into a private dining room where he could entertain clients or small dinner parties. Faced with the threat of great power lines going across the property on the south side, he remarked, "Then we will turn the buildings 180 degrees around and face the mountains behind us!" He achieved that "turn" by articulating the outlook of the complex in the protected direction: a large series of square gardens was planted directly north of the pergola wall, beyond that a grove of citrus trees was planned (which are now thriving). He re-established the entry road parallel to the front prow, affording a dramatic preview of the buildings as the road rises to the car court. The canvas rooftops proved costly to replace every two or three years, and he searched for preservatives that would seal them and render them waterproof; he tried plastic fabrics, but would not give up the idea of a translucent tent overhead. He brought in vast sheets of plate glass to rise from walls to roof trusses, to open onto intimate garden courts, and to provide views of the distant mountains off to the east. The buildings were eventually connected to public services, at first electricity and later telephones.

Taliesin West and Taliesin in Wisconsin are the most personal of his buildings. They seemed to live and breathe alongside him, combining the magnificent idiosyncrasies of his complex nature and personal genius. There are wonderful structures around the nation that he designed. "Fallingwater" will always have a magical charm and allure about it. The Guggenheim Museum will attract and amaze generations to come. The early work will sing of his prophetic beginnings, and each well-kept house and well-maintained building will continue to exert its influence on the world of architecture. But these two Taliesins will always stand apart: apprentice-built and apprentice-maintained—mostly by novices in the craft of building construction. It is indeed ironic that America's greatest architect would live in two homes built by young men and women in the act of learning the art of architecture. But that was the way he chose to have it, and the vitality that passed from Wright and Olgivanna to his apprentices was also a source of vital energy for them. Taliesin and Taliesin West are living embodiments of that seemingly ceaseless energy.

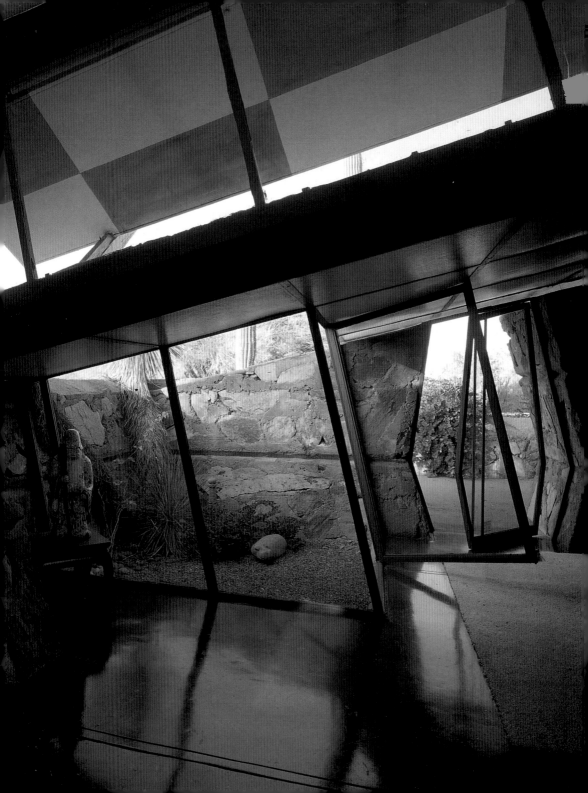

# THE LEGACY

THE LEGACY OF FRANK LLOYD WRIGHT takes many forms. Quite obviously the most apparent is the built architecture he left behind: the homes that bring pride to the families that live within them and the larger, public spaces that inspire the people working or worshiping within them. Hundreds of his designs, still preserved on paper in The Frank Lloyd Wright Archives, form another aspect of his timeless legacy. This includes dozens of unbuilt projects that he intended to be realized and that perhaps someday may even come to life off those lovely sheets of paper as future generations grasp their significance.

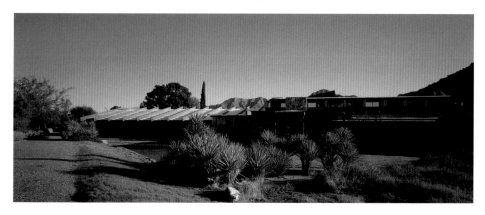

The drawings themselves are indeed works of art. That he was a master draftsman was first recognized by Louis Sullivan in 1887, and a love for drawing consumed Wright his entire life. His sketches are not muddy muddlings or the musings of his thoughts, rather they are clearly expressed concepts of buildings already well formed in his own mind and set down on paper so as to convey the ideas to his draftsmen and, later, to his apprentices. The beautiful color renderings, prepared by draftsmen and apprentices to show to clients, also frequently have Wright's own touches upon them: added dashes of color here and there, added shading, landscaping, flowers, and plants. Yet the aim of this work was single-minded: to show the client what a building would look like. The later working drawings for each project constitute the documents by means of which the building is built. The Frank Lloyd Wright Archives holds more than twenty-one thousand original plans, sketches, renderings, and working drawings and is today a national treasure.

FRANK LLOYD WRIGHT'S OFFICE, WEST ENTRANCE.

HILLSIDE, DRAFTING ROOM.

TALIESIN WEST, DRAFTING ROOM.

Books and articles, which Wright wrote constantly throughout his life, also carry his legacy. His concern for a creative architecture as the basis for a culture for the United States of America prevails in almost everything he wrote. He also wrote about Japanese art, in particular Japanese prints, a favorite art form that he collected extensively; about political conditions; and about urban planning—extolling decentralization and criticizing the evils of the modern city.

But his two homes, Taliesin in Wisconsin and Taliesin West in Arizona most clearly represent Wright—these are where he lived and worked, where he literally changed, remodeled, rebuilt, added to, and subtracted from on an almost daily basis. Maintained by The Frank Lloyd Wright Foundation, they are the objectives of thousands of visitors each year. Wright created the foundation in 1940, so that his work and ideas, including Taliesin and Taliesin West, would be protected, conserved, and even advanced. As he wrote in 1951:

The F.Ll.W. Foundation has no other meaning than the sole repository of my life-work for whatever it may be worth for the next hundred years. I have no private fortune. My dependents I can only leave to our Foundation. If the Foundation cannot protect them by protecting itself for another half century (at least) the result will be tragic: not only tragedy to my loved ones, I believe, but also a tragedy to the Cause of Architecture which I love as a whole with my whole heart.[1]

The Taliesin Fellowship, founded by Wright and his wife in 1932, continues as an active architectural office, with apprentices who worked with Wright now supervising new apprentices who come to Taliesin in order to learn architecture. Early in the years of the fellowship Olgivanna remarked to Wright, "It is not enough to build monuments, Frank, now you must build the builders of monuments."

During the last ten years of his life, Wright spoke to the fellowship—usually on Sunday mornings following breakfast—and these talks were recorded and transcribed. From this great wealth of nearly three hundred transcripts can be found his continual advice and counsel to the young student of architecture.

I love to work the way I work, to work with young lives, young people. I have always done it. I have always been surrounded by them, even before the days of the Fellowship. I want to continue working that way and all I am interested in is seeing that way of work take effect and become the way of work that is productive of great architecture the world over.[2]

Form is to the life as the life is to the form. In other words, the nature of the thing has its own expression according to the materials, according to the method, according to the man. And when the building is of that character, it is beautiful. It has not failed the beauty because it will have the same quality that a tree has, or that flowers have, or that a beautiful human being has.[3]

Organic architecture takes this thought from within the nature of the thing. It is a profound nature study. And out of all of that projects these effects, these ideas, these structures in tangible spirit form so that life is lived in them and architecture is an experience. All this is genuinely constructive, genuinely new in the history of culture in the world. That will be more and more realized as it goes along and proves itself. . . .

As beautiful building after beautiful building gets itself constructed and built, they will begin to look into it, try to find out what the secret was that kept it perennially young and always working, and never let it die because it couldn't die. You see, a principle never dies. The fellows who practice it do, the principle doesn't. So here you have in all these structures from first to last a growing idea. And in this work I think it would be well to see the growth of the idea. You can see it quite clearly because I myself looking back upon it now realize where it began to come in, and how it continued and where it was most effective, successful; and where it languished and then again where it picked up. But it is a pretty steady development from the beginning to the end which is quite interesting when you know how to follow it.[4]

When I go back and look at these things that I have done, I think, "Well, that is pretty good stuff, that time I did ring the bell." But I have to be careful of that because it is poison to the creative spirit. You do not learn by way of your successes. No one does. Your successes gradually build a wall between you and your creative self. You must always keep that wall aside so that you can see out. That you will find applying to everything you do—at the drawing board, in the kitchen, in the field, or building or anything else. You keep your mind open, keep inquiring and try to drive that nail a little better than you drove the one before, and see the mistake you made when you slammed the wood alongside instead of hitting the nail. You learn from that blow more than you do from one when you hit the nail. And that applies all down the line.[5]

It is my conviction and belief that the things that are more excellent—the things that really are valuable to you—are the things that are not on the surface and yet that do rise to the surface after many years experience. . . . In all of us there is a certain perceptive faculty which is the quality in us. Our quality as human beings as well as our quality in the future as creative architects consists very largely in little sensitivities, in little abilities to perceive and to feel that require cultivation and that will grow if you give them a chance. What we aim to do here is to create an atmosphere in which those incidentals which eventually become so important can form, can grow, and of course with all that there is a certain questioning taking place in your own mind, in your hearts. A great architect is not made by way of a brain nearly so much as he is made by way of a cultivated, enriched heart. It is the love of the thing he does that really qualifies him in the end. And I believe the quality of love is the quality of great intelligence, great perception, deep feeling.[6]

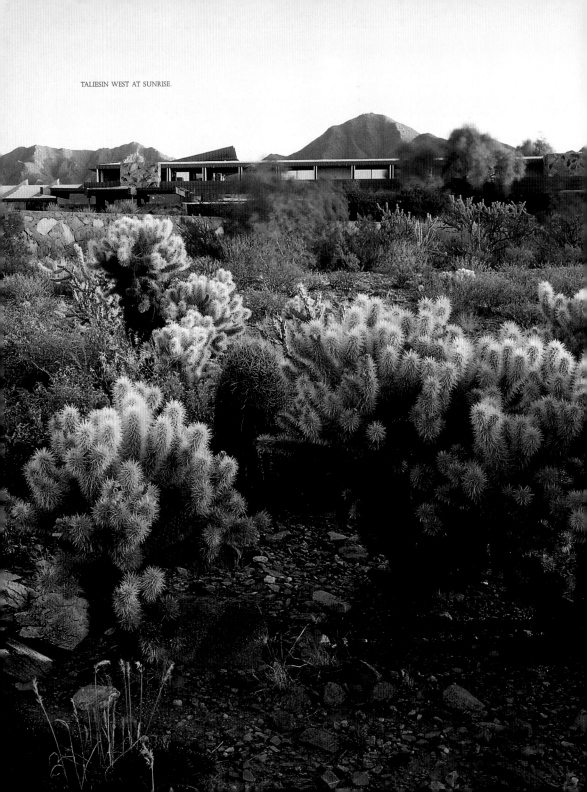

TALIESIN WEST AT SUNRISE.

# NOTES

All texts are by Frank Lloyd Wright unless otherwise noted. FLLW FdnAV numbers refer to transcripts of taped talks by Wright.

## INTRODUCTION

1. "The Architect and the Machine," 1894. Reprinted in Frank Lloyd Wright Collected Writings, vol. 1 (New York: Rizzoli, 1992), p.23. (Hereafter Collected Writings.)
2. "In the Cause of Architecture: Second Paper," 1914. Reprinted in Collected Writings, vol. 1, p.127.
3. Wright paraphrase of Okakura Kakuzo in The Book of Tea (Rutland, Vermont: Charles E. Tuttle, 1956), p.45.
4. "In the Cause of Architecture," 1908. Reprinted in Collected Writings, vol. 1, p.100.

## HOME AND STUDIO

1. Photograph of mural, FLLW Fdn #9307.002.

## WILLIAM H. WINSLOW HOUSE

1. An Autobiography, 1932. Reprinted in Collected Writings, vol. 2, p.189.
2. A Testament (New York: Horizon Press 1957), p.36. (Hereafter A Testament.)
3. "The Art and Craft of the Machine," 1901. Reprinted in Collected Writings, vol. 1, p.66.
4. A Testament, p.188.
5. Ibid., p.189.
6. "Two Lectures on Architecture," 1931. Reprinted in Collected Writings, vol. 2, p.87.
7. An Autobiography, 1932. Reprinted in Collected Writings, vol. 2, p.189.

## THE PRAIRIE YEARS

1. Life Works Series, 1951, vol. I, plate 3.
2. Following Wright's own 1908 "New School of the Middle West" and Thomas Tallmadge's "Chicago School," the "Prairie Style" was defined by Wilhelm Miller in 1915.
3. "Recollections, The United States: 1893–1920," Architects' Journal (London), July 6–August 6, 1936.
4. An American Architecture, edited by Edgar J. Kaufmann, Jr. (New York: Horizon Press, 1955), p.61. (Hereafter An American Architecture.)
5. Ibid., p.61.
6. Ibid., p.193.

## SUSAN LAWRENCE DANA HOUSE

1. Wright to the Taliesin Fellowship, August 27, 1952, FLLWFdn AV#1014.045.

## WARD W. WILLITS HOUSE

1. An Autobiography, 1932. Reprinted in Collected Writings, vol. 2, p.207.

## UNITY TEMPLE

1. The New York Times Magazine, October 4, 1953.
2. An Autobiography (New York: Duell, Sloan, and Pearce, 1943), pp.154–155. (Hereafter An Autobiography, 1943.)
3. Wright to the Taliesin Fellowship, August 13, 1952. FLLW FdnAV#1014.044.
4. Ibid., June 5, 1952, FLLW FdnAV#1014.041.
5. Ibid., January 30, 1955, FLLW FdnAV#1014.121.

## EDWARD E. BOYNTON HOUSE

1. Leonard K. Eaton, Two Chicago Architects and Their Clients (Cambridge, Mass.: MIT, 1969), p.116.

## FREDERICK C. ROBIE HOUSE

1. Architectural Forum, October 1958, p.126.
2. House and Home, May 1957, pp.110 and 116.

## EXODUS AND NEW ERA

1. An Autobiography, 1932. Reprinted in Collected Writings, vol. 2, p.219.
2. Ibid., p. 229.
3. Ibid., p. 229.

## ALINE BARNSDALL "HOLLYHOCK HOUSE"

1. An Autobiography, 1932. Reprinted in Collected Writings, vol. 2, p.275.
2. A Testament, p.158.
3. An Autobiography, 1932. Reprinted in Collected Writings, vol. 2, p.275.

## JOHN STORER HOUSE

1. An Autobiography, 1932. Reprinted in Collected Writings, vol. 2, pp.276–277.
2. Ibid., p.282.

USONIA
1. *An Organic Architecture* (London: Lund Humphries & Co., 1939), Reprinted in *Collected Writings*, vol. 3, pp.339–352.

EDGAR J. KAUFMANN HOUSE, "FALLINGWATER"
1. Edgar J. Kaufmann, Jr., *Fallingwater* (New York: Abbeville Press, 1986), p.36.
2. As related to author by Edgar J. Kaufmann, Jr.
3. Wright to the Taliesin Fellowship, May 1, 1955, FLLW Fdn AV#1014.129B.

HERBERT JACOBS HOUSE
1. Wright in interview with Jeffrey Aronin, May 1957, FLLW FdnAV#1014.297.

HERBERT F. JOHNSON HOUSE, "WINGSPREAD"
1. An Autobiography, 1943, p.476.

C. LEIGH STEVENS HOUSE, "AULDBRASS PLANTATION"
1. The actual origin of the name "Old Brass" appears to be obscure. For an exhaustive discussion of the history of the property, however, see Jessica Stevens Loring, *Auldbrass: The Plantation Complex Designed by Frank Lloyd Wright* (Greenville: Southern Historical Press, Inc., 1992).
2. Wright to the Taliesin Fellowship, March 9, 1958, FLLW FdnAV#1014.207.

THE FINAL YEARS
1. Wright, *When Democracy Builds* (Chicago: University of Chicago Press, 1945), p.7.

SOLOMON R. GUGGENHEIM MUSEUM
1. The Solomon R. Guggenheim Museum (New York: Horizon Press, 1960), pp.16–17.
2. Ibid., p.48.
3. Telegram to Hilla Rebay, December 30, 1943.
4. Wright to Hilla Rebay, January 20, 1944.

UNITARIAN CHURCH
1. *The Future of Architecture* (New York: Horizon Press, 1953), p.23.
2. Wright to the Taliesin Fellowship, August 28, 1955, FLLW FdnAV #1014.138.

ISADORE J. ZIMMERMAN HOUSE
1. Taliesin apprentice who supervised construction.
2. Letter from Zimmermans to Frank Lloyd Wright, June 16, 1952.

MARIN COUNTY CIVIC CENTER
1. Patrick Meehan, ed., *Truth Against the World: Frank Lloyd Wright Speaks for an Organic Architecture* (New York: Wiley-Interscience, 1987), pp. 439–440.
2. Aaron Green, *An Architecture for Democracy: The Marin County Civic Center* (San Francisco: Grendon Publishing, 1990), p. 21.
3. Ibid., p.73.
4. *An Organic Architecture*. Reprinted in *Collected Writings*, vol. 3, pp. 339–352.
5. Wright to the Taliesin Fellowship, March 9, 1958, FLLW FdnAV#1014.207.

TALIESIN III
1. *An Autobiography*, 1943, p.387.
2. See *Collected Writings*, vol. 3, pp.39–49.
3. *An Autobiography*, 1932. Reprinted in *Collected Writings*, vol. 2, p.295.
4. Wright to the Taliesin Fellowship, October 10, 1954, FLLW FdnAV#1014.110B.
5. Ibid., December 20, 1952, FLLW FdnAV#1014.055.
6. Jenkin Lloyd Jones to Richard Carney, November 30, 1992.

TALIESIN WEST
1. *An Autobiography*, 1932. Reprinted in *Collected Writings*, vol. 2, pp.329–330.
2. *An Autobiography*, 1943, p.452.
3. Wright to the Taliesin Fellowship, March 2, 1952, FLLW FdnAV#1014.035.

THE LEGACY
1. Wright in letter to G. M. Loeb, January 29, 1951.
2. Wright to the Taliesin Fellowship, September 17, 1952, FLLW FdnAV#1014.047.
3. Ibid., August 16, 1955, FLLWFdnAV#1014.259.
4. Ibid., August 13, 1952, FLLWFdnAV#1014.044.
5. Ibid., August 3, 1952,FLLW FdnAV#1014.046.
6. Ibid., Sept. 24, 1952, FLLW FdnAV#1014.048.